The Recreational Hiker's Guide to Las Vegas Area Trails

A Compilation of Level 1, 2, and 3 Hikes in the Area Immediately Surrounding Las Vegas

by CHRIS DEMPSEY

Bloomington, IN Milton Keynes, UK

AuthorHouse™
1663 Liberty Drive, Suite 200
Bloomington, IN 47403
www.authorhouse.com
Phone: 1-800-839-8640

AuthorHouse™ UK Ltd.
500 Avebury Boulevard
Central Milton Keynes, MK9 2BE
www.authorhouse.co.uk
Phone: 08001974150

First published by AuthorHouse 9/29/2006

ISBN: 1-4259-2009-8 (sc)

Library of Congress Control Number: 2006901430

Printed in the United States of America
Bloomington, Indiana

This book is printed on acid-free paper.

Photographs courtesy of Jerry Blum, Brian Dodd, Diane Dempsey, and Dick Miller.

This book is dedicated to the memory of Jerry Brown,
a great hiker and outdoor enthusiast whom I considered a friend,
to Wendell Stants, who got me involved in hiking in Las Vegas,
and to my great hiking friends
Jim Kaleka, Jerry Blum, Al Marino, and Roy Ota
who spent a lot of time with me on the trails.
Thanks for everything.

TABLE OF CONTENTS

MOUNT CHARLESTON AREA HIKES

LAS VEGAS VALLEY HIKES

LAKE MEAD AREA HIKES

INTRODUCTION

Sometimes a small project that has limited specific intentions turns into something with far more extensive size and purpose. Such was the case with this book. To explain how that came to be, I must first take you back to the beginning of my hiking career.

My wife and I moved to Las Vegas in November 2000, coming from the somewhat frozen tundra of that great northern state, Minnesota. To be sure, I had done some hiking while a resident of the north; among my accomplishments was a hike to the highest point in Minnesota, Eagle Peak, with a towering elevation of 2,301 feet above sea level. Rather than hiking, my passion during the 80's and early 90's was running. I had participated in several marathons and countless road and track races of lesser distances. I was slightly better than average for my age, and actually won age group awards on about a dozen occasions. In the mid 90's, however, a recurrent foot injury caused me to hang up my running shoes for an extended period of time.

My first year in Las Vegas, I found my way to Red Rock Canyon in the cooler months and the higher Spring Mountains in the summer to hike on several occasions. I mainly hiked trails like Pine Creek Canyon and Cathedral Rock. Still, I was more interested in reinventing my running career, now that my foot had healed. At the beginning of 2002, I made a New Year's resolution to get back into running, and I went out and

bought a good pair of running shoes. Unfortunately, after one week of doing two miles each day, my knees became so inflamed that I needed to take Celebrex and undergo physical therapy for nearly a month to get rid of the pain and swelling. I had to acknowledge that my running career was over.

One of my neighbors had been pestering me to consider joining the hiking club for Sun City Summerlin, where I live (oops, I gave you a hint about how old I am). The name of the club is Lone Mountain Hiking Club. In February 2002, I went to the monthly meeting, joined up, and went on my first group hike to Liberty Bell Arch. It was awesome. Later that month, I went with the group to Gass Peak, on the north side of the city in the Las Vegas Range. I was hooked. By August of that year, I made my first summit of Mount Charleston itself, using the Trail Canyon and North Loop approach and returning the same way.

By 2003, I found myself much more engaged with hiking, having gotten established with a smaller group of club hikers who did more demanding hikes, and more often, than the average club member. I also started leading hikes for the club on a regular basis, and began going on some of the Red Rock Canyon Interpretive Association group hikes.

In early 2004, one of the best-known characters at Red Rock, "Cactus" Jack Ryan, went into the hospital for heart bypass surgery. I had had the pleasure of hiking with him several times, and very much appreciated the contributions he had made to the hiking community. Knowing that Red Rock could use another hike leader, I volunteered, and started leading "official" hikes in July. The first three hikes I led for them were Fletcher Peak, Griffith Peak, and Mount Charleston. Since then, I have continued to lead hikes two or three times each month.

In December 2004, I was elected president of the Lone Mountain Hiking Club for the following year. In the three years I had been a member, I had seen a significant shift in the hiking club's general skill levels and

in hike participation. The more experienced hikers, who generally did hikes rated level 3 or higher, were diminishing in numbers as they got older, injured, or just moved away. The new hikers who were joining the club were recreational hikers – they were looking for nothing more complicated than a level 2 hike with a distance of three to five miles. Where two years before we had often had twenty or more participants on a hike, now we only occasionally got more than ten or twelve. One of the projects I decided to take on early during my year in office was to generate more excitement among the club membership about hiking in general. My thought was to do some write-ups on selected level 1 and 2 hikes with the idea of encouraging broader participation on the part of the club members in both scheduled and off-scheduled hikes. I started by listing eight hikes on a sheet of paper and asking for any input on other hikes any of the members would like to see included. No one added to the list. Knowing there were a lot of hikes that would fit into the level 1 and 2 categories, I started expanding the list until it grew into the production you now have in your hands.

The first pass at writing up the hikes took me about four months to accomplish. During that time, I often went out with one or two other hikers, clipboard, pen, and compass in my hand, pedometer clipped to my belt, taking copious notes on each of the hikes before doing the write-up. As much as possible, I tried to go with hiking buddies who had GPS units, so that I could get backup data for distances and elevation gains. For a while I had to hurry, trying to beat the heat expected to be sweeping over the lower desert by mid-May. Then I had to wait for the snow to melt in the Charleston area to finish off the last seven hikes. As you can see, I got it all done.

The purpose of my book is to provide a compilation of hikes that would appeal to the beginning or recreational hiker. Most of the hiking books you can buy these days are fixated on providing something for every-one – they include many hikes as short as ½ mile with a level 1 rating to hikes in excess of 20 miles that include significant vertical gains and

carry a level 5 rating. Many of these hikes involve routes rather than established trails. As defined in the narrow sense, a route hike goes directly over rough terrain, using only landmarks such as rock outcroppings, boulders, or trees to direct the way. A recreational hiker winds up utilizing only a fraction of the hikes provided in these books. On the other hand, a recreational hiker would be capable of doing 100% of the hikes in my book. Of the 46 hikes described here, all of them except Lost Creek/Willow Springs Loop are between 2 and 7 miles in length (no filler hikes included), stay primarily on trails, and have maximum vertical gains that can be handled by most hikers. In addition, I have not scrimped in providing trail directions, and I have included maps with nearly all of the hike descriptions to simplify the journey.

If you look at the Table of Contents, it is apparent that the majority of hikes are in the Red Rock area. That is by design. First of all, I live on the northwest side of town, so getting to Red Rock is very convenient for me. More important, however, is the fact that there are an extremely large number of hiking trails, biking trails, horse trails, and old roads that allow for the description or development of hikes that fit within the level 1, 2, or 3 category ratings. Only a few of the hikes involve any off-trail excursions, and these are in more or less accepted routes in the canyons and washes. Not only is this to the benefit of the recreational hiker from a safety perspective, it is more responsive to the concepts of wilderness protection. It really is important to safeguard our natural resources so that generations down the line will have the opportunity to see our wonderful landscapes and vistas as we see them today.

Now that I have mentioned Red Rock Canyon, let me tell you a little about it. Red Rock Canyon can be found by driving west on Highway 159 (Charleston Boulevard) for 5 ¼ miles past County Road 215, which will eventually be designated as I-215 when the limited access highway is completed. The area is managed by the Bureau of Land Management and is designated as a National Conservation Area. There is a fee for entry into the conservation area. A short distance inside the fee booth entrance

is a Visitor Center that includes many displays related to the area, the geology, the flora, and the fauna. There is also a gift shop that includes books and souvenir items from the area. Outside, you can view groupings of native desert plants with name signs, a large walled-in desert tortoise habitat area housing Mojave Max and several other desert tortoises, and even a picnic pavilion where you can sit and eat lunch amid the splendor of the desert and surrounding mountains and rock formations.

The ability to access the natural splendors of Red Rock Canyon is centered around the 13-mile paved scenic loop drive that runs counter-clockwise through the conservation area. The first 4 ½ miles of the loop generally run in a northwest direction, and include the drive past the multi-colored formations known as the Calico Hills. These sandstone hills rise to an elevation of nearly 5,500 feet, or about 1,000 feet above the surrounding area. They are the remnants of ancient sand dunes that were formed into rock through compression and the natural elements. The two predominant colors in the sandstone are cream and deep red, and there are distinct lines where the color suddenly and dramatically changes from one to the other. There are two observation areas, designated as Calico Overlook I and Calico Overlook II, where the viewer can get a close look at the rock composition and formations. There are hiking routes that begin at the overlook areas. A few of these routes involve trails that drop into the canyon between the scenic loop and the Calico Hills, but many involve rock scrambling or even rock climbing using advanced equipment. At the northwest end of the Calico Hills is Sandstone Quarry. This is an area where extraction of the cream-colored sandstone in block form was carried on for a short time many years ago. There are several hiking trails originating at this location, including the popular trail to Turtlehead Peak, a strenuous 5-mile hike that carries a difficulty rating of 4, and is therefore not included in this book, and Calico Tanks, which is included.

The middle 3 miles of the loop road generally run southwest past the White Rock Hills, consisting of two sandstone peaks, with the higher

limestone peaks of the La Madre Mountains in the background. This section contains the highest point on the scenic loop at 4,771 feet above sea level, or 1,050 feet above the Visitor Center. There are two trailhead areas in this stretch. The first is at White Rock Springs, located at the end of a ½ mile gravel road beginning at the 6-mile mark of the scenic loop, and includes such trails as Keystone Thrust. The second is at Willow Springs, at the end of a ½ mile paved road that starts about 7.5 miles into the loop, and includes the starting points for White Rock Hills Loop and La Madre Springs, as well as North Peak, a level 4 hike. A subsidiary trailhead on the spur road is the starting point for Lost Creek and the Children's Discovery Trail.

The last 5 ½ miles runs southeast along the escarpment, the towering sandstone cliffs on the west side of the conservation area. The escarpment contains the high sandstone peaks of North Peak, Bridge Mountain, Rainbow Peak, Juniper Peak, Wilson Peak, and Indecision Peak, as well as five canyons between them – Ice Box, Pine Creek, Juniper, Oak Creek, and First Creek. The peaks are extremely difficult to hike, all rated as level 4 or 5. The canyons are a composite of approach hikes on trails that of themselves are generally rated no more than level 2, with boulder scrambling sections that are much more difficult. Of these canyons, the only boulder scrambling section included in this book is the 0.4 miles into Ice Box Canyon that takes you to a sensational seasonal waterfall.

The staff at Red Rock Canyon is actively involved in providing quality programs for out-of-town guests and Las Vegas residents. Hikes led by staff members or volunteers are scheduled virtually all year long, including shorter walks and evening hikes during the summer months, and are free of charge to the public. Other activities include programs on map and compass, first aid, the environment, photography, children's programs, and informative talks on western subjects by "Cactus Jack," Red Rock's local living legend. There is also a very active support group called Friends of Red Rock Canyon that provides countless volunteer

hours to the conservation area through the staffing of the Visitor Center, the fee booth, hike leading, and trail cleanup. Without the efforts of this support group, Red Rock could not sustain the level of service it provides to the general public.

Las Vegas is fortunate to be surrounded by several other areas with abundant natural resources and scenery. Valley of Fire State Park is located 45 miles northeast of the metropolitan area just to the west of the Overton Arm of Lake Mead. This area is known for its deep red sandstone formations, including Elephant Rock and Seven Sisters, and for its many petroglyphs. Some of these petroglyphs give the appearance of being on fire when reflecting the sun's rays, thus the name for the park. A state of the art Visitor Center is located on the main road through the park, with great views of the Muddy Mountains to the southwest. There are several short hiking trails, including one to Mouse's Tank, named after a Paiute Indian who used the water tank as a base for hiding out in the area, and a few longer routes through the sandstone hills. I have not included any of the Valley of Fire hikes in this book, but the area is definitely one suitable for a day trip in the cooler months of the year.

Lake Mead National Recreation Area encompasses 1.5 million acres surrounding Lake Mead, as well as Lake Mojave, stretching as far south as the Davis Dam and Laughlin, Nevada, about 80 miles to the southeast of Las Vegas. The central attraction of the Lake Mead area is Hoover Dam, located at the southern end of Lake Mead and holding back the drainage of the Colorado River. The dam draws millions of tourists each year to see the 726-foot structure that was completed in 1936 and provides water resources and electricity for a large portion of the southwestern desert. Lake Mead itself is the water home for countless enthusiasts who enjoy boating, sailing, or spending time on one of the lake's fine beaches. There are a large number of hiking trails along or near the lake, as well as hiking routes through many of the washes or climbing one of the various peaks in the area. While many of the route hikes are difficult and require climbing over extensive rock formations,

the trail hikes are generally suited for the recreational hiker. Most of these trails, ranging in size from ½ mile and up, are located on the west side of the lake. The Alan Bible Visitor Center, located at the intersection of U. S. Highway 93 and State Highway 166, is somewhat of a focal point for the area, and provides a wide variety of information on recreational uses, including the hiking trails. Because Lake Mead is lower in elevation than the metropolitan area, the temperatures are generally hotter. Therefore, hiking in the area is not advisable for any distance during the summer months.

The upper region of the Spring Mountain National Recreation Area is a hiker's paradise during the hot summer months, with temperatures generally 20 to 30 degrees cooler than the lower valley. Mount Charleston rises to a lofty 11,918 feet above sea level, and dominates the landscape. Two other peaks, Mummy Mountain and Griffith Peak, rise above 11,000 feet, with several others in the vicinity of 10,000 feet. Snow is often present on the mountains between October and June, and provides a great alternative landscape to the desert below. The area is forested with a variety of trees, including aspen, red pine, and the gnarly bristlecone pine, which is only found above 9,000 feet.

There are two main canyons in the recreation area. Most of the hikes in the Charleston area are long and difficult, with vertical climbs ranging up to 4,300 feet in the case of Mount Charleston. There are several trails, however, that are perfectly suited for the recreational hiker in terms of vertical climb and distance.

Five of these that are described in my book are located in Kyle Canyon, which runs in a westerly direction from just north of the metropolitan area off U. S. Highway 95 to the base of the big mountain itself. The Fletcher Canyon trail, one of the five, is one of my absolutely favorite trails in the area, with spectacular scenery surrounding a reasonably short 4-mile hike into a narrow canyon with vertical rock walls. State Highway 157 provides access to the canyon. There are services in this

canyon, not including fuel, with a new Visitor Center and places to eat or stay at Mount Charleston Hotel and the Mount Charleston Lodge at the top of the road.

Lee Canyon, which is farther to the north and is serviced by State Highway 156 off U. S. Highway 95, is more of a wilderness area. The Bristlecone Loop, the only trail in the recreation area where mountain biking is allowed, is at the end of Highway 156. This trail provides great views of the back part of Mount Charleston and Mummy Mountain, as well as more remote peaks, such as North and South Sister, Mack's Peak, and McFarland Peak. The Bonanza Trail, a 13-mile dirt trail that runs along the northern spine of the Spring Mountains, takes off from the Bristlecone Loop and heads north toward the community of Cold Creek nestled in the northern part of the mountain range. Lee Canyon is also home to the area's only ski resort, which operates near the Bristlecone Trail. If you head up to Lee Canyon, make sure you have sufficient fuel in your car for a 60-mile round trip, as there are no other services in the canyon.

On the south end of the range is Lovell Canyon, serviced by a paved road coming off State Highway 160 on the far side of the mountain pass on the way to Pahrump. The north end of Lovell Canyon culminates at a saddle connecting Griffith Peak and Harris Peak, with Kyle Canyon on the other side of the saddle. The best views of the canyon are from the trail going to Griffith Peak off Harris Springs Road on the Kyle Canyon side. There are some hiking options in Lovell Canyon, most notably routes that climb up to the escarpment to the west of Red Rock and a gravel road that links up with Rocky Gap Road coming out of Red Rock Canyon from the Willow Springs area. These hikes are so remote, however, that they should only be attempted with a group led by an experienced hike leader. No hikes from Lovell Canyon are described in this book.

Mentioning remote hiking options leads me into my next topic, namely hiker safety. Unexpected events can often occur during the course of a

hike, and the individuals involved in the hike need to be aware of that fact. While I consider myself to be an experienced hiker, my number one rule is to hike alone only on relatively safe trails that carry a consistently high amount of traffic. Although I am prepared to handle an unexpected event on my own, an inexperienced recreational hiker is not. Therefore, it is important for the recreational hiker to be with other people as much as possible on his or her hiking expeditions. Sometimes you only need to be off a road a few hundred feet on the other side of a small ridge and, if an accident happens, you might not see another person for days.

Injuries are probably the number one problem that hikers face. I have suffered cracked ribs, a broken thumb, scrapes, and lacerations in the course of some of my hikes. Once, on a remote route off-trail with two fellow hikers, coming back from Willow Peak on the far north end of the Spring Mountains, I slipped on a scree field and slammed my knee into a large boulder. For about 15 seconds, the pain was so intense that I thought I had broken my knee. Fortunately, I had not, and I was able to limp out of the remote area with the assistance of my friends. This particular route probably does not see more than a dozen hikers in an entire year, so if something serious had happened and I had been alone, I might never have been able to get back to safety. I generally carry a first aid kit with me on all hikes, with the usual assortment of bandages, wraps, and ointments, and I can figure out a way to make a splint for a fracture should the need arise.

Sudden events brought about by physical conditions are another danger that hikers need to be aware of. Although not very common, heart attacks or cardiac arrest can occur during the course of a hike, even for people who otherwise appear to be in excellent physical condition. A basic knowledge and understanding of CPR is a must for anyone who wants to become serious about hitting the hiking trails.

Other physical conditions that occur much more frequently, especially for hikers in the desert area surrounding Las Vegas, are dehydration and

heat exhaustion. Either of these ailments can occur suddenly without much warning. Anyone hiking a distance greater than one or two miles is foolish if he or she does not carry a sufficient amount of water to keep them hydrated during the course of the hike. The amount required can vary by the individual, but the recommended safe amount of water is at least ½ liter of water for every hour you intend to hike. This amount can vary depending on the amount of heat you are expected to encounter during the hike – more water should be taken along for afternoon hikes or when temperatures are expected to climb through the 70's. A beverage that replaces your body's electrolytes is also recommended, especially on summer hikes at higher elevations. My first aid kit also includes tablets to replace the natural salts in the body if a physical imbalance should occur. In the event of heat exhaustion, it is necessary to find some shade and eliminate any physical exertion, and to follow up by seeking competent medical attention as soon as possible.

One dangerous situation that cannot be controlled and that can occur without warning is related to weather. If you are hiking in winter conditions with lower temperatures, make sure that you have several thin layers of clothing and proper socks, gloves, and hats to protect you from hypothermia, a subnormal body temperature condition that can come on suddenly. The summer months in the higher mountains is monsoon season, when storms can materialize in a very short time, producing significant rainfall, hail, and winds, with lightning an ever-present danger. In 2003, I was leading a hike to Mount Charleston on a day that started with absolutely no clouds in the sky. Four miles and 3,000 feet of vertical climb later, as we reached the saddle close to Griffith Peak on the South Loop Trail, we saw two puffy white clouds above us. We debated a few minutes as to whether any threatening weather was brewing, but decided to keep going with the proviso that we would reverse direction and get down as soon as possible if a storm erupted. After going another three miles on the ridge, an electrical storm suddenly intensified. Unfortunately, the main area of concentration was between our position and Griffith Peak to our rear, so turning around was not an

option. We spent many anxious moments as we hiked above the tree line with nearly continuous lightning just on the other side of the ridge in Kyle Canyon. Fortunately, the storm was of relatively short duration, and the skies cleared as we crossed the peak and headed down into Kyle Canyon on the North Loop.

Sudden significant rainfalls can also bring about flash floods, which can be a big problem if you are hiking in or near drainage areas or in canyons. If you are planning on doing a hike in that kind of terrain, it is strongly advised that you pay attention to the weather forecasts and, if necessary, select an alternate hike without any exposure to flooding. There seem to be several occasions each year when so much rain falls within a relatively short time period in Red Rock Canyon that the scenic loop is closed because of the threat of flash floods flowing across the roadbed.

Finally, some consideration must be given to the presence of wild animals, especially mountain lions living in the Spring Mountains, as well as snakes, scorpions, and tarantulas. At last count, I believe the Nevada Division of Wildlife had identified 38 mountain lions, also known as cougars, in the mountains surrounding Red Rock. These cats are generally nocturnal, and stay away from groups of people, so the chance of seeing one of them is very slim. Yet the possibility of an encounter cannot be disregarded. If you find yourself close to a mountain lion in the wild, do not run. The natural instinct for the big cat responding to that action is to chase and attack. Rather, wave your arms in the air and make noise to alarm the cat into moving off. Some people have jokingly said that you should only run from a mountain lion if you are in a group, and then only if you are faster than at least one other person in the group.

Although rattlesnakes are occasionally seen in the mountains, more often in the Red Rock area than in the higher Spring Mountain Range, they will usually sense people and try to avoid them. The danger is in coming across one and putting it into a position of having to defend itself. Be alert during the months of April, May, and October in the Red

Rock and Lake Mead areas, and in June in the higher elevations, for the possibility of running across a snake. The most common rattlesnakes found in the Red Rock area are the Mojave Green Rattlesnake, found on the level ground of the desert floor, and the Speckled Rattlesnake, found in the rockier areas around the canyon. Of the two, the Mojave Green is far more dangerous, because its venom is actually a neurotoxin that can cause serious medical problems within ten minutes of the bite. Personally, I had not seen a rattlesnake in my first four years of hiking near Las Vegas. In April and May of 2005, while I was writing this book, I happened across four on separate hikes over a six-week span. Rattlesnakes will be more prevalent during years of higher winter precipitation, when the lizard population grows significantly, than during dry years.

Scorpions live naturally in the desert and are not sensitive to the presence of people like snakes are. Although generally not deadly, they will have an effect similar to a bee sting. If you are allergic to the venom, however, the reaction could be much more severe. On a recent hike I led for Red Rock, one of the participants, who didn't know very much about scorpions, spotted one and foolishly picked it up. Luckily for him, the scorpion only got him with a front pincher and not the venom-injecting tail.

Tarantula spiders are generally very docile, and many people claim that you can pick one up and hold it in your hand. Even so, I would rather leave that action to someone who is familiar with how to handle a tarantula. Although not severely poisonous, they can bite and cause a systemic reaction. Also, the hairs on a tarantula's abdomen can sting, resulting in an itching sensation that can last for hours. If you happen to spot one on a trail (I have seen half a dozen), just take the precaution of leaving them alone.

Having the proper equipment is essential if you are going to enjoy hiking on any kind of a regular basis. Proper equipment starts with a good pair of hiking shoes. Trying to find the right pair of shoes can be very confusing. Prices range between $20 and $400 per pair, and there

are a lot of claims that the more expensive shoes will serve you better in your hiking endeavors. This is not necessarily the case. The more expensive shoes should certainly be looked at if you are planning on doing specialized hiking, or if you are prone to foot, ankle, or leg problems. Quality replacement orthopedic inserts can alleviate most of the problems resulting from physical conditions, and these are often needed in the most expensive shoes as well. For the beginner or recreational hiker, I would suggest looking at shoes in the $40 to $70 range. Most important, make sure that they are comfortable and provide sufficient support for your feet and ankles. If you are concerned about ankle weakness, get high-cut hiking boots for added support. If you plan on doing hikes that involve steep trails, purchase shoes about ½ size larger than your street shoes. This will keep your toes from getting pinched on the descent. If you plan on hiking more than twice a week, consider purchasing two pairs of shoes and alternate their use.

Footwear also includes your socks, and I feel that your selection here is more important than the brand of shoes you buy. I purchase socks specifically meant for hiking that retail around $10 a pair. They are not extremely thick, but are made out of advanced material with a high degree of durability and cushioning and are designed to wick moisture away from the foot during use. I have used cotton socks in the past, but I seem to wear them out after a few months, and my feet feel damper from the perspiration.

The clothing you wear needs to be durable but not bulky. The hiking trousers I wear during the winter months are good quality nylon trousers with a detachable lower leg section, in case the weather becomes hot and I need a little more ventilation. I also wear these trousers anytime I am involved in rock scrambling where I will need a little extra protection from brush and rocks. In the summer, I often wear shorts, which also are made from 100% nylon. Shirt selections are more a matter of personal comfort. Some people prefer cotton, which tends to hold moisture from perspiration and provides the sense of a cooling effect on the

upper body. My preference is polyester, which wicks moisture away from the body and is quick drying. My advice is to select the type of shirt that is most comfortable for you during periods of exertion when you are most prone to sweating. The proper choice of headwear is also important. I recommend that you select a hat with a floppy brim to protect as much of your face and ears as you can from the sun.

Although many people don't consider this to be equipment, a good sun block is as important as anything else you can put on. To be effective, you need to select a product with a UVB rating of 30 or higher. The incidence of skin cancer is quite high in the southwest, and the face and ears are usually the most exposed part of the body for hikers where melanoma or basal cell cancers can occur.

Perhaps the most important part of your equipment is some kind of a pack to carry water. For most hikes in the winter, and for shorter hikes during the summer, I generally carry a belt pack that holds two bottles with a capacity of close to 600 milliliters in each bottle. Mine also has about 200 cubic inches of storage for food, additional water if needed, and a basic first aid kit. These belt packs are very light weight and don't get in the way while hiking. You should be able to find a decent one for under $15, so the cost is very nominal. During the longer hikes in the summer, I use a hydration backpack. This system contains a two-liter high quality plastic bladder with a tube that comes over the shoulder, giving you constant access to water. There should be enough storage capacity in your pack for extra bottles of electrolyte fluid and food. If you want to pay for a name brand pack, you can easily spend $60 or more, but other durable versions are available starting in the $25 to $30 range.

Optional equipment that you may want to consider includes:

1) Hiking sticks. Depending on how you hike, these sticks can take a tremendous amount of strain off your knees. Some people prefer one stick, while others use a pair. The best kind are adjustable, so you can

change the length from the uphill portion of your hike to the downhill segment. Some are spring loaded, to further reduce the strain.

2) Pedometers. It's always nice to know how far you have hiked. Besides distance, most types provide information regarding steps taken, calories burned, and moving time. Pedometers can be tricky to program, because you have to enter your weight fairly accurately and know what your stride length is under varying conditions, but they can be fun and informative. A reasonably priced pedometer can be acquired for about $25.

3) GPS Units. If you have the money and don't mind spending it on toys, get a GPS unit. Good units not only keep track of distance and elevation, they also map out the hiking route you have taken and can pinpoint coordinates and allow for programming of key information that you may wish to store for a repeat hike in the future. Try to remember, however, that GPS units are not always totally accurate. On many occasions, I have hiked with three or more such units at the same time, and none of them have provided the same information as the others. Don't be insufferable and claim that yours is 100% accurate at all times.

Before I get to the discussion of how the various hikes in this book were selected and rated, there is one further subject I need to touch on, namely hiking ethics. Hiking ethics can be summed up concisely in the three-word slogan "Leave No Trace." Recreational hikers do not need to be trailblazers since there are already so many established options to choose from. Only a few of the hikes in this book involve any hiking terrain that does not consist entirely of established hiking trails, horse trails, bike trails, or roadbeds, and those are in acceptable hiking routes with a minimum of off-trail exposure. Please stay on the trail and avoid taking any shortcuts through the desert or cutting switchbacks in the mountains. Do not attempt to get closer looks than permitted of the many rock art sites and historical artifacts found in the Red Rock and

Valley of Fire areas, such as petroglyphs, pictographs, and prehistoric kitchens (agave roasting pits). All Indian rock art sites are protected by law. Collecting artifacts is also prohibited. Rock art should not be touched because oils in the skin will cause damage. Always remove all your trash when you are done with a hike, including apple cores, orange and banana peels. These things do not blend in with the natural environment and can take years to decompose. Take out whatever you brought in. Be aware that other people may be using the hiking trails in your vicinity, and respect their rights to enjoy nature just as you would expect them to respect yours. Make sure that your hiking partners are prepared for the elements you might encounter, and be ready to lend assistance to another hiker should the need arise. If you use common sense and follow these principles, we can all enjoy hiking more and leave the environment for our children in the same state that we found it in.

I have tried to keep the hiking jargon to a minimum in this book, but there is some that I have used out of necessity. A beginning hiker may not understand the exact meaning of the terms used, so let me give you a short explanation of some that are used in this book. A wash, a desert arroyo, and a drainage are used somewhat interchangeably. They all refer to a form of runoff channel that takes flowing water from a higher area, similar to a riverbed. Most of the time in the desert, however, these channels are dry.

Bouldering and rock scrambling are also similar, in that they usually require the use of hands to get over and around rock formations, primarily in canyons and washes. The distinction has to do with the size, boulders generally being larger. Trails refer to established paths over dirt and some small sections of rock. Routes generally refer to hiking areas where the terrain is too rough for trails to exist, but I have also used the term to describe the course which a hiking trail takes. I hope this will not be too confusing. Caliche is a compressed composition of dirt, sand, and small pebbles that often has the overall appearance of being larger rock formations or boulders. Scree and talus are similar, both

names referring to areas of loose rock of various sizes. Scree is generally found near the bottom of a hill or drainage and talus is found on a slope. Cairns are trail or route markers using piles of rocks to guide the hiker in the proper direction. These are often used to provide security to the hiker that he is on the right course. Prehistoric kitchens or agave roasting pits are used interchangeably, and refer to the areas with rock edges built up around shallow pits that were used by ancient groups of people in the area for cooking food and for ceremonial purposes. Petroglyphs refer to the ancient carving of symbols in the side of rock formations. These are different from pictographs, which are not carved but are painted on the rock surface. I am sure you may have other questions about terms used in this book, but you will have to go on a Red Rock hike with me sometime if you want further answers.

Finally, let me discuss the formulation of the hikes in this book and the ratings I have given each one. As I stated toward the beginning of my introduction, the original purpose of compiling these hike descriptions was to broaden the participation level of the members in my hiking club in Sun City Summerlin, by providing a how-to-do-it approach to level 1 and 2 hikes. As the list of potential hikes grew, however, I had to acknowledge that you didn't have to be a senior citizen to approach hiking without wanting to expose your physical health and mental state to the rigors of difficult hikes. I also decided to include hikes that I determined, using my somewhat composite criteria, to be level 3 hikes. It was my feeling that such hikes would be of interest to beginning hikers after they had mastered the easier hikes and wanted to progress. Recreational hikers in reasonable condition would find these hikes slightly more challenging but definitely within the range of their abilities.

Most of these hikes I had done many times over, so the main thing was to redo each hike, taking notes of distances and usable landmarks for each of the hikes. I decided on the first pass to write my descriptions without the benefit of pictures. I thought that if I could direct people on trails using only written words to explain what I had seen that I would

be forced to make my descriptions much more understandable. When pictures were added, they would only be used as a supplement to provide an understanding of the scenery, and not as the main source for directing the hike route. I think I accomplished that task in this book.

There has been and always will be a constant debate on how to rate hikes. The most popular local hiking book on the market (before this one, I hope) rates hikes using 1 through 5 for difficulty, danger, and how easy the correct trail or route is to follow. Since virtually all of the hikes described in my book are on trails, with only an occasional slight exposure, I essentially felt that the danger and easiness to follow classifications would be rated either level 1 or 2 for both of those categories on all of the hikes. Therefore, I have not classified either of these two categories in my hike descriptions.

The difficulty ratings system used in the aforementioned book was written by a much younger individual, who had hiking skills that far surpassed those of the average recreational hiker. What he judged to be a level 3 hike could actually be rated as a level 5 hike by a middle-aged weekend hiker or a retired 68-year old. The criteria I eventually adopted for assigning difficulty levels to the various hikes was a combination of Red Rock's designation of easy, moderate, and difficult descriptions to hikes it sponsored and the ratings from various members of my hiking club, tempered slightly to acknowledge that the average recreational hiker may be slightly younger than 65. Please be aware that these are general guidelines; trail conditions and rates of climb are as important in determining each hike's rating as are distance and total elevation gain. Accordingly, here is the rating system I have used:

1) Level 1 is assigned to hikes with a distance of up to 3 miles with a maximum vertical gain of 300 feet. Trail conditions should be such that a person should not have to be overly concerned about footing, such as jagged rocky areas in the trail. An exception to the distance criteria is the Historic Railroad Tunnels hike, which has a total

distance of 4.2 miles if hiked to the end of the last tunnel and back, but has very little elevation gain to wear out the hiker.

2) Level 2 is assigned to hikes with a maximum distance of 6 miles and a maximum vertical gain of 700 feet. Surface conditions for the hike could result in a higher difficulty rating than one simply based on distance and elevation gain. The Ice Box Canyon hike is a prime example, being rated as a level 2 hike because of the amount of bouldering involved in the back part of the canyon.

3) Level 3 is assigned to hikes with a maximum distance of 9 miles and a maximum vertical gain of 1,500 feet. Again, surface conditions on the trail or high elevation gains could cause a shorter hike to be assigned a level 3 rating. The Calico Tanks and Cathedral Rock hikes are prime examples of how that can happen.

As you probably noted, there is something of a geometric progression as the levels advance, particularly in regard to vertical gain. I believe most hikers are capable of making the same progressions as they develop their hiking skills to the fullest.

There are a few more bits of information you need to know regarding the hike descriptions included here. Most of the hikes in this book are either out-and-back hikes, where you will go from Point A to Point B and simply reverse your route on the same trail to return to the start, or they are loop hikes, in that you return to the beginning without retracing any of your steps. In all cases, the distances listed for each of the hikes represents the total distance that you will travel from the beginning to the end.

At this point, having given you as much general information as I thought you could use in one reading, it's time to turn you loose exploring specific hikes and determining where you want to start or continue with your hiking exploits. Above all, have fun and enjoy the variety of scenery you are about to encounter on the trails.

RED ROCK AREA HIKES

RED ROCK ENTRANCE LOOP

Starting Point: Red Rock Fee Booth Parking Lot (on the left side just before the fee booth)
Difficulty Rating: 1
Distance: 2.6 Miles
Elevation Gain: 200 Feet

Comments: If you are just starting into hiking, make this hike your first one. The moderately short distance and minimum elevation gain will give you an idea if hiking is a physical activity you would like to pursue. Even if you are not a beginner, this is an ideal hike during the period between October and May when you don't have a lot of time to hike, or for taking visitors to our area who would like to get a feel for Red Rock without expending a great amount of energy. Parking is easy and you don't have to drive any of the scenic loop, thus allowing for a quick exit and return to Las Vegas. This hike can either be done as described, or can be shortened by 1 ¼ miles by not doing the middle leg up to Calico I Overlook and back.

Hike Description: Beginning from the Red Rock Fee Booth parking lot, go through the opening in the fence on the north side of the parking lot and look for the two old crosswalk indicators slightly to your left that point toward the Visitor Center. Go around the small island that separates them and pick up an unmarked trail that heads directly toward the Visitor Center. The trail has a rock border for most of its short length. In about ¼ mile you will arrive at the lowest of the three paved parking areas for the Visitor Center. Go up three flights of steps and proceed to the south side of the building. If you have friends along who have never been inside, here is a good opportunity to take them through the

displays that show the geology and the various types of animals and reptiles that inhabit the canyon.

If you want to proceed directly with the hike, go around the left side of the building and the left side of the low block wall that houses the Desert Tortoise Habitat. At the corner of the habitat is a sign that indicates "Moenkopi Trails System." Go past the sign and take the dirt trail that starts off in a northwesterly direction as it drops slightly into a minor wash. Just after you reach the low point of the wash, there is a fork in the trail with a directional sign. Take the right fork that is indicated on the sign as the direction to Calico Hills. The location of this sign is just short of one-half mile from the start of your hike.

Past the sign, the trail starts off heading toward the east and then bends slightly to the left. About ¼ mile past the sign, the trail intersects the scenic loop drive. Cross the road surface and continue on the trail as it begins a slight climb up the side of a minor wash. About 400 feet past the road crossing, you come to a trail intersection marked by a sign. If you have decided to shorten the hike to 1.35 miles, take the trail to the right and return to the fee booth as indicated after the next paragraph. Otherwise, take the trail to the left that the sign indicates is the direction to Calico Hills.

If you have taken the trail toward Calico Hills, about 600 feet past the intersection a faint trail comes in from the right and a very worn sign stuck in a rock pile points the way to Calico I Overlook. Stay on the main trail as it proceeds along the top of the ridge, heading north at first and then angling to the left back toward the road. Along this stretch, you get a great view of the canyon forming on your right that separates you from the Calico Hills. The trail continues to climb slightly and the Calico I parking area is directly in front of you. At 1.4 miles into the hike, you arrive at the overlook area. Take a moment to sit on one of the benches and gaze at the multi-colored rock formations directly in front of you that comprise the Calico Hills. When you are ready to move on, reverse your hiking route for the last 5/8th mile and return to the trail

intersection where you came up from the Visitor Center. Take a left on the trail that heads toward the fee booth.

Just past the trail junction is a short climb heading in a SSE direction. At the crest of the small rise, the trail begins a long gradual descent over a hiking surface that contains several minor rocky outcroppings. About ¼ mile from the previous trail junction, the trail you are on empties into a minor wash containing quite a bit of small gravel. Stay in the wash for a few hundred feet. The trail climbs out of the wash slightly to your right and the fee booth becomes visible as you reach the top of a small ridge. The trail takes a sharp bend to the right, heading west, and crosses a drainage. A short climb from this point brings to back to a corner at the start of the scenic loop, from where you can see the starting point of your hike.

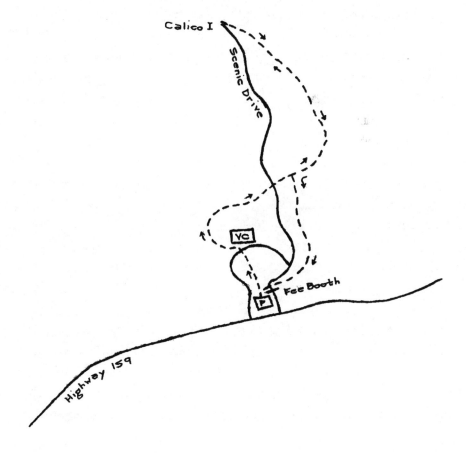

CALICO HILLS

Starting Point: Red Rock Fee Booth Parking Lot (on the left just before the fee booth)
Difficulty Rating: 3
Distance: 6 Miles
Elevation Gain: 725 Feet

Comments: This hike takes you along nearly the entire southwest side of the Calico Hills, from about ½ mile below the Calico I Overlook to Sandstone Quarry. This is an out-and-back hike, so you can decide along the way how much of the entire 6-mile length you want to cover. An alternate starting point for this hike is the Visitor Center, which takes about ½ mile off the total distance. For this starting point, park in the upper lot and follow the directions as indicated in the 2nd and 3rd paragraphs of the preceding hike (Red Rock Entrance Loop). The Calico Hills trail crosses several sections of sandstone slab rock where it becomes obscure, so it is essential on your first attempt to look around as much as you can and familiarize yourself with your surroundings. The information you retain will be valuable in retracing your steps on the return. Past Calico I Overlook, the main trail winds up and down ridges fairly close to the southwest wall sections of the Calico Hills, so try not to get on any trails that take you up to Calico II Overlook or the scenic loop road until you get to Sandstone Quarry.

Hike Description: Beginning from the Red Rock Fee Booth parking lot, go through the fence on the north side of the parking area and angle to your right, crossing the entrance road toward the trailhead sign that indicates "Calico Hills Trail System." This sign is located at the right corner of the entrance road near a 35-MPH speed limit sign, about 270

feet from the opening in the fence at the parking area. The trailhead sign gives distances to the two overlook areas and Sandstone Quarry. As you start on the trail, you will be heading to the northeast and away from the scenic loop road. After a short distance, the trail bends left, toward the northwest, and heads straight at the Calico Hills. The trail drops into a gravelly drainage area for a few hundred feet before angling to the right and continuing uphill out of the wash. The trail is now running parallel to the scenic loop. At slightly more than ½ mile into the hike, you come to a trail junction, with a sign pointing left to the Visitor Center and right for the Calico Hills trail. Go to the right at this point.

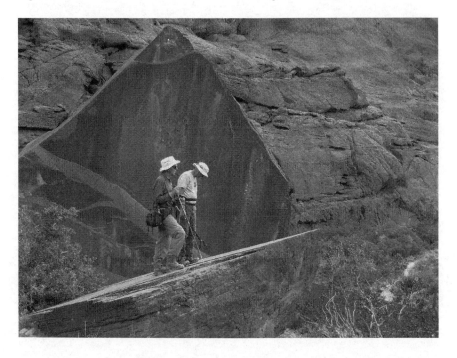

About 600 feet past this intersection, a faint trail comes in from the right and a very worn sign stuck in a rock pile points the way to Calico I Overlook. Stay on the main trail as it proceeds along the top of the ridge, angling back toward the road, with a canyon forming on your right separating you from the Calico Hills. The trail continues to climb slightly and the Calico I parking area is directly in front of you. At 1.1 miles into the hike, you will arrive at the first overlook area. Stay

along the wood fence separating the parking area from the canyon, and proceed to the center section of the overlook that contains the informational signs about the Calico Hills. Look for the wide dirt ramp that drops down to a rocky area at the end of a point. There is a sign that says "Caution – Steep Slope" at the top of the ramp. Go down the ramp past the sign and look for a small directional sign near the bottom that points to the left for Calico II and Grand Circle. Take this trail to the left, which drops down into a drainage area.

As you get to the bottom of the drainage area, trails seem to diverge in several directions. Stay fairly close to a broad red-and-white striped sandstone rock on your right that is about 20 feet high, and look for the trail continuation on the other side. A brown directional arrow sign marks the correct trail, but you will have to cross a small sandstone slab to get to the sign. Go past the sign and begin a very steep uphill climb section with the trail bending to the right toward the Calico Hills. At the top of this climb, you are within 70 feet of the sandstone walls on the southwest side of the Calico Hills. The trail bends to the left along the narrow canyon separating you from the sandstone walls.

In about 1/10th mile, with the main trail dropping slightly into the drainage, you encounter a trail junction. Stay on the trail to the left that climbs rather than the one on the right that drops into the drainage. The climb is moderately steep for about 1/10th mile and crosses a rock outcropping before cresting a ridge. The Calico II Overlook area is visible across the wash on your left. The trail crosses the ridge and starts descending toward the drainage on the opposite side. Although you are on a stretch of the Grand Circle Trail, for the next 0.4 miles the trail will be obscure in several sections. Care must be taken to find the proper way through and you need to be alert for the landmarks that will take you back through this stretch on your return.

From the top of the ridge indicated in the last paragraph, the trail descends over a distance of 400 feet until it comes to a red sandstone

rock formation. Continue onto the rock formation and make a 120-degree bend to the left where the sandstone appears slightly worn. Go only about 20 feet on this course before taking a 90-degree turn to the right and continuing to descend on another sandstone outcropping. At the bottom of this slab, the trail becomes noticeable for a short distance just to the left of a rock formation. The next short segment of trail is very rocky and has four or five red sandstone steps at the bottom of the section. Past the steps a short distance, the trail appears to have come to an end. When you get to this point, scramble to your left over a 3-foot wide rock ledge marked with a cairn and climb into the narrow crack that continues to drop between the red sandstone walls. There are a few gray rocks at the top of this crack that give the appearance of steps. The drop through the crack is not dangerous, and is only about 15 or 20 feet in length.

Once past the crack, the trail takes on more definition for a short distance before crossing another rock slab. Stay on the slab formations to the right of the drainage. At the far end of a 100-foot section of sandstone slab, the trail again becomes slightly more identifiable. About 200 feet past the slab, look for a spot where the faint trail drops into the wash before crossing another sandstone slab. Turn left into the wash and make an immediate right to stay in the drainage of the wash. Continue in the wash for about 130 feet to a point where the trail climbs out of the wash over a rock slab on your left. About 160 feet later, you begin a steep climb up to a ridge, keeping the canyon on your right in sight. At the top of this ridge you are again hiking over a rock slab, but the trail becomes much easier to follow on the other side. You are about 2 miles into the hike when you reach this spot. Cross the rock ridge and make a slight descent on the trail, staying left of the drainage.

In 1/10th mile, continue straight (left) at another trail junction. Your view up the wash is now dominated by a 40-foot high rock that, along with several others near it, broke off from the cliffs on your right centuries ago. As you get to the rock, the trail turns left and starts uphill. Just

to the left of the 40-foot rock is another red sandstone slab that is loaded with petroglyphs, an ancient form of Indian communication. Take a moment to look at these petroglyphs, but do not attempt to touch them, before continuing on. This spot is about 2.25 miles into the hike.

About 1/6th mile past the petroglyphs is a large red sandstone formation that has several holes in it, including one that is showing evidence of having an opening on the top back section. The trail climbs around this rock and crosses another rock outcropping. The trail becomes visible again at the top section of this outcropping. In another 450 feet, an 80-foot slab must be crossed, but the trail is easy to see on the other side.

Following a slight descent, the trail begins a gradual climb that lasts for 0.3 miles. At the top of the ridge at the end of this climb, the Sandstone Quarry parking lot becomes visible about 700 feet in front of you. The area of large cream-colored sandstone rock formations on your right is an ideal spot to grab a snack and something to drink while contemplating what you have seen on the hike so far. If anyone in your party is in need of restroom facilities, some are located at the far end of the Sandstone Quarry parking area near the trailhead area for the Calico Tanks hike. If you go up to the parking area, another sign is located at the beginning on the return trail indicating "Calico Hills Trail System." The point where the trail exits into the parking area is 3 miles into the hike. If you don't need the restroom facilities, start your return hike from the snack spot.

To Return: Reverse your direction and return past the Calico overlooks to the fee booth. Hopefully, you remembered all the tricky little spots that you encountered on the way up. If you want to avoid the confusing section in the middle of the return, there is an alternate route. About one mile into the return, the trail makes a steep climb and you will get a view of Calico II Overlook a short distance away. Stay on the well-defined trail that starts to the right and arcs back to the left below the overlook. When you come to a directional sign, take the trail that keeps

you below the overlook and points you back toward the drainage. Near the drainage, the trail bends to the right and becomes somewhat obscure for a short distance. Stay on the trail to the right of the drainage, and it will take you back directly to the Calico I Overlook where you will be just over one mile from the starting point of the hike.

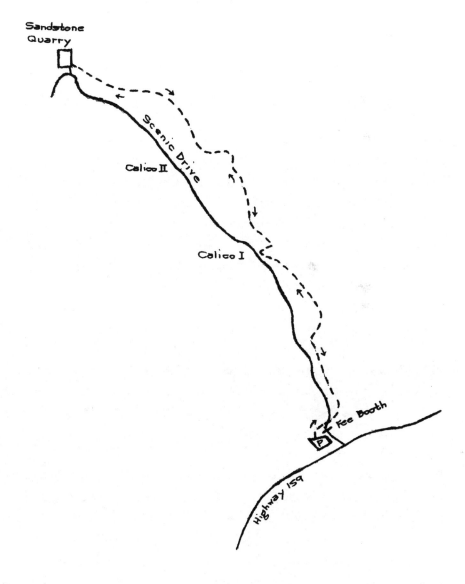

MOENKOPI LOOP

Starting Point: Red Rock Visitor Center
Difficulty Rating: 1
Distance: 2 Miles
Elevation Gain: 140 Feet

Comments: This is one of the more popular hikes in the Red Rock area for a number of reasons – it is short, has good surface conditions on the trail, great views of the escarpment to the west and the Calico Hills to the northeast, and, after doing the hike, you can exit straight out onto Highway 159, thus avoiding having to drive the 13-mile scenic loop. There are a number of informational signs along the trail that describe the different geological features, such as the desert itself, the formation of the sandstone Calico Hills, and the Moenkopi Limestone, which underlies the canyon. This is a great trail for an early morning stroll with a bench at the highest point overlooking the Visitor Center.

Hike Description: Beginning in front of the Visitor Center, proceed to the left around the Desert Tortoise Habitat that lies to the rear and left side of the Visitor Center. The trail begins at a sign titled "Moenkopi Trails System." The dirt trail starts off in a northwesterly direction as it drops slightly into a minor wash. Just after you reach the low point in the wash, about 1/8 mile from the start, there is a fork in the trail with a directional sign. Take the left fork, as indicated on the sign. The trail proceeds north up a small ridge. Once you get part way up the ridge, the Calico I parking area appears in the distance straight to the front. The trail bends slightly to the left (northwest) as it continues, and the Calico I area will continue to be visible to the right.

At about 0.7 miles, there is a marked trail junction. The trail to the right goes to the Calico I Overlook area. Take the trail to the left, which is marked as the Moenkopi Trail. Shortly after the sign, the trail bends to the left (south) as it climbs to the top of an 80-foot ridge. The Visitor Center will come into view about 30 degrees to your left. Continue ascending on the trail along the edge of the ridge as it crosses an exposed area of the underlying Moenkopi Limestone. A sign along the trail discusses its formation. At 0.9 miles, there is an apparent fork, with the trail to the right crossing the ridge and starting to make a gradual descent. While the two trails converge in about ¼ mile, I prefer to take the trail to the left that continues up to the highest point of the ridge. At the highest point, you will find a bench to sit on and admire the great views of Red Rock looking back toward the Visitor Center. If you are not in a hurry, this is an excellent spot for either a snack or a nap.

As you begin your descent from the top of the ridge, you will be heading in a westerly direction. The merger with the trail mentioned in the previous paragraph is about halfway down from the top of the ridge. Make sure you stay to the left or you will be going back on a small loop. You need to be cautious on the descent because of loose rock that can cause problems with footing.

As the trail reaches the bottom of the ridge, it turns SSE and goes into a small wash. Look for the rock border in the wash that gives definition to the trail. The trail continues in the wash for a short distance before meeting the Grand Circle Trail 1.5 miles into the hike. You are now ½ mile from the Visitor Center. Head ESE on the combined trail. This portion of the trail is in a drainage area with a small ridge on your left. The Visitor Center is visible from time to time about 30 degrees to the left. As you continue straight on the trail, the fee booth will become noticeable directly ahead. As you go past the 1.8 mile mark of the hike, the trail to the Visitor Center, which is marked by a stone border, goes to the left. Take that trail and return to your starting point.

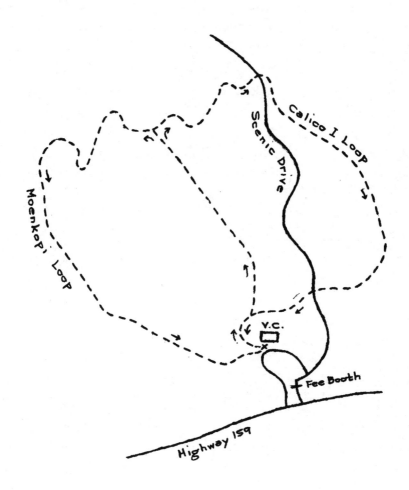

CALICO I LOOP

Starting Point: Red Rock Visitor Center
Difficulty Rating: 1
Distance: 2.2 Miles
Elevation Gain: 150 Feet

Comments: This is a very nice short hike that follows the beginning section of the Moenkopi Loop before heading toward the Calico I Overlook. For about ½ mile after reaching the Overlook, there are great views of the deep canyon that lies between the Calico Hills and the scenic loop drive. Since the hike starts from the Visitor Center, one can exit directly out to Highway 159, thus avoiding the 13-mile drive around the scenic loop.

Hike Description: Beginning in front of the Visitor Center, proceed to the left around the Desert Tortoise Habitat that lies to the rear and left side of the Visitor Center. The trail begins at a sign titled "Moenkopi Trails System." The dirt trail starts off in a northwesterly direction as it drops slightly into a minor wash. Just after you reach the low point in the wash, about 1/8 mile from the start, there is a fork in the trail with a directional sign. Take the fork to the left of the sign that indicates the Moenkopi Trail. The trail heads north up a small ridge. Once you get part way up the ridge, the Calico I parking area appears in the distance straight to the front. The trail bends slightly to the left (northwest) as it continues, and the Calico I area will continue to be visible to the right.

At about 0.7 miles, there is a marked trail junction. The trail to the left is the continuation of the Moenkopi Trail. Take the trail to the right

that indicates ¼ mile to the Calico I area, although the distance to the parking area is slightly greater. You will be heading north again along the major drainage wash for that small section of Red Rock. After a short distance, the trail drops into the wash and crosses it in an easterly direction. The vertical gain on the climb out of the wash is about 40 feet. As the trail meanders, you will cross two more washes. In each case, you will be close to the highest level of the wash, so the vertical gain is negligible. Just past the last wash, you intersect the scenic loop drive. Cross the road and head toward the fence on the far side of the parking area. You are now slightly more than halfway into the hike.

As you walk along the fence, a wide trail to your left goes down about 50 yards to a viewing area directly across a narrow rocky ravine from the Calico Hills. This is an excellent location to view the different colors found in the sandstone formations of the Calico Hills. There are also some benches in the vicinity of the Overlook, so you could stop here for a snack before continuing on.

To continue on, head along the fence going in a SSE direction toward the "Do Not Enter" signs on either side of the scenic loop. Cross the concrete trough that takes runoff from the road surface. A sign indicates the distances to the fee booth and the Visitor Center. Continue on the path as it veers away from the road about 1.4 miles into the hike. This spot affords another good view of the deep canyon on your left.

As you hike this section of the trail, the Visitor Center comes into view at 30 degrees to your right. At 1.6 miles into the hike, a slightly less defined trail goes to the left along the top of the ridge. This trail goes along the canyon and eventually drops down toward it as the canyon flattens. Stay on the main trail that goes to the right. You will drop into a small wash as you head toward the Visitor Center. At a hike distance of 1.8 miles, the trail heading toward the fee booth goes off to the left. Stay to the right and cross the scenic loop road. As you near the Desert Tortoise Habitat at the rear of the Visitor Center, continue on the main

trail that parallels and goes by the Visitor Center until you reach the junction with the sign you encountered 1/8 mile into the hike. Turn left at the sign and return to the Visitor Center.

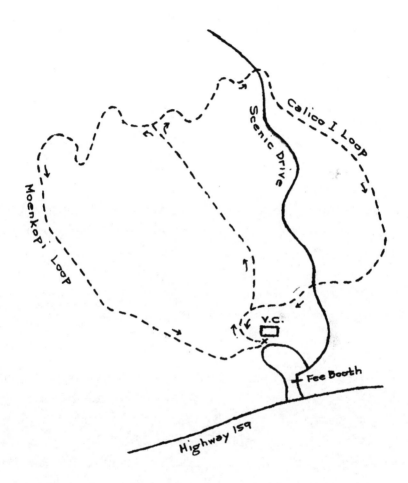

CALICO TANKS

Starting Point: Sandstone Quarry (marked) about 2.6 miles on the scenic loop

Difficulty Rating: 3

Distance: 2.8 Miles

Elevation Gain: 800 Feet

Comments: This is the hike to take out-of-town company on if they don't mind climbing about 10 sections of rock stairs and other ascending rock areas with most of the 800-foot elevation gain in about three-fourths of a mile. Calico Canyon is beautiful with the different colored layers of sandstone, and the view to the east and south of the overlook ledge at the upper end of the hike is awesome. A rather large tank just before the upper end of the trail can seasonally hold water up to a depth of 5 or 6 feet. This is an out-and-back route.

Hike Description: Begin the hike at the end of the Sandstone Quarry parking area near the restrooms. The sign at the trailhead is labeled "Sandstone Quarry Trails," and includes distances for Calico Tanks and Turtlehead Peak. As you start down the trail heading north, you will come to a wide gravel area with an informational sign at the far end. Look to the left side of this area for a small directional sign that points the way to the hiking trails that access Calico Tanks and Turtlehead Peak. Go past the sign and cross the wash immediately in front of you. The path across the wash is highlighted with a rock border, but heavy rains can sometimes turn washes like this into rushing rivers and wipe out the rock border sections. Continue straight on the main trail as one marked for Turtlehead Peak goes off to the left. A short distance past this trail junction, a sign on your left indicates the location of an agave roasting pit.

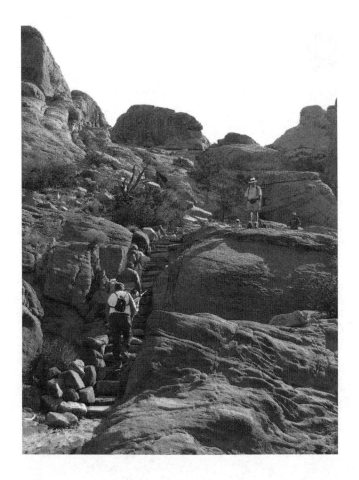

Just past the agave roasting pit, about ¼ mile into the hike, the trail for Calico Tanks goes off to the right. A directional sign indicates this turn. The trail empties into a wash with a gravel base that goes between cream-colored sandstone rock formations on either side. Go a short distance further in the wash. At a bend in the wash to the left, two trails on the right climb out of the wash. The second of these trails has a directional arrow for hikers. Take either trail, as they merge in about ten feet. You are now about 0.4 miles into the hike and about to enter Calico Canyon.

The trail surface starts out with a mixture of dirt and sand, but soon starts to go across sections of the sandstone rock. There are ten areas

on the way to the upper end of the trail where the trail builders from Red Rock have used flat rocks from the immediate vicinity to construct stairways climbing some of the steeper rock areas. The actual trail can appear very obscure, even to hikers used to this trail, but the main thing is to stay within the canyon and not try to climb either of the sandstone ridges on either side of the canyon.

The first long set of stairs is about ¾ mile into the hike, looking up the left side of the canyon. Turn right at the end of the stairs and go around the 7-foot boulder that you see on the large platform in front of you. Forty feet past the boulder, look up to the left at a cliff wall with a steep area of loose boulders on its left. This wall is known as the Great Production Wall, and is a registered climbing wall in the southwest United States.

Proceed to the other end of the rock platform, cross the drainage and climb another set of stairs. Stay on the right side of the drainage as you continue to climb. Some sections of the trail will again be composed of sand as you get to the upper part of the route. About 0.85 miles into the hike, you will actually encounter a rock stairway that drops eight stairs. A long section of stairs composed of about four segments is about 500 feet ahead and takes you to a higher terrace area. This is a good place to catch your breath and look back down the canyon to get an idea of how far you have climbed.

As you near 1.2 miles into the hike, you will climb to a point above a large tank that often contains water early in the year. Proceed down a 10-foot chute and go between the bush and rock formation on its right to get to the edge of the tank. If there is no water present, a trail crosses the right side of the tank to an ascending 20-foot chute with a bush near the top on the other side of the tank. If the tank is full of water, the only access to the lookout point is to climb over the rocks to the right of the tank. Be careful, as there are varying sizes to the uneven boulders in this stretch.

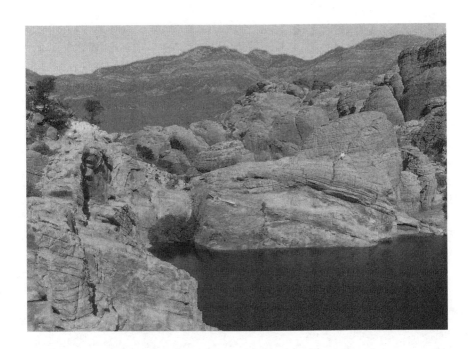

As you reach the top of the 20-foot chute, you start to experience views you might only have dreamed of before. To get the best panoramic view, climb the rocks to the left that lead to a well-defined ledge below a towering rock cliff. Be careful, as the rocks are uneven and of various sizes. You have come 1.4 miles. Directionally, you will see Ash Canyon to your immediate left running down to the community of Calico Basin, with Las Vegas twenty miles away in the near background and, on a clear day, Lake Mead and the mountains of Arizona in the far background. The line of the Calico Hills continues in a southwesterly direction, with Red Rock Visitor Center and Calico I Overlook visible to the right of the Calico Hills. Take some time to admire the view and grab a snack before heading back down.

To Return: Reverse your direction and go down the canyon. The most confusing spot coming down is in the vicinity of the large rock by the Great Production Wall. You must cross over the drainage from left to right, and go by the 7-foot rock to find the stairway descending to the lower part of the canyon.

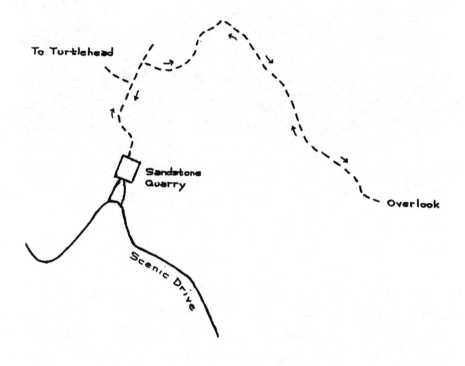

To Turtlehead

Sandstone
Quarry

Overlook

Scenic Drive

WHITE ROCK/SANDSTONE QUARRY LOOP

Starting Point: Lower parking area on gravel road at 6-mile mark of
the scenic loop

Difficulty Rating: 3

Distance: 7 Miles

Elevation Gain: 1,020 Feet

Comments: This is one of the truly great sleeper hikes in Red Rock
Canyon. It combines a fairly lengthy hike with a good elevation gain
and a variety of trail surfaces and conditions to hold the hiker's interest.
About ½ mile of the downward leg of the hike is in a narrow rocky wash
that allows a hiker to find out how he or she enjoys rock scrambling
without making the exercise extremely difficult. Because about half of
the hike is not on any of the official Red Rock hiking trails, many people
are unaware of its existence. This hike has also been called Grand Circle
West, even though the route lies straight north of the longer Grand Circle
Trail. The hike is described in a clockwise loop, which is the easiest direc-
tion due to the loose gravel encountered in the middle section.

Hike Description: The hike starts at the parking area at the beginning
of the gravel road that spurs off the scenic loop road at the 6-mile mark.
Begin by hiking up the gravel road, about ½ mile, to the White Rock
Springs parking area. I prefer to start with the road because it has to be
hiked at some point and is the least interesting aspect of the hike – so
get it over right away. There are restroom facilities at this parking area
in case you didn't get a chance to stop at one of the earlier pull-offs.

At the northwest side of the lot is a sign that reads "White Rock Trail
System." Take the only trail that leads from the sign, heading slightly

northwest toward the right side of White Rock Springs Peak. There is an agave roasting pit, a cooking and ceremonial site during the times when Indians roamed the area, on your left side. Just beyond that, you will head into a gravelly wash. Cross the wash and resume the trail on the other side. About 1/6th mile from the sign, a defined trail marked as the Keystone Thrust Trail, formerly maintained by the Penn State Alumni Association, goes up to the right over a railroad tie stairs. Go up the stairs to the right and head up the trail. In 1/8th mile, the single lane path you are on meets an old jeep track. The trail starts a continual elevation gain as it heads toward and around Cactus Hill, with La Madre Peak in the background on the horizon. Stay on this combined track as it winds its way around to the backside of Cactus Hill. About 1/10th mile beyond the point where the trail again becomes a single path is a crossover point on a ridge, where the trail appears to turn right and go downhill. This is the Keystone Thrust Trail discussed in the next hike in this book. By way of reference, you have now hiked about 1 ¼ miles and climbed about 550 feet.

Instead of dropping down to the fault, continue straight ahead over the rock border onto another jeep track heading north toward an unnamed pyramid-shaped knob that appears to be about 60 feet high. As you approach the knob, you realize that the wash to the right and in front of the knob is much deeper than you anticipated from first glance. As you hike even with the knob, about 1/5th mile from the Keystone Thrust Trail junction, the jeep track fades away and a single lane trail continues on.

This trail is fairly well defined for the most part, but there are a few slightly obscure sections, so be aware of your surroundings. About 1/8th mile past the knob, at what appears to be a somewhat obscure trail divide, stay to the left headed up the ridge. You will now start seeing occasional cairns marking the advance of the trail. As you gain the ridge and continue on, you will be headed straight toward La Madre Peak. Another ridge starts to rise on a parallel course to your right across a

wash. This ridge is higher at the back end than the one you are on. As you reach the top of the wash that separates the two ridges, you have hiked 2 miles from the start, and arrived at the highest point of the hike – the elevation is 5,700 feet and you have climbed 1,020 feet from your starting point.

At the top, the trail takes a sharp right around a cairn and starts dropping into a new wash heading to the northeast. In 1/8th of a mile, the trail comes to another cairn in the bottom of the wash. The wash then bends to the southeast, and the trail becomes very erratic as you work your way down through a rock scrambling section that lasts for the next ½ mile. Although the trail itself is often hard to see, there are plenty of cairns to mark the passage. As long as you stay heading downward close to the middle of the narrow wash, you will be in the right place when you get to the far end. Exercise care in hiking through this section, as heavy rains have caused quite a bit of erosion damage in the drainage of the wash.

Shortly before the boulder section ends, the wash begins to widen. Rocks and boulders suddenly give way to loose gravel in the bottom of the wash. With the widening of the wash, you start to get a clear view of the sandstone formations that make up the Calico Hills a few miles in the distance. One sandstone peak that stands out has a base of cream-colored rock with a dark red mantle forming the top section. This peak is Turtlehead Junior, which also goes by the name of Red Cap. The formation lies to the southeast, and you want to set your course almost straight at it as you descend in the wash.

For the next 1 ½ miles, you will be hiking in loose gravel. Fortunately, this is a downhill section, so it is not nearly as hard on the leg muscles as if you were reversing the route and going up in this section. About 1/3rd mile into the gravel, a more significant wash comes in from the left and the trail bends slightly to the right (south). You now have a view of the gypsum mining area on Blue Diamond Hill on the other side of

Red Rock. In another ¼ mile, a ridge starts to form on your right and the wash bends back in the direction of Turtlehead Junior.

As you draw somewhat even with Turtlehead Peak on your left, you have come about 1 mile in the gravel. A sandstone formation much lower than the Calico Hills appears ahead and to the right. As you approach this area, I recommend that you work your way toward the left side of the wash, if you are not already there. Just past the first sandstone formation that you encounter on your left is the trail coming down from Turtlehead Peak. A short scramble through brush near the base of that formation brings you to the trail at the earliest possible location to get you off the gravel. Otherwise, continue in the gravelly wash for another 1/6th mile and intersect the Turtlehead Trail as it crosses the wash.

Once you gain the trail, the Sandstone Quarry parking lot will be visible in the opening between the sandstone formations. As the trail meanders through what is now a fairly broad wash, it drops down to the main drainage for the wash. Continue in the drainage for about 200 feet to the trail continuation. There is a directional sign at that location indicating 0.35 miles to Sandstone Quarry.

As you approach Sandstone Quarry, the trail you are on intersects with the Calico Tanks trail. Take a right on the combined trail. Just ahead is an 80-foot long sandstone rock about 8 feet in height. You have now hiked 4.7 miles, and the big rock is a perfect place for a snack and some water, or even just a short rest. A 15-foot rock just to the south has a U-bolt in the top section. This rock is one of the places where beginning rock climbing and rappelling classes are taught. On weekends, you may even get to see the show.

If you look back to the last page, you will note that you climbed 1,020 feet to the highest point on the hike. The descent from that high point to your current position has been 1,380 feet. To get back to your starting point, you will have a climb of 360 feet over the next 2+ miles.

After your stop, take the Calico Tanks Trail a short distance toward the trailhead, going between the 15-foot rock on your right and the pile of sandstone blocks remaining from the quarrying days on your left. As you come to a large open space below the parking lot trail, look for the Grand Circle trail going off to the right. There is a sign indicating the trail name, but it is facing the other direction for people coming down from the parking lot.

After taking the right, you cross a shallow rocky wash on a faint trail marked with a rock border. You can see the continuation of the trail rising up the hillside across the wash, and the trail you are on is the only way to get through some dense foliage and access the obvious path. Wind through some trees and past a sandstone slab and make the short, steep ascent to the top of the hill. The trail then heads in a WSW direction toward Bridge Mountain on the escarpment before bending to the right and climbing another ridge. The trail drops down slightly into a gravelly wash, with a well-defined rock border along the edges. Where indicated by the border, turn left out of the wash onto a dirt path. Cross two more minor washes before heading north up another ridge, pointing straight at La Madre Peak in the distance. The sandstone formations you hiked past a mile back are on your right. Cross over another wash and hike up a hill to the point where the trail crosses the scenic loop. You have gone 5 ¾ miles so far, and are coming to the last phase of the hike.

The trail now meanders with many sharp turns, going up and down over ridges and through washes. Around the first corner from the road, the highest point on the scenic drive is visible to the right. A long, straight downhill in a southwest direction gives back most of the elevation you have gained since Sandstone Quarry. A cairn marks the point where you cross the bottom of the drainage and pick up the trail continuation. In another ½ mile, you come around a turn on the top of a ridge and the starting point of the hike becomes visible below and to the right of White Rock Hills Peak.

When you get to the final major wash, take a hard right immediately after entering the wash and look for the very large cairns that mark the trail crossing. It is about 200 feet from where you dropped into the wash to where the trail exits. Once out of the wash, continue on the trail another ¼ mile until you come to the scenic loop. Cross the pavement and you are back at your starting location.

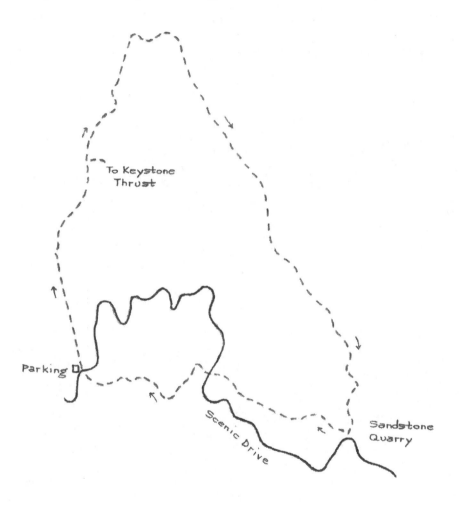

KEYSTONE THRUST FAULT & CACTUS HILL

Starting Point: White Rock Springs parking area at end of ½ mile
gravel road going to the right at the 6-mile mark of
the scenic loop
Difficulty Rating: 2
Distance: 2.5 Miles
Elevation Gain: 460 Feet

Comments: This hike will surprise you. Although it is only 2 ½ miles
long, it includes fairly intensive hiking on sandstone slabs and on rocks
in the bottom of the Keystone Thrust wash and another good climb
section to the lookout on Cactus Hill. A hiking stick is highly recom-
mended. You may also have to use your hands for balance on a couple
of occasions. It is advisable that you do this hike with at least one other
person, because of the amount of rock scrambling involved.

Hike Description: Begin the hike at the sign that reads "White Rock Trail
System" located at the northwest side of the parking lot. The gravel trail
starts in a northwest direction to the right of White Rock Springs Peak. You
will pass an agave roasting pit on your left as you head toward a gravelly
wash. Cross the wash and resume the trail on the other side. At about 1/6th
mile, go right on the Keystone Thrust Trail, formerly maintained by the
Penn State Alumni Association, that climbs a short set of railroad tie steps.
The trail starts a continual elevation gain as it heads toward and around
the left side of Cactus Hill. Shortly above the steps, the trail is formed by
an old jeep track. Stay on this trail to the backside of Cactus Hill.

As you come around Cactus Hill, you will get a great view of Turtlehead
Peak to the east. At about 2/3rd mile into the hike, you will come to a
high spot on a ridge. A trail continues straight ahead (north) across a

rock border. This is the White Rock/Sandstone Quarry Loop trail. Take the right turn presented by the rock border on the main trail and go down toward the fault. At the high point of the trail, you have climbed 360 feet from the trailhead.

About 200 feet ahead, the trail empties into the top of a sandstone rock formation and becomes rather obscure. If you are not fond of rock scrambling, you may want to turn around at this point. If you continue on, look for cairns on the red sandstone rock surface indicating where to start dropping into the wash. As the wash descends over rocks, stay on the right side next to Cactus Hill. Ahead of you is a 50-foot wall dropping into the wash. Go around this section to the right, looking for faint signs of trail and any cairns. You must cross small sections of sandstone in order to reach the drainage at the bottom of the wall. When you arrive at the bottom of the drainage, turn around and look at how water has discolored the sandstone where it falls over the 50-foot wall. You have now hiked about one mile.

The last section downward requires rock-scrambling techniques. Continue downward into the wash, passing another drainage that comes in from the left. The section of sandstone slabs you are walking on switches from the rusty red color of the formations when you entered the wash to a cream color. As you reach the last section of sandstone, about 1.1 miles from the start, look up at Cactus Hill. You will be standing on cream-colored sandstone, with red sandstone above it, and gray limestone above that. The significance of Keystone Thrust is that the older and higher mantle of gray limestone has been forced above the younger underlying sandstone due to intensive geologic activity.

To Return: Reverse your direction, climbing on the left side of the drainage toward and then around the 50-foot wall. As you look up toward a red sandstone formation, you should see a cairn marking the route connecting to the trail. Go past the cairn and look for the section of trail partly up the hill straight ahead that has two logs along the edge. The trail section

starts about 40 feet to the right of those logs. Proceed to the starting point of the trail, turn left and ascend to the junction with the White Rock/ Sandstone Quarry Loop trail. On your way up to that junction, you will get a good view of White Rock Hills Peak straight ahead, and then North Peak and Bridge Mountain as the view to the left opens up.

About 600 feet past the trail junction on your return to the trailhead is a trail going off to the left to the top of Cactus Hill. It is less than 1/5th mile on that trail to the cap on Cactus Hill, with a vertical gain of about 100 additional feet, but the view is definitely worth it. On the top of Cactus Hill, you have achieved an elevation of 5,330 feet above sea level, and can see all the area that makes up Red Rock Canyon. Soak in the view. On your return, hike down to the main trail and turn left. Come down the trail past the railroad tie steps, turn left, and head back toward the trailhead.

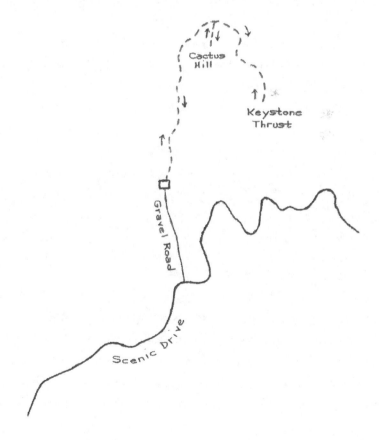

WHITE ROCK HILLS LOOP

Starting Point: Willow Springs picnic area at end of paved spur road
about 7.5 miles on scenic loop
Difficulty Rating: 3
Distance: 6.4 Miles
Elevation Gain: 900 Feet

Comments: The White Rock Hills Loop is one of the more popular hikes in Red Rock Canyon, because of the distance and the variety of flora that you can see on the hike. The trail is easy to follow and the surface conditions are generally excellent. It is also one of the favorite locations in the conservation area for trail runners, so you need to keep an eye out for faster traffic, especially on weekends. The vegetation behind the White Rock Hills is far more luxuriant than on the front side, because many localized rain showers are channeled into the valley between the peaks of the White Rock Hills and the La Madre Mountains to the northwest. My preference, as detailed in the hike description, is to do the hike clockwise from Willow Springs, but it is also enjoyable reversing the route.

Hike Description: The hike starts at the Red Rock sign titled "Willow Springs Trail System" at the edge of the gravel parking area by the start of Rocky Gap Road. Head northwest on the 4x4 gravel road, keeping the White Rock Hills on your right. In about ¼ mile you will pass a sign for a prehistoric kitchen (agave roasting pit) on your left. Continue on the road through a wash. As you go up an incline on the far side of the wash, a sign directs you to go right on another old road for the La Madre Springs and White Rock trails. Take the right, go around some large boulders blocking access for motorized vehicles,

and continue north on the old roadbed. A little over one mile from the start of the hike, a sign directs you to go right on the trail toward White Rock, listed as 2.5 miles. Take the right, which heads toward the mountainous formation of the White Rock Hills before bending around to the left.

This trail starts off as a double track, but soon drops to a single path heading to the northeast. Most of the trail surface is dirt. You will notice the explosion of vegetation, mainly junipers, pines, and manzanita shrubs, that grow in the area. About ½ mile past the junction, look up on the ridge between the two peaks of the White Rock Hills. A landmark on the ridge is Whiskey Bottle Rock, a large sandstone rock that looks like a whiskey bottle on its side with the neck of the bottle pointed to the left (north).

Two miles into the hike is a small, dark brown caliche ridge that rises up about 15 feet, with four very discernable points. It is amazing to think that this small formation was able to resist the elements and remain as a kind of sentinel for the area. After leaving this caliche formation, continue NNE on the trail. As you near a saddle below White Rock Springs Peak, the trail is formed by packed red sand. This is the highest point of the trail, about 2.6 miles into the hike. About 1/10th mile down the trail is a red sandstone formation about 20 feet off the trail on your right. This is a great place to sit and admire the scenery as you have a snack.

Upon leaving the sandstone formation, continue SSE on the trail with White Rock Springs Peak on your right. In 1.1 miles, the Keystone Thrust trail, formerly maintained by the Penn State Alumni Association, goes up some railroad tie steps to your left. Stay on the trail straight ahead. In another 1/6th mile, or 4 miles into the hike, you arrive at the upper parking area for White Rock Springs.

Go along the fence to your right and pick up the trail continuation on the southwest side of the parking area. The trail heads SSW down an old road. In a very short distance, a trail goes off to the right toward White Rock Springs, and the White Rock Hills Loop trail you are on becomes a jeep track. Continue down the jeep track for about 2/3rd mile, where it drops down to a single path. Do not take the apparent trail to the right at this point, which goes down into the major wash for the area. While passable, this wash is loaded with boulders, and hiking it is very difficult. The trail you want bends slightly to the left and crosses a minor wash coming in from the east. As you climb the minor ridge in front of you, the trail bends slightly right and you get a view of a small portion of the scenic loop road.

At 5 ¼ miles into the hike, the trail descends into the major wash and crosses the drainage. Water is often present at this location in late winter through early spring. This small area on the front side of the White Rock Hills is very lush, and reminds you of an oasis in the desert. Cross the

creek, stepping onto a rock slab on the other side. Go between some large cream-colored sandstone boulders, and the trail becomes more defined in about 20 feet. As you gain the small ridge you are hiking up, the trail becomes very rocky. From this point to the end of the hike, the landscape is strewn with many large boulders that have tumbled from the very steep White Rock Hills Peak on your right. In this same area, the abundance of cholla cactus is very noticeable.

After passing another minor drainage, the trail turns southeast, then bends back to the west, as it climbs for about 1/3rd mile to the top of a ridge overlooking Lost Creek. The total vertical ascent on this climb is about 150 feet. As you descend from the ridge, the trail is comprised of deep red sand and numerous rocks. At 6 miles into the hike, the trail intersects the Lost Creek trail. Go to the right at the junction. Shortly, you will pass another agave roasting pit and the trail comes to a concrete slab in front of an archaeological site. In the rocks to your right are five handprints painted by ancient residents of this area. As you leave this site, a number of trails seem to branch off. Any of them will lead you back to the Willow Springs Picnic area, now only 1/10th of a mile away, where you will find your vehicle.

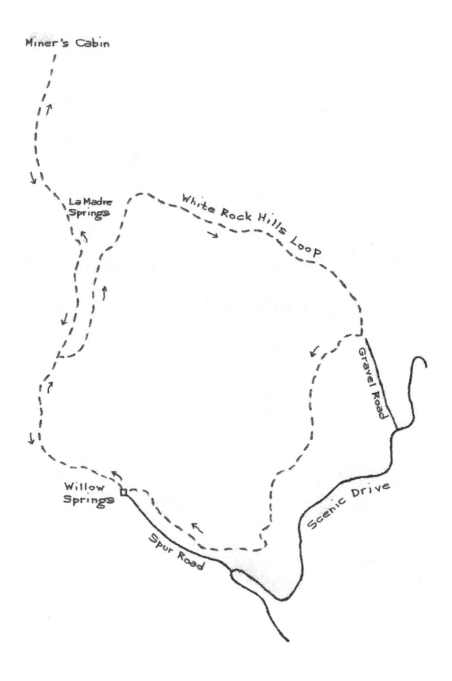

Miner's Cabin

La Madre
Springs

White Rock Hills Loop

Gravel Road

Scenic Drive

Willow
Springs

Spur Road

LA MADRE SPRINGS/MINER'S CABIN

Starting Point: Willow Springs picnic area at end of paved spur road
about 7.5 miles on scenic loop
Difficulty Rating: 3
Distance: 3.6, 4.3, or 5 Miles
Elevation Gain: Up to 1,200 Feet

Comments: This is an out-and-back hike where you can pick your distance, depending on how much time you have available and how much climb you want to make. A sign at the springs tells you the history of its use, from the days of the Paiute Indians to the miners who worked in the canyon above the springs to the archery club that occupied the area in the middle of the last century. There are also two old foundations in the area, one that is from a house built in the secluded area and one from the archery club.

Hike Description: The hike starts at the Red Rock sign titled "Willow Springs Trail System" at the edge of the gravel parking area by the start of Rocky Gap Road. Head northwest on the 4x4 gravel road, keeping the White Rock Hills on your right. In about ¼ mile you will pass a sign for a prehistoric kitchen (agave roasting pit) on your left. Continue on the road through a wash. As you go up an incline on the far side of the wash, a sign directs you to go right on another old road for the La Madre Springs and White Rock trails. Take the right, go around some large boulders blocking access for motorized vehicles, and continue north on the old roadbed.

A little over one mile from the start, the White Rock trail (see previous hike) takes a right from the roadbed you are hiking on, and another sign

indicates La Madre Springs straight ahead 0.55 miles. Continue straight ahead. In about 1/3rd mile, a trail leads off at an angle to the right and takes you to the location of a foundation slab for an old house that had occupied the property at one time. The foundation floor still has many of the slate tiles that had been placed in one of the rooms when it was built. Return to the main trail and head up the hill through a clearing. Another foundation slab is on your left about 100 feet off the trail. This foundation apparently was part of the archery club that was once located in this spot.

The trail crests the hill you have been hiking up just before you get to the La Madre Springs. At the crest, you can look down at the springs area, where a concrete dam was constructed in the 1960's. The pool held behind the dam is still a major source of water for bighorn sheep and other animals that inhabit the area. Your hiking distance to this point has been 1 ¾ miles, and you have reached the first location where you may wish to turn around and retrace your steps.

If you decide to keep going, however, you will probably find the next part of the trail to be quite interesting. Continue up the trail on the left side of the creek heading NNW. In about 400 feet, you will make the first of three very quick crossings of the creek, which sometimes contains flowing water even during the summer months. After the third crossing, the trail becomes steep. Somewhat past the 2-mile point of the hike, the trail climbs on the right side above an 8-foot waterfall. This is a very picturesque location with the waterfall and the narrowness of the canyon, and may be a good spot to turn around.

To see the miner's cabin and get the best view down the canyon you have been hiking, you will need to continue for slightly more than ¼ mile. If you opt for that choice, continue on the trail as it crosses the creek at the top of the waterfall. Just beyond the waterfall is a section of slick rock that must be crossed. Be very careful on this rock because there is virtually no traction. Beyond that rock a short distance, you will see a

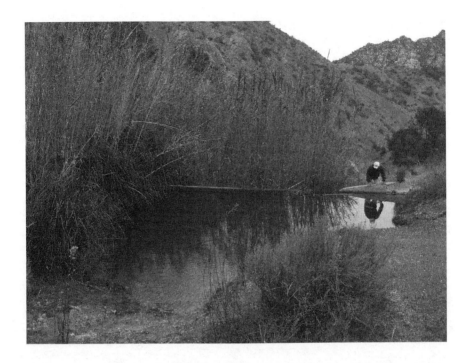

minor wash coming in from the left and a steep ridge forming between
that wash and the creek. Stay on the trail as it makes an ascent of the
ridge, beginning on the right side above the creek but finishing in the
middle of the ridge. As you come out at a small plateau in front of some
rocky crags, the miner's cabin is directly in front of you. All the walls of
the cabin consist of stone, including a small outside courtyard, and the
low roof of the structure is made of logs that were rolled on top of the
walls. There is not enough headroom inside the cabin to stand erect. As
with all other historical sites that you may encounter on your travels,
make sure that you do not alter the structural integrity of this cabin
or remove any artifacts. After you have wondered whether the effort
needed to build the cabin was worth it, take a break and gaze back down
the canyon you hiked up. The White Rock Hills are about one mile away
to the south. The feeling of isolation you get is incredible.

To Return: Reverse your direction and return to the starting point. If
you only got to the springs area, your total distance will be 3.6 miles

with a difficulty rating of level 2. If you got to the waterfall, your total distance is 4.3 miles and the hike level is somewhere between 2 and 3. If you made it to the miner's cabin, your total distance will be 5 miles and the level 3 rating would apply.

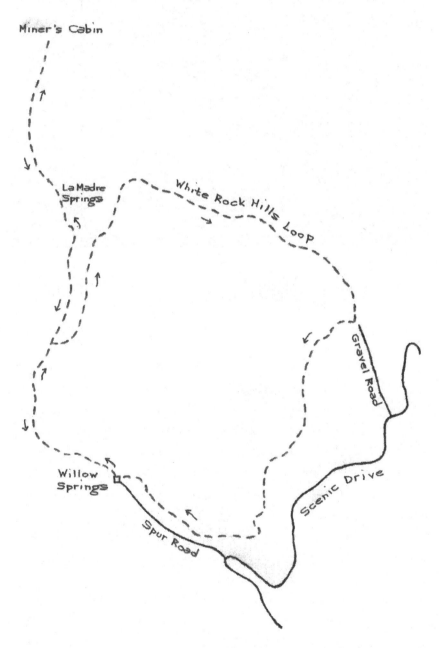

LOST CREEK/WILLOW SPRINGS LOOP

Starting Point: Lost Creek Trailhead (marked) located ¼ mile up paved spur road to Willow Springs about 7.5 miles on scenic loop

Difficulty Rating: 1

Distance: 1.5 Miles

Elevation Gain: 100 Feet

Comments: This is a combination trail hike that loops on both sides of the spur road to Willow Springs. The Children's Discovery Trail (which is not described in this book) is another short trail of about one mile, and is located in the same vicinity as the two trails described below. During periods of rainfall and in late winter when the snow is melting above on the escarpment, the waterfall at the end of Lost Creek Canyon can be spectacular. This is a great hike for children because of the distance and the waterfall.

Hike Description: The Lost Creek Trail begins in the middle of the southwest edge of the paved parking area. The trail starts off in southwest direction toward the waterfall. About 250 feet into the hike, the SMYC Trail branches off to the left. Continue straight ahead and cross a large wash, using the rock border on both sides of the trail as a guide. After a heavy rainfall, this rock border is vulnerable to being washed away by the volume of water that can be carried down the drainage. If that should occur, go past a couple of redbud trees standing in the wash, which produce red blossoms prior to leafing out in early May, and look for the stone steps that mark the trail continuation. As the trail exits from the wash you will ascend this rock stairway. After climbing the stairs, take the main path straight toward the waterfall. About 250 feet

past the rock stairway is the Lost Creek Walkway, a wooden platform that crosses an unusually marshy area around the creek drainage. At the trail junction just ahead, veer to the left.

Soon you will encounter a bench and a set of stone steps. In the immediate area, there are channels for water flowage on both sides of the trail. Within 200 feet of the waterfall a rock stairs leads around some 15-foot boulders on the right and finally under a 10-foot boulder that provides a tunnel effect. The 40-foot waterfall is in view straight ahead. You can climb around behind the water dropping over the falls. If you have children along, the area immediately around the base of the falls is like a playground.

Turn around and take the trail as though you were returning to the trailhead. Just a little way past the stone steps and bench is a trail junction. Take the trail to the left and go around a large rock on the left. A restoration area will be on your left as you continue, and just past that area the trail bends to the northwest and you get a view of Willow Springs picnic area. About 400 feet further, the main trail appears to drop down to the wash below. Look for a crack between two large boulders on the left with stones piled in the lower part of the crack. A newly installed sign is located at this spot. Go up through this crack to a more distinct trail that stays on the ridge above the wash.

In 1/8th mile, you will spot a wilderness sign on the left side of the trail. This trail section becomes very rocky as it leads to a descent off the ridge into the wash below. There is a set of stone steps on this descent. Enter the wash and go straight across to the trail continuation. Cross the paved road and head for the picnic tables to the right of the restroom facilities. Just past the tables, turn right (southeast) onto the trail marked with a stone border. Go to the right around a massive red boulder.

After you pass the boulder, the trail goes onto a concrete slab next to a log fence with a sign describing the Indian painted hands on the rock

in front of you. Look above an archaeological sign next to one of the large boulders 20 feet from you. Above the sign is a set of five handprints painted by the Indians who once dwelt in the area. Depending on the time of day, these handprints can be very distinct or be difficult to see at first glance.

As you continue along the railing, you will pass an agave roasting pit. The trail soon divides, but the two trails rejoin shortly. When the trails divide again, turn left onto the upper trail that is defined by the dark red dirt on the surface of the trail. Within a short distance there is another trail junction. The left trail climbs up a ridge and heads for White Rock Springs about two miles away. Take the right trail, which bends back toward the Lost Creek parking area and crosses the paved road about 300 feet later. You have now returned to the parking area where you started the hike.

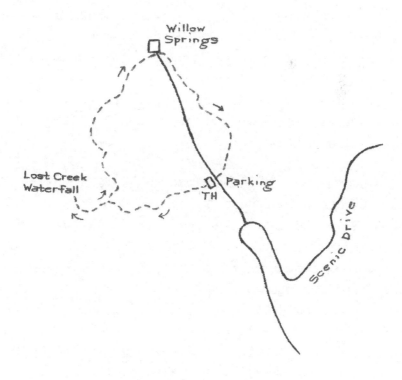

SMYC TRAIL

Starting Point: Lost Creek Trailhead (marked) located ¼ mile up paved spur road to Willow Springs about 7.5 miles on scenic loop

Difficulty Rating: 1

Distance: 2.2 Miles

Elevation Gain: 200 Feet

Comments: This trail was originally built by a work force from the Spring Mountain Youth Camp, for which the trail is named. It is the northernmost part of the series of trails that form the route along the edge of the escarpment, running in a southeast direction from the Lost Creek trail just off the trailhead to the Ice Box Canyon trail about 1/5th mile up from that trailhead. As a separate trail, it provides some excellent scenery, rolling up and down along ridges next to the escarpment in the area north of Ice Box Canyon. It can also be combined with the Ice Box Canyon trail (see next description) to increase the distance of that hike to more than 4 miles.

Hike Description: Start the hike at the southwest edge of the parking lot next to the brown sign that states "Lost Creek Canyon Trail." Go down the four log steps just beyond the sign and take the rock-bordered trail that heads toward the Lost Creek Waterfall. In about 250 feet you will come to a trail junction with a directional sign. Take the trail to the left that, as indicated by the sign, is the SMYC Trail. About 200 feet farther along, you will come to a long, rock-bordered trail crossing of the main wash. There are actually two sections to the wash crossing, the first about 260 feet in length and the second about 300 feet in length, that are separated by a very short section of slightly higher ground.

As you exit the last section of wash, the trail consists of red-colored dirt. Almost immediately, the trail climbs over a set of stone steps to the side of a ridge about 20 feet above the floor of the wash. The trail continues parallel to the wash for about 650 feet until it descends another set of stone steps. The trail climbs a bit and crosses a ridgeline. As it proceeds along the backside of the ridge, a short stub trail takes you to the top of a red sandstone rock formation that is about 30 feet above the wash and provides you with a scenic view of the area. At this point you have hiked about ½ mile.

As you return to the main trail, only about 50 feet away, you will notice how that trail took a 130-degree turn to the right and proceeded down the ridge over a series of steps and large rocks to the drainage area below. That drainage receives a fairly high level of runoff from the cliffs above, and the vegetation is extremely dense in the small pocket on your right. Where the trail crosses the bottom of the drainage, the trail surface consists of gray-colored dirt with gravel. Just past the drainage is the biggest climb of the hike that includes about half a dozen sets of rock steps in a vertical gain of more than 100 feet. At the top of this section, the trail continues along the ridge for a short distance. At 7/8th mile into the hike, a faint rock border directs you to the left at what appears to be a trail junction. As you make a shallow descent down the side of a ridge, the trailhead for Ice Box Canyon is in view to your left.

The trail surface changes to cream-colored sand with several small rock outcroppings on the surface. Just around a point of cream sandstone boulders is another trail junction. This spot is exactly one mile into the hike. The trail to the right follows along the ridgeline and is used primarily by climbers interested in scaling the cliff walls on the north side of Ice Box Canyon. Take the trail to the left. In 1/10th of a mile, the SMYC Trail you are on ends at the Ice Box Canyon trail, with Dale's Trail continuing on the other side. If you intend to do some further exploration, the basic options are to continue ahead on Dale's Trail or

take a right to view the great beauty of Ice Box Canyon. Otherwise, this is the point where you will turn around.

To Return: Reverse your direction and return to the Lost Creek trailhead. It is easy to follow the trail on your return trip. The only minor difficulty that may occur is at a spot about 1/4th mile into the return. The trail makes a gradual climb to a ridge and turns left, going across some low, red sandstone rocks and staying on the ridge. There is almost a tendency to look for a descent toward the wash at this point, but there is really no trail.

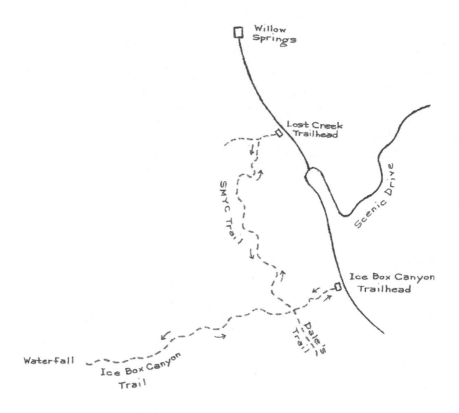

ICE BOX CANYON

Starting Point: Ice Box Canyon Pull-off (marked) about 8 miles on scenic loop

Difficulty Rating: 2

Distance: 2.6 Miles

Elevation Gain: 300 Feet

Comments: Ice Box Canyon gets its name because the high, steep walls and the narrowness of the canyon prevent direct sunshine from getting into the back portion of the canyon. It is one of the few hikes in this book that involves off-trail scrambling up and around boulders in a creek bed. During periods of any significant rainfall or when snow has accumulated on the higher ledges of the escarpment and begins melting, water will flow in the main drainage. The more rainfall that occurs, the higher the water level and the more difficulty one encounters in negotiating around many of the large boulders. The higher the water level, however, the more spectacular the reward when you reach the big waterfalls at the end of the canyon. The best time to do this hike with a good chance of seeing flowage over the waterfalls is between December and April.

Hike Description: The general direction for this hike is southwest into the canyon and northeast on the return. Begin at the signed and marked trailhead on the southwest side of the parking area. Go past the sign down a slight hill and cross the wash you encounter almost immediately. Red Rock volunteers try to maintain a rock bordering for the trail as it crosses the wash, but excessive runoff can wipe out the border, so look carefully for the continuance of the trail after it crosses the wash. To connect with the trail past the wash, go slightly to the right past some redbud trees, which don't blossom until late April, and look slightly to your left for the

rock stairway that rises 10 or 12 feet on the far side. Go up the stairs and continue on the trail as it heads toward the canyon. From this point to the end of the trail portion of the hike, the surface conditions on the trail are quite rocky, so care should be exercised to prevent turning an ankle.

At about 1/5 mile into the hike, you will encounter a marked trail crossing. Dale's Trail goes to the left across Ice Box Creek and heads toward Pine Creek Canyon while the SMYC Trail goes to the right toward Lost Creek. Continue straight on the main trail toward the canyon. From this point until the 7/8th mile mark, when the trail dumps into the creek bed, you will encounter what appear to be several options with trails going to the left and right. Since most of these options remerge within very short distances, it doesn't really matter which option you choose, as long as you stay near the top of the ridge that heads directly toward the narrow part of the canyon ahead.

If you are on the main trail, about ½ mile from the trailhead you will come to a sign on the left side of the trail that indicates a "Wilderness Study Area." A short distance past the sign, you will begin to notice several differences in your surroundings - the trail goes along the top edge of a bank that drops into the creek bottom on your immediate left, the walls of the canyon are now on either side of you, and there may be a seasonal waterfall cascading down a 100-foot drop through a crack in the cliff wall on your left. You will also notice that the boulders in the trail are generally much larger with several rock slabs and that brush is encroaching on the trail in several areas. Continue straight up the narrowing canyon until the trail descends rapidly into the creek bed about 7/8th mile into the hike.

Immediately upon descending into the creek bed, turn around and examine the landmarks at that location and try to commit them to memory. When you are returning from the far end of the canyon, it almost seems natural to stay in the creek bed, and you can easily go past the right location to climb back onto the ridge.

From this point to the end of the canyon is about 0.4 miles, and you will have to negotiate some rather intense terrain. When no water is present, it is often easy to climb up some of the small waterfall sections or the other boulders. With water present, however, you must find routes around these obstacles. About 1/10th mile after entering the creek bed, go to the right around a waterfall and return to the streambed. Almost immediately, you will encounter a 20-foot boulder that seems to block the way. Go left around that boulder and climb to the next level of the stream. The next major obstacle is a 12-foot boulder. Go around to the left of that one as well. Another small waterfall with a deep pool in front comes next, and it can be bypassed on the right side. At many locations on the way up, you can walk on the edge of the streambed or hop from rock to rock to cross the water.

If you have managed to negotiate all the obstacles, slightly more than 1/3rd mile from the point you entered the streambed you will encounter some significant boulders that appear impossible to climb. Look to the left side of the canyon. If you are in the right spot, you will notice a tree growing from the base of the rock wall, and there will be some small boulders lodged between the tree trunk and the steep bank behind it. The correct route goes up behind the tree with the boulders used as stepping-stones. This will take you to the last terrace before the waterfalls.

When you get to this last terrace, you will notice that two small canyons are actually converging. You are now about 1.25 miles from the trailhead. When you reach this point, you will need to climb on the low rock ledge on the left side of the canyon and continue to work along the cliff wall on that side. As you round a slight bend, the beauty of the upper and lower waterfalls will immediately become the center of your focus. The upper falls cascades down a cliff from a ledge hidden above and appears to have about a 60-foot drop. At the base of that falls is a pool hidden from view. Water flows out from that pool via the lower falls, a 30-foot vertical trough down a steeply sloped rock wall. Do not try to climb beyond the midpoint of the lower falls – the last two short climbs

to the upper pool are difficult going up and treacherous coming down. The visual effect should be an ample reward for your perseverance.

To Return: Reverse your direction and go down the canyon. Hopefully, you remember what the terrain looks like where you descended into the creek bed so you can climb out of it at the right point. The only other difficult spot on the return is about 1/8th mile past the exit from the creek bed. You are faced with a trail junction that you probably didn't notice on the way up. Take the left fork, cross the small wash, and head straight for the trailhead.

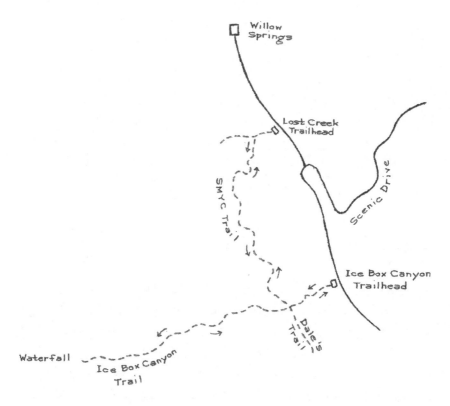

DALE'S TRAIL

Starting Point: Ice Box Canyon Pull-off (marked) about 8 miles on scenic loop

Difficulty Rating: 2

Distance: 4.7 Miles

Elevation Gain: 150 Feet (outbound) and 365 Feet (inbound)

Comments: One of the more interesting hikes in Red Rock because of the great views and terrain through which it passes, Dale's Trail runs from the Ice Box Canyon Trail on the north to the Pine Creek Canyon Trail on the south. It is described here as an out-and-back hike starting from the Ice Box Canyon trailhead. Dale's Trail could also be done as an out-and-back hike from the Pine Creek Canyon trailhead, but the distance would be about 0.6 miles longer. Dale's also represents the middle section of the Escarpment Trail (see hike after next), combining with the Arnight and SMYC trails to form one continuous trail section along the base of the escarpment for a distance of 5.4 miles.

Hike Description: Begin the hike by going past the sign titled "Ice Box Canyon Trail System" on the edge of the small parking area on the right side of the scenic loop road. Go down a slight incline heading southwest toward Ice Box Canyon. The trail crosses a fairly wide wash coming out of the area beyond Lost Creek. Red Rock volunteers maintain a rock border for the trail as it crosses the wash, but heavy rains can sometimes wipe out the border. On the other side of the wash, the trail climbs the far bank using a flight of stone steps. Just beyond the steps, the surface conditions of the trail become quite rocky. For most of the hike, there are a lot of small rocks imbedded in or on top of the trail, so you will need to be careful not to make any missteps.

At about 1/5th mile into the hike, you will encounter a marked trail crossing. The SMYC Trail goes to the right and Dale's Trail, the one you want, goes to the left. As soon as you make the turn, the trail becomes very rocky and, for about 50 feet, is also somewhat obscure. For the first section of the trail, you will be hiking in a southeasterly direction. About 300 feet past the trail intersection, Dale's Trail begins to descend toward Ice Box Creek, and crosses the creek a little more than 1/3rd mile into the hike. Water can often be found in this section of the creek through early May.

From the bottom of the creek bed, the main trail will appear on the far side about 20 feet to your right. There is a faint trail that continues straight across the creek that will intersect with the main trail in a short distance, but it is more difficult to follow, so look for the main trail. There is a short but steep climb out of the bottom of the creek bed on either trail. If you are on the main trail, an old bench sits on the ridge overlooking the creek. Shortly, you will encounter the first of many sections where the red sand eroded off the cliffs to the right becomes the predominant surface of the trail.

At about 0.8 miles, the trail begins to bend slightly to the right, heading directly to the south, and starts climbing slightly. At the one-mile mark, the soil again turns red as you approach a second bench, this time in a more isolated spot to the side of a 50-foot knob. Go around behind the knob, cross a small drainage, and climb another slight ridge.

In 1/8th of a mile, you come to the top of a reasonably deep drainage. This is the first of four deep drainages taking water from the area of Bridge Point (to your right on the top of the escarpment) that you will encounter in the next ¾ mile. As you make the steep climb out of this drainage, you will arrive at the highest point on Dale's Trail, with an elevation of 4,335 feet. The Pine Creek Canyon parking area becomes visible about one mile away on your left. A bench has been

placed about 30 feet off the trail as it starts its descent into the next deep drainage, providing a panoramic view of the lower Red Rock Canyon area.

Continue the descent into this second deep drainage, with two others following in fairly close succession. As you get to the ridge before descending into the last drainage, you are hiking through an area containing several large cream-colored boulders. If you look across this fourth drainage, you will see the back of a large brownish-red boulder on the far side that is the only significant boulder in the area with that coloration. That boulder is Skull Rock. The trail crosses the drainage and goes within ten feet of Skull Rock, where you can find another bench in a good viewing position for the rock. Looking at the rock from the front-left, it is supposed to have the appearance of the bony portion of a skull. Personally, I think you have to have a great deal of imagination to come up with that description, but other people seem to have no problem making the connection.

If you are considering having a snack at this location, I suggest you finish the last 1/5th mile of the trail until it intersects with the Pine Creek Canyon Trail and stop on your return leg. From Skull Rock to Pine Creek Trail, Dale's Trail makes a slight descent to the intersection, where you can see one of the stone pillars marking the edge of the property for the old Wilson homestead up in Pine Creek Canyon.

To Return: Reverse your direction and return to Ice Box Canyon. There is a vertical elevation gain of 365 feet from the intersection with Pine Creek Trail until you get to the high spot of Dale's Trail, on the ridge past the first three deep drainages that you cross on the return. The most obscure bend in the trail occurs about 2/3rd mile into the return, when the trail crosses a short drainage and turns hard left over some two-foot boulders. The Ice Box trailhead area becomes visible about ¾ mile from the end of the hike. Cross Ice Box Creek, angling to the right

(downstream) for about 20 feet to pick up the trail continuation. When you get to the Ice Box Trail, turn right and proceed about 1/5th mile to the parking area.

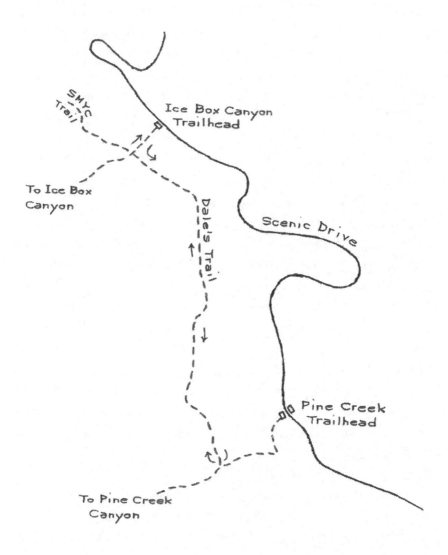

PINE CREEK CANYON/
FIRE ECOLOGY TRAIL

Starting Point: Pine Creek Canyon Pull-off (marked) about 10.7 miles on scenic loop

Difficulty Rating: 1

Distance: 3 Miles (including Fire Ecology Trail)

Elevation Gain: 100 Feet

Comments: Hiking in Pine Creek Canyon offers a variety of trail conditions and scenery. The hike that is described here takes you by trail to the point where the north and south forks of Pine Creek converge in front of a steep, pyramid shaped peak with a dark red cap on the top known as Mescalito. Along the way, you can visit the Fire Ecology Trail, where a project involving a controlled burn of brush along an overflow drainage of Pine Creek occurred in 1992, the aim of which was to protect a stand of ponderosa pine, which rarely can be found near the desert floor. Farther along on the trail is the foundation for the Wilson homestead, one of the early residences in the Red Rock area. The site includes a single apple tree, which still bears fruit. That tree is the last remnant of an orchard started by Mrs. Wilson on the property. Pictures of the old homestead can be seen in the Visitor Center.

Hike Description: Begin the hike at the west edge of the Pine Creek pull-off at the trailhead sign that indicates "Pine Creek Trail System." Just past the trailhead sign is another sign that reads "Caution – Steep Slope." The first 1/5th of a mile descends on this trail, which is very rocky with loose material, towards a wash. At the bottom of the grade, the trail turns right (west) and crosses the wash. The trail surface becomes sandy,

with a well-defined rock border lining the way. For the rest of the hike, the main trail will head in a westerly direction toward Mescalito, which divides the two upper forks of Pine Creek Canyon.

About 1/3rd mile into the hike, you will come to the first intersection for the Fire Ecology Trail, which has a shape like a figure eight. The entire Fire Ecology trail is about 3/8th mile in length (the current directional signs are wrong). If you want to see the ponderosa pine stand closer up, take this left. The majority of the trail has a rock border, so it is quite easy to follow. The trail bends to the right in an arc along the overflow drainage, until it comes to a spot near an old picnic table where you cross the drainage. After crossing, take the rock-bordered trail that goes off to the left (SSE). This section of the trail rapidly begins bending to the right in an arc until it comes to the main drainage for Pine Creek. There are two benches overlooking the creek and some signage that indicates a treatment project to reduce brush, the main fuel source for ground fires spreading out of control. Continue around on the arc to the right until you get back to the picnic table. Cross the drainage again at this point. Look for the sign that discusses the old controlled burn, and turn left on the trail that goes by the sign. You will intersect the main Pine Creek trail in about 400 feet at a spot just 160 feet farther along the trail than the first Fire Ecology trail sign.

As you exit the Fire Ecology Trail, turn left on the main trail and head directly toward Mescalito. In about 1/8th mile, Dale's Trail goes to the right. Stay straight on your current trail. The trail is fairly easy to follow as it stays on the ridge to the right of the creek bed. About 1/3rd mile past the Dale's Trail junction is a short dirt path that runs 40 feet to the Wilson homestead foundation.

Go up and view what remains of one of the earliest homesteads in this area. Imagine what it must have been like living in this remote area in the early 1930's. The naturalists from Red Rock Canyon Interpretive Association often conduct guided hikes to the old homestead and give a

full account of the history of the place. There are also some old pictures of the homestead at the Visitor Center that show it in its splendor.

When you leave the Wilson site, return to the trail and turn left. Shortly, the trail bends toward the cliff walls on the right. In about 1/8th mile, a well-defined trail goes off to the right. This trail is a very steep climb of about 200 vertical feet to the base of the cliff walls on your right, where you can find a great view looking down into the canyon. This trail is very difficult to negotiate, however, with some serious rock scrambling in addition to the steepness, so don't attempt it unless you are with other people and prepared for the difficulty. At the trail intersection, the main trail continues straight toward the north fork of the canyon to the right of Mescalito.

The trail becomes quite rocky in this section. In ¼ mile, the trail crests the narrowing ridge you are on and drops down a slope to a sandy junction area. Go down the slope and turn right on the dirt path, which winds through some bushes. As you get to an area with large boulders close to the trail, the main trail comes to an end on a rock porch directly above the intersection of the two canyon forks. If you have taken the Fire Ecology trail, you have hiked a distance of nearly 1.7 miles to get to this spot. If you came directly up the trail, you will have gone about 1.35 miles.

While my description of the hike ends at this point, many people like to hike down the faint, steep trail, past the rock porch and over boulders, dropping into the drainage, and go rock scrambling in one of the two forks of Pine Creek Canyon, either of which can be accessed at this point. If you decide to try this type of hiking, do it with a group and make sure to monitor everyone's progress in case of any problems. Go only as far up into the canyon as you are comfortable with in regard to the terrain. In the early months of the year, there is generally water flowing in both drainages, and it can often be of such significant volume that it will force you to do some extra scrambling. When it becomes

too difficult, or you think the chance of slipping or falling has become too great, simply turn around and retrace your steps out of the canyon. Hopefully, you will remember how you dropped into the canyon in the first place.

To Return: Turn around and retrace your steps. Remember that you need to climb up to the ridge, now on your left, about 300 feet from the turnaround point of the hike. The rest of the trail is easy to follow, generally heading east with the parking area visible in the distance.

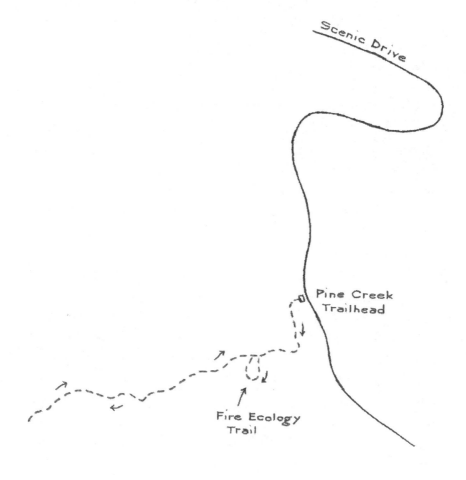

ESCARPMENT BASE TRAIL

Starting Point: Parking lot at end of gravel road with directional sign to Oak Creek Trailhead located just past the 12-mile marker on scenic loop

Difficulty Rating: 3

Distance: 5.4 Miles

Elevation Gain: 470 Feet

Comments: This is the only hike in the book that I have described as a point-to-point hike. It could of course be done as an out-and-back, but 10.8 miles of hiking is beyond the scope of this book. The full hike involves using all of Arnight, Dale's, and SMYC trails, plus a short segment of the Pine Creek Canyon trail. It has also been referred to by some of the Red Rock naturalists as the 3-in-1 hike. To avoid excessive trips around the 13-mile scenic look, my advice is to drop one or more vehicles at the Lost Creek trailhead on the spur road to Willow Springs and drive the remaining vehicles to the starting point, to be picked up on the way out. This makes the hike marginally more difficult because the end of the hike is at a higher elevation than the beginning, but there is sufficient rolling terrain to cause this hike to be rated as a 3 regardless of which direction is taken.

Hike Description: Begin the hike at the signed trailhead titled "Arnight Trail System" located in the northwest corner of the parking area. Take the Arnight Trail, heading in a northwest direction toward Bridge Mountain on the horizon. The trail surface is mainly dirt, but becomes rockier about 1/3rd mile into the hike. Just past the ½ mile mark, you will cross Juniper Creek, which appears as a boulder-lined drainage. About 1.1 miles into the hike, you arrive at a trail junction with Knoll

trail going to the left. Continue straight where the sign points toward Pine Creek. In another 1/10th mile, a worn but less-traveled trail goes off to the left toward the opening for Juniper Canyon. Stay straight on your current trail.

About 1/3rd mile from that point, the trail comes to a bank about 50 feet above Pine Creek with a great view of the Wilson foundation. Stay on the trail as it descends along the bank and goes through some thick foliage as you near the bottom. The trail shows evidence of rutting from excessive water runoff. When you reach a sign at an intersection pointing back to the Oak Creek area, take a right and proceed down to the creek crossing. The Arnight Trail climbs the far bank slightly to your right and ends as it intersects the Pine Creek Canyon trail near the Wilson foundation. You have now hiked 1.7 miles.

Take a right on the Pine Creek Canyon trail, heading east toward the trailhead, and follow it for about 1/3rd mile until you reach the junction with Dale's Trail. The sign for that trail faces hikers going in the opposite direction, so you will have to go past the sign to make sure, but it is the first marked junction you will come across. Your hiking distance so far is just over 2 miles.

Take a left on Dale's Trail, heading northwest, and begin a slight climb for about 1/5th mile until you get to the vicinity of Skull Rock. There is a sign for the landmark on the right side of the trail. This is a good spot to replenish your energies, with a bench and some large, flat rocks to sit on.

A short distance past Skull Rock you encounter the first of four deep drainages taking water from the vicinity of Bridge Point, on your left, to the lower washes. Past this first drainage, the climb up to the next ridge is quite steep and goes for a distance of about 1/5th mile. About 2.7 miles into the hike, you encounter an obscure bend as you drop into a short drainage. The trail makes a hard left turn over some 2-

foot boulders before picking up more definition in about 15 feet as you make a hard right turn. After you get past the last of the deep drainages and achieve the next ridge, the trail begins a long gradual descent that goes directly by a bench that affords a great view into the northwest part of Red Rock Canyon. This bench is located about 3.5 miles into the hike.

The trail begins to meander over fairly level ground for another 3/5th mile, where you come across another bench sitting on a bank above Ice Box Creek. As you arrive at the bench, take a hard right on a more obscure section of the trail that starts off very rocky as it drops into the drainage. When you come to the creek, cross on the rocks to a point about 20 feet to your right, where the dirt trail continues amid some heavy foliage. There is a short climb out of the drainage and the trail becomes very rocky as you now approach the Ice Box Canyon trail. When you arrive at the trail, you will have hiked 4.3 miles.

Continue straight across the Ice Box Canyon trail onto the beginning of the SMYC Trail. The trail begins to climb very gradually as it pulls away from the Ice Box trail. This section of the trail also has a rock border to help distinguish the hiking route. About 1/8th mile up the SMYC Trail you will make a right at an apparent trail junction and go around the point of a small ridge. The trail to the left goes toward the cliffs on the north side of Ice Box Canyon, and is used primarily by rope climbers. In another 1/8th mile, the SMYC Trail makes a gradual climb to the point of another ridge and makes a hard left over some red sandstone slabs. The trail is somewhat obscure in this spot, but becomes very apparent within 15 or 20 feet after making the correct turn. By now the Lost Creek trailhead, your final destination on the hike, is very apparent off to your right.

With about ¾ mile to go, the trail makes a big descent into a wash. On the way down, the surface conditions consist of rock and red soil, with about half a dozen sets of rock steps, dropping more than 100 feet to

the bottom of the wash. In the wash, the trail surface consists of gray dirt. As you cross the wash and start your last significant climb, the soil turns red again with several imbedded rocks that are used as steps. At the top of this ridge, there is a minor observation point on your right about 30 feet above the floor of the main wash coming from above Willow Springs.

The trail continues to roll slightly for a short distance, climbing and then descending over a few sets of stone steps, and finally drops into the main wash. This wash is quite wide, with the crossing about 600 feet in length, including a small section of ground higher than the drainage area. Red Rock volunteers have installed a rock border across the wash to keep you pointed in the right direction. Be aware, however, that excessive runoff from heavy rains can obliterate this border, making it more difficult to find the way. After crossing the wash, continue about 200 feet to the spot where the SMYC Trail ends at the Lost Creek trail. Take a right and walk 250 feet to the trailhead, where you spotted some of your vehicles earlier.

Lost Creek
Trailhead

SMYC Trail

Ice Box
Trailhead

Scenic Drive

Dale's Trail

Pine Creek
Trailhead

Pine Creek Trail

Arright Trail

Gravel Road

Highway 159

Exit

Oak Creek
Trailhead

ARNIGHT-KNOLL LOOP

Starting Point: Parking lot at end of gravel road with directional sign to Oak Creek Trailhead located just past the 12-mile marker on scenic loop

Difficulty Rating: 1

Distance: 3 Miles

Elevation Gain: 200 Feet

Comments: This hike combines portions of the Arnight and Oak Creek Canyon trails with the entire Knoll Trail that runs between the two. It is a relatively easy workout with only slightly rolling terrain over the 3-mile distance and gradual elevation gains. An individual hiking this combination of trails can get good views from relatively close up of Juniper and Oak Creek Canyons.

Hike Description: Begin the hike at the trailhead labeled "Arnight Trail System" located in the northwest corner of the parking area, heading in a northwest direction on the Arnight Trail. In about 1/8th mile, the trail bends slightly to the left (west) and heads toward the escarpment, then bends slightly to the right toward Juniper Canyon. Just past the ½ mile mark, you will cross Juniper Creek. Continuing on a little farther, you get a direct view up into Juniper Canyon. This is a very steep canyon with a vertical gain of nearly 2,000 feet to the back of the canyon. As you continue on the Arnight Trail toward Pine Creek Canyon, you will come to a trail junction about 1.1 miles into the hike.

Go left at this junction onto the Knoll Trail, heading south. Disregard the distances listed on the nearby sign for Knoll Trail, as they are extremely inaccurate. In 1/10th mile, a cairn marks a divide in the trail.

The one to the right goes up into Juniper Canyon. Take the trail to the left, heading toward Oak Creek Canyon along the escarpment. In about 1/8th mile, rock stairs lead down to the creek. There are several large boulders in the area of the creek crossing, and the picturesque setting provides a great place for a short stop.

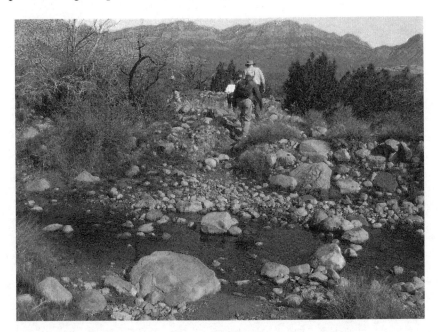

As you leave the creek, go up the obscure trail over the rocks on the left rather than what appears to be a trail going off to the right. In ten feet, the trail will take on much greater definition. Rainbow Peak will be on your immediate right and Wilson Peak will be farther along on your right across the mouth of Oak Creek Canyon. Cars in the parking lot where you started this hike are visible to the left. Continue on the Knoll Trail until it intersects the Oak Creek Canyon trail about 2 ¼ miles into the hike.

Take a left on the Oak Creek Canyon trail and return to the starting point. There is only one significant trail junction on this last part of trail, and you need to stay left at the stone cairn about 1/8th mile from where you entered the Oak Creek Canyon trail.

Scenic Drive

Gravel Road

Knoll Trail

Arright Trail

Oak Creek
Trailhead

Oak Creek Trail

Exit

Highway 69

OAK CREEK CANYON
(FROM SCENIC LOOP TRAILHEAD)

Starting Point: Parking lot at end of gravel road with directional sign to Oak Creek Trailhead located just past the 12-mile marker on scenic loop

Difficulty Rating: 1

Distance: 2.7 Miles

Elevation Gain: 250 Feet

Comments: This is an out-and-back approach hike to the interior drainage of Oak Creek Canyon. The route I have described here includes the established trail past the junction with the Knoll Trail, continuing straight on the right side of and above the streambed until the path drops into the bottom of the drainage on the canyon floor. The north wall of Oak Creek Canyon is a favorite place for climbers using ropes and equipment to practice their sport, and you can generally spot climbers on the cliffs when weather conditions are temperate.

Hike Description: Begin the hike at the trailhead sign that states "New Oak Creek Trail System" that is located in the southwest corner of the parking lot. Go past the sign and take the trail that heads off in a southwest direction. The trail surface generally consists of dirt with a few rocks. Until the trail passes the Knoll Trail, the general direction of the trail is southwest, ranging between Wilson Peak on the left and the opening for Oak Creek Canyon on the right. Until it intersects the Knoll Trail, there is very little elevation gain.

About 2/3rd mile from the start, a trail comes in from the left and meets the Oak Creek Canyon trail. There is a cairn at this intersection. That

trail is part of the Oak Creek hike that begins at the scenic loop exit (see next hike). In another 1/10th mile you arrive at the junction with the Knoll Trail.

As you continue past the Knoll Trail, the surface of the Oak Creek Canyon trail becomes much rockier and the vertical climb rate increases. Slightly more than one mile into the hike, you arrive at a high point on a slight ridge before descending on a red dirt track. The trail becomes narrower and you arrive at a trail junction. The trail to the left descends onto the first bank above the creek bed, while the trail to the right continues along the base of the cliffs on the north wall of the canyon. Although it is slightly easier to follow the trail to the right, staying high above the drainage floor, the two trails will intersect in about 1/6th mile. While hiking through this stretch, take note of the red sandstone rock formation immediately above you that includes some cliffs approaching 60 feet in height.

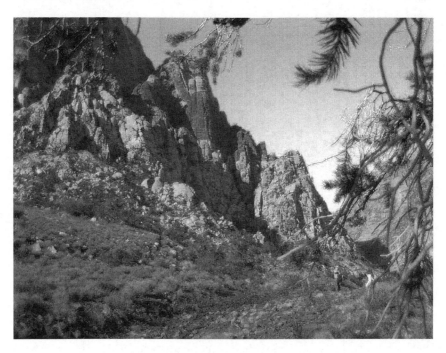

About 300 feet past the point where the two trails come back together again, the upper trail crosses some boulders and makes a drop of about 30 feet over some rock slabs to the floor of the canyon. You are now 1.35 miles from the trailhead. You have the option at this point of continuing further into the canyon or turning around and returning to the trailhead. If you decide to continue on, be advised that Oak Creek Canyon is probably the toughest of the canyons to boulder through, because many of the boulders are in the 10 to 20 foot size range, and there are many places where you can be exposed to falls of 10 or more feet. Going up the canyon should probably be attempted only by experienced hikers and only in groups in case of any problems.

Another option, if you would like to get a sample of large rock bouldering, is to drop into the drainage and work your way downstream. You will have several chances to descend on six to eight foot boulders as you look for a way to exit from the bottom and get back onto the ridge that takes you back to the trailhead. If you do this, my advice is to keep the descent in the drainage to a reasonably short distance, so that you can find your way back to the trails on the north side of the streambed above the drainage.

To Return: Reverse your direction and return to the trailhead. If you have decided to do some bouldering in the canyon, you need to be aware of the terrain and alert for possible exits from the bouldering section to get back on the trails that return you to the correct trailhead.

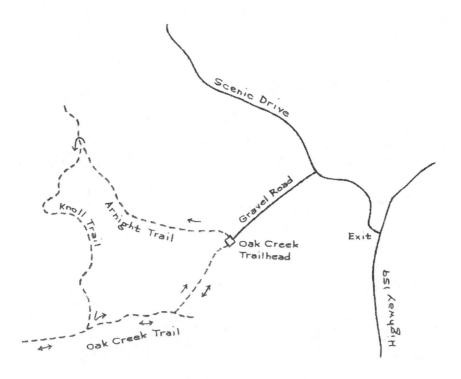

OAK CREEK

Starting Point: Gravel parking area on Highway 159 at Scenic Loop
Exit
Difficulty Rating: 2
Distance: 4 Miles
Elevation Gain: 200 Feet

Comments: If you are looking for a Red Rock hike that can be done in less than two hours (at an easy pace) and that provides a variety of scenery during the hike, this is the one for you. The starting point is on Highway 159, so you can save the time needed to drive around the scenic loop. The first and last miles of the hike are out-and-back, and the middle two miles are a loop. There are good views of Oak Creek and the hike route crosses the creek twice. The vegetation near the drainage is quite lush, so you don't have the feeling of being in the desert for the entire trek. The best time of year to do this hike is from December to May, depending on amounts of snowmelt and rainfall. Like all hikes in the desert, it is most enjoyable when you can see water flowing.

Hike Description: Begin the hike from the parking area by crossing the scenic loop at the exit gate and taking an unmarked horse trail that lies just inside the fence on the southwest side of the road. This trail parallels Highway 159 for about 900 feet before a bend in the trail points you toward Wilson Peak to the southwest. About 0.9 miles from the start, the horse trail intersects an old jeep road. There is a cairn at the intersection. Turn right (west) on the jeep road, heading directly toward the opening in the distance for Oak Creek Canyon.

A little more than one mile into the hike, the trail becomes very rocky as it drops down to a single track and begins to climb slightly. There are many

rocks between 12" and 16" in size imbedded in the reddish dirt over which the trail runs. As the incline becomes slightly steeper, the trail passes by a field of boulders in the four or five foot range. A little more than 1.5 miles into the hike, the main trail bends slightly to the right as an obscure track appears to go left and drops into the Oak Creek drainage. Stay on the main trail as it crests a small ridge and descends on the other side. At about 1 ¾ miles, this trail intersects with and dead ends at the main Oak Creek Canyon trail coming from the trailhead accessed from the scenic loop drive (see previous hike). There is a cairn marking this trail intersection.

Turn left on the Oak Creek Canyon trail and proceed for only about 60 feet, where you will spot another cairn on your left. Take a left at this cairn, heading south. The trail makes a few bends as it descends toward Oak Creek, generally heading for the gap between Wilson Peak and Potato Knoll. In about 1/8th mile, you come to the edge of a 20-foot bank overlooking the creek. If you are doing this hike at the right time of the year, water should be present in the creek. Turn left, heading east, and hike along the top of the bank. The trail begins to descend gradually toward the drainage for Oak Creek. About 2 miles into the hike, the trail you have been hiking empties into a well-traveled horse trail just a little to the north of the creek. Turn left on this horse trail.

As you proceed along the horse trail, you will notice a ridge running somewhat parallel to you on the left. At the point of the ridge are some dark brown caliche boulders. The trail goes just to the south of those boulders and almost immediately drops to the creek bed. This is the first crossing you will make of the creek on this hike. Find some decent rocks to hop across and look for the trail continuation on the far side of the creek, only about 15 feet away. As you step across, continue straight on the main trail for about 50 feet to a fork and take a left. The trail merges with a fainter trail from the left in about 30 feet. Continue on the combined trail for just under ¼ mile, until you get to a broad dirt spot where a wide horse trail comes in from the left. There is a large juniper tree at the head of this T-intersection.

Turn left on the wide horse trail, which soon becomes a single track with a worn groove about four or five inches deep. About 1/10th mile from the previous trail intersection, look for a trail coming in from the left that is marked by a cairn sitting on a large, flat rock on the right side of your current trail. Take a left on the new trail, which brings you back to the drainage for Oak Creek in about 800 feet. Go across the creek, looking for the trail continuation slightly to your right. Follow the trail as it first winds to the north of Oak Creek before bending left and climbing out of the drainage area. A short distance past the climb the trail intersects with the jeep road that you were on earlier. At this point, you have hiked 3 miles.

Turn right on the jeep road and proceed about 500 feet to the spot where a horse trail goes off to the left. There is a cairn at the spot marking the turn. The horse trail is quite loose in spots as it winds its way over the desert, with Highway 159 in view to the east. As you get within ¼ mile of the end, you will be able to see the parking area where you began the hike.

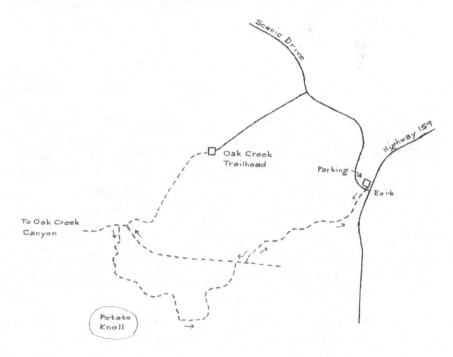

POTATO KNOLL

Starting Point: Gravel parking area on Highway 159 at Scenic Loop
Exit
Difficulty Rating: 2
Distance: 5.3 Miles
Elevation Gain: 665 Feet

Comments: Potato Knoll is an excellent hike to do early in the year or after a good rainfall because the route crosses Oak Creek four times. This hike is an out-and-back with a loop around Potato Knoll, which is a 500-foot hill in the shadow of Wilson Peak. Think of the general shape as a balloon on a string. You start at the bottom of the string, run around the balloon, and finish at the bottom of the string. The trails that are used for this hike are not marked; therefore, I highly recommend that you familiarize yourself with the appearance and surroundings of all the trail intersections you encounter on the outbound portion so that you can recognize your turns on the way back.

Hike Description: Begin the hike from the parking area by crossing the scenic loop at the exit gate and taking an unmarked horse trail that lies just inside the fence on the southwest side of the road. This trail parallels Highway 159 for about 900 feet before a bend in the trail points you toward Wilson Peak to the southwest. About 0.9 miles from the start, the horse trail intersects an old jeep road. There is a cairn at the intersection. Go right (west) on the jeep road, and travel about 500 feet to a spot where a dirt trail goes off to the left in a southwest direction toward Oak Creek Wash. A cairn marks this trail junction as well. You have now hiked about one mile.

Take the trail to your left, which becomes rocky as it descends into the wash. Follow along the north side of the creek until you reach a crossing about 1/10th mile from the previous trail intersection. The trail on the other side of the creek is slightly to your right as you make the crossing. The trail continues about 800 feet past the crossing, where it intersects with a well-used horse trail. Turn right on the horse trail, heading west. In 1/10th mile, the trail you are on intersects with the main lower trail looping Potato Knoll, which is the hill directly in front of you, at a T-intersection. There is a fairly large juniper tree at the head of this junction. Familiarize yourself with the intersection, as you will be returning to it and will need to make the correct turn to head back to the starting point of the hike.

Turn left onto the new trail, heading in a southerly direction. This trail is actually an old jeep track, so there are two tracks to follow through this section. There is a short but steep climb out of a wash as you make your way toward the south end of the hill on your right. Slightly more than 1 ½ miles into the hike, a cairn marks the intersection with a rocky jeep road running west that parallels the Oak Creek trail on the other side of a wash. Take a right on the jeep road – you do not need to cross the wash. Continue along the wash on the right side. About 1 ¾ miles into the hike, the wash disappears at its upper end and the trail you are on merges with the Oak Creek Trail coming along the left side of the wash.

As you continue around Potato Knoll, you will now be heading to the northwest. At about 2 miles into the hike, you will arrive at the high spot on the trail. It should be obvious that this is a high spot, because the trail starts to descend immediately down a hill. If climbing Potato Knoll is on your agenda, this is the point from which you will want to start. If not, you will be reducing your hiking distance to 4.25 miles. See continuation of the hike after the next paragraph.

To climb Potato Knoll from the high point of the main trail, look for a faint trail that approaches the hill and veers off to the left on a track

paralleling the loop trail below. Continue on this faint trail past the first switchback, which takes you in a southeasterly direction, as it continues to climb. When you get to what appears to be a defined switchback heading to the north, continue straight ahead up a grassy incline. A faint trail marked with several cairns winds its way up the side of the hill. Follow the trail as best you can but, should you lose it, just continue up looking for the easiest approaches to the top. The view that awaits you on the top is much better than you might have expected by looking at the hill from other angles. If you brought a snack, this is the place for it. Retrace your steps as best as possible to return to the loop trail. WARNING – Be very alert for the presence of rattlesnakes on the climb to the top. They are generally very active during the months of April and May, and can lay in the grass along the approach trail.

As the main loop trail descends between the hill on your right and Wilson Peak on your left, you may notice that the vegetation is quite thick in this area. This small ecosystem difference is likely due to the sheltering effect of the higher terrain on either side holding more moisture in the area. Go 0.3 miles from the high point of the trail and, at the top of a small crest on the far side of a small wash, look for a horse trail going off to the right (north). Take this trail to the right. In 1/8th mile, there is another trail junction marked with a cairn. Go to the right at this trail junction.

Stay on the horse trail as it winds fairly close to the north end of Potato Knoll. In ¼ mile, you will cross Oak Creek for the second time on your hike. After the crossing, continue east on the trail. You will soon see some dark brown caliche boulders that mark the tip of a ridge that has been running east-west on your left. Just beyond these boulders is the third crossing of Oak Creek. Make the crossing, stay on the main trail, and take the left trail at the fork you encounter about 50 feet past the crossing. Continue on this trail for another ¼ mile to the junction that will close the loop portion of the hike, where you will take a left. Look for the large juniper on the right.

In 1/10th mile, the return trail takes a left just on the other side of another juniper tree. A cairn sitting on a large, flat rock marks the spot. About 800 feet beyond that turn is the last crossing of Oak Creek, one that you did in the reverse direction as you were approaching the Potato Knoll. The trail veers right along the creek until it rises out of the wash and intersects the old jeep road. Take a right on the jeep road and look for the rock pile 500 feet later that marks the left turn onto the horse trail that will take you back to the parking area.

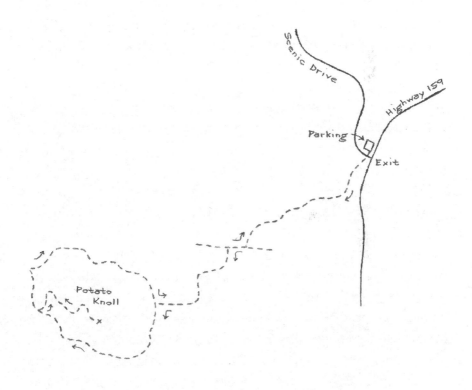

OAK CREEK CANYON
(FROM HIGHWAY 159)

How to Get There: Drive 3.7 miles past the entrance to the Red Rock Visitor Center heading west on Highway 159. The marked trailhead is at a pull-off area on the right side of the highway heading south toward Spring Mountain Ranch. There is no parking lot at the site, but there is room for about eight or ten vehicles in the gravel pull-off area.

Starting Point: Marked sign for Oak Creek Canyon
Difficulty Rating: 2
Distance: 5.3 Miles
Elevation Gain: 350 Feet

Comments: While the previous Oak Creek Canyon hike described in this book utilize trails on the north side of Oak Creek, this hike follows trails that are on the south side of the Oak Creek drainage. The series of trails climbs a ridge on the south side of the canyon and goes deeper into the canyon than the other hike does before emptying into the drainage. As the trail ends, the hiker is treated to an area of red sandstone rock formations that provide the backdrop for the spectacular scenery of the upper canyon. The seasonal waterfall that flows over these rock formations can have a very high flow level during the snowmelt and rainy seasons of late winter and spring.

Hike Description: Begin the hike from the pull-off area by going around to the left of the metal gate that keeps vehicle traffic from entering an old gravel road heading in the direction of Wilson Peak. Proceed down the road, heading west, through an area that was once an old campground. At the bottom of the road, about 1/6th mile from the start, is a sign titled

"New Oak Creek Trail System" that indicates a distance of 2.5 miles to Oak Creek Canyon. Just past the sign, the trail crosses the lower portion of the Oak Creek drainage. Water is only present in this part of the drainage immediately after significant rainfall events. Immediately after crossing the drainage, the old roadbed resumes. It bends slightly to the right, heading northwest straight toward Bridge Mountain on the horizon.

In about 400 feet, the road bends to the left, climbing a slight hill and heading toward the opening in the escarpment for Oak Creek Canyon. A little less than 600 feet later, you will pass a stone bench that someone has made using flat rock slabs held together with free-formed concrete. The road narrows and in about 1/5th mile becomes very rocky. This will be the predominant surface for the trail over most of the next mile of the hike.

About ¾ mile into the hike, the road comes to a fork with a jeep track heading off to the right. Take either the left road continuation or the horse trail that goes off to the left about 15 feet before the fork. The horse trail parallels the wider but rockier old road for about 1,000 feet where the two intersect. The road turns left, heading west directly at Wilson Peak on the escarpment. Potato Knoll will be slightly to your right and its size at this close-in distance blocks your view of the opening for Oak Creek Canyon.

The road climbs slightly through this section, continuing straight toward Wilson Peak, with a drainage area on your left and a 20-foot high ridge on your right. At 1.25 miles into the hike, the road crosses the drainage. If you look to the right, you will notice a distinctive line of dark brown boulders at the base of Potato Knoll. Continue up the old rocky road, with the drainage on your right. Near the top of the wash, with the base of Wilson Peak only a few hundred yards away, the road starts to become more of a trail as it bends to the right and climbs between Wilson Peak and Potato Knoll. The trail consists of a gray clay-type material as you

start this climb, but soon becomes red in color as you approach the saddle between the two formations. At this saddle, you have hiked a little more than 1.6 miles.

On the day I did the write-up for this hike, I had an interesting encounter. On the way out, my hiking partner and I heard a loud animal cry that I could only associate with the braying of one of the wild burros from the area. It lasted for about 30 seconds, and it really sounded like the animal was in pain. After another 30 seconds of silence, there was a short burst of noise that lasted for just a few seconds. We tried to pinpoint the location of the noise, which seemed to come from higher up near the base of the cliff wall of Wilson Peak, thinking this was pretty steep ground for a burro to be in. Not spotting anything, however, we turned our attention back to the hike. On our return trip, we met a small trail ride coming out of Spring Mountain Ranch right at this saddle. During the course of our short conversation, we mentioned the noise we had heard earlier. The cowboy in charge of the trail ride then told us about the 150-pound mountain lion that has a den in that immediate area about 200 yards above the trail and pointed it out to us. Needless to say, I now have a new respect for this area.

Returning to the hike description, cross over the saddle and continue downward on the trail, heading northwest toward the canyon opening, which is once again visible. The multi-colored Rainbow Peak is directly ahead of you as you make this descent. As you go farther past Potato Knoll, you get a panoramic view on your right of Red Rock Canyon, stretching to the Calico Hills and the area of the Visitor Center way off to the right. About this time, you realize that the trail surface is no longer littered with imbedded rocks, and the footing becomes very easy. Stay on the main trail heading toward Rainbow Peak and the canyon opening as you pass some horse trails going off to your right.

At the two-mile point of the hike, you will come across a cairn marking a trail divide. From this point on, there are several potential trails to take,

so it is a good idea to stop occasionally and view your surroundings. This will help you choose the trails on your return trip that will provide the best route to return to your present location. Start off by taking the left fork at the junction. The trail makes a steep climb up the front of a ridge before crossing a drainage area. In the area of the crossing, the trail has a tendency to become very obscure. The trick is to find the faint trail in the middle of the slight ridge just past the second drainage crossing that runs toward the escarpment for a few hundred feet. Once near the top of the ridge, the trail that goes down the other side toward the canyon opening becomes more apparent and easier to follow. There are a few cairns in this vicinity, but they are not easy to spot. As you drop down on the other side of the ridge, the trail you are on becomes much more defined and a trail junction with a cairn can be spotted below and to your right. Proceed to this junction and take a left.

In 360 feet, the trail divides again. Take the left fork, which becomes rocky. In less than 200 feet, you encounter another fork, where you will again head toward the left, climbing a ridge. You are now close to the canyon opening and the drainage for the creek bed is visible below and to your right. You only have about 1/3rd mile to go to the end of the trail section of this hike, but the landscape is about to make a dramatic change from what you have seen previously.

The trail becomes rocky as it winds toward the canyon. You will now start to see some large sandstone boulders close to the trail in the area you are hiking. Two large boulders about ten feet in height seem to block the way, but the trail goes around them to the right at the base of the boulders. You are now directly above the canyon drainage. In another 200 feet, a 15-foot boulder blocks the way. The path looks like it goes around to the left, but take the fainter trail that hugs the boulder going around to the right. The trail crosses a rocky section and descends slightly. When two 10-foot boulders appear to block the way, go around this pair on the left. The trail basically ends at this point, but the real beauty is about to begin.

Go around to the right of a juniper tree that you see directly in front of you and enter the drainage area. As you turn to your left, you will encounter a red sandstone formation with a trough in the middle. When water is flowing in the canyon, the front edge of the trough is a waterfall that handles the entire flow of the upper canyon. When the flowage is high enough, water can jettison out from this trough for several feet before dropping into a pool that can reach a depth of four or five feet. If water is present, you can access the higher rock formation on your left by going back around it and picking up a faint trail that brings you to the top of the rock. Without any water, it is fairly easy to walk up the rock formation on your right, even though it is steep and about eight feet high. This is the place for your mid-hike snack. A rock outcropping behind you in the canyon hides your view of any sign of civilization, and the view up the canyon is wonderful. The cliff walls on the north side of the canyon below Rainbow Peak are very popular with rope climbers, and there is a good chance you might spot some climbers and follow their slow progress up the cliffs.

If you are in a group of experienced hikers and are looking for some real excitement and terrific scenery, the bouldering route going up Oak Creek Canyon from this point is probably the most challenging of any of the canyons in the escarpment area. Your progress up the canyon will be slow, however, since many of the boulders are in the 10 to 20 foot height range, and require a fairly high level of technical expertise that may include the need for webbing or rope.

To Return: Reverse your direction and return to the trailhead. Once you clear the area of large boulders, you will be able to spot the top section of Potato Knoll off to your right. While you may not be on exactly the same trail you took on the way out, the most important thing is to maintain your direction as close as possible straight at Potato Knoll. There will be a few washes to cross and some smaller ridges to climb, but in short order you will be back on the trail (with red dirt) that leads to the saddle. Once at the saddle, the return route is easy to spot and the parking area can be seen from more than one mile away.

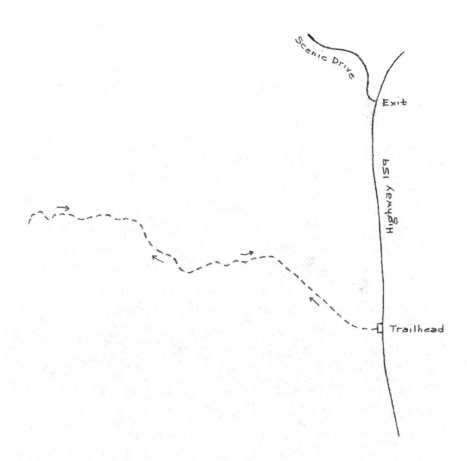

FIRST CREEK

How to Get There: Drive 4.3 miles past the Red Rock Visitor Center heading west on Highway 159. The marked trailhead is at the bottom of a hill 0.6 miles beyond a trailhead marked for Oak Creek Canyon. There is no parking lot at the site, but there is room for fifteen or twenty cars pulled off the highway on the west side near the trailhead.

Starting Point: Marked sign for First Creek Trailhead
Difficulty Rating: 2
Distance: 4 Miles
Elevation Gain: 250 Feet

Comments: First Creek is a great hike one or two days after a significant rainfall of ¼ inch or more. The first mile in from the trailhead is very easy and culminates at a beautiful waterfall in a hidden alcove of the creek bed. The second mile is slightly more difficult, and has two magnificent boulder waterfalls at or near the end of that distance. Above the third waterfall, First Creek Canyon becomes a much more strenuous hike, and inexperienced hikers should not attempt to go any farther.

Hike Description: Go through the fence by the trailhead sign just off the road and veer left to cross a creek bed and pick up the trail continuing on the other side. Head for the canyon straight ahead, which is First Creek Canyon. The trail proceeds almost straight west with some slight meanderings. The surface condition is excellent, mostly dirt with a minor amount of fine gravel and only occasional rocks. At about 2/3 mile, there will be a short but dense rocky section of the trail. As you look over to your right, you will notice a reddish brown dirt bank on the other side of the wash. The first waterfall to be visited lies upstream from that red dirt bank about 200 yards.

Continue on the trail until you have walked about one mile from the start. As the main trail takes a bend to the left, a well-defined trail heads to the right. Take the trail that goes right. It is about 280 feet to the highest edge of the creek bed and the waterfall. Go down the bank about 15 feet and look out over the top edge of the waterfall.

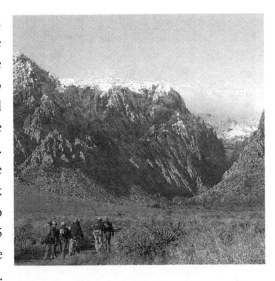

To access the hidden glen below the waterfall, go back downstream a short distance to a scrub pine tree on the upper bank, go around the tree on either side and take the trail that goes down between the caliche wall and a 3-foot boulder. The feeling you get of seclusion at the base of the waterfall is completely contradictory to its presence in the desert.

When leaving the falls, climb the path to the bank and either return to the main trail or continue along the bank of the creek bed toward the canyon. If you stay along the creek, the trail starts off quite rocky, but soon feeds into a horse trail. The surface of the trail consists of several inches of fine, loose dirt. This trail empties into a more significant horse trail and accesses the main hiking trail about ¼ mile from the waterfall. There appear to be several trails going off in this section, but they all generally merge back within short distances, so don't panic. Stay between an ascending ridge on your left and the creek on your right and you will find your way. While there is not any one correct way of negotiating the remaining ¾ mile, the rest of the directions match my most preferred route.

At about 1.3 miles into the hike, go around to the left of some large rocks. In about 150 feet, there is a large scrub oak with a boulder to the

right front. Go around this tree to the right and head straight toward the escarpment. The creek will be on your right and the trail will be very sandy. In slightly more than 300 feet, the trail veers right and heads straight toward the canyon. Do not take the trail that appears to take you up on the ridge, but stay along the creek. The trail turns right again at a small rocky wash in about 350 feet. In another 370 feet, the trail takes a sharp left and climbs the ridge on your left, which is now much less climb relative to your position on the trail.

Another trail comes in from the left at this point. Continue going up between two juniper trees over the rocks you see in front of you. The trail becomes rocky as it intersects yet another defined trail. You are now about 1.6 miles into the hike with less than ½ mile to go up the wash. Go around the 8-foot boulder in front of you. The trail again crosses a rocky area as it continues to slowly climb. In about 300 feet, the trail bends to the left, goes down into a small drainage area, and then over some large rocks at the end

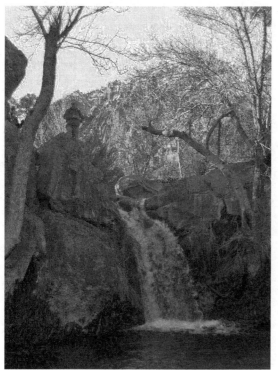

of the drainage. The trail continues on the other side of the rocks.

In another 300 feet, if much water is in the streambed, listen for the sound of falling water to your right. The scramble to get down to this waterfall is slightly tricky, so take your time if you decide to have a look. To get the best view, you need to climb out on a rock slab that sits just beside the streambed about 15 feet

from the waterfall. Water cascades down between two 20-foot boulders into a pool at the base of the boulders. The vertical drop of the falls is about 8 feet. Again, be careful as you return to the trail.

The third waterfall is about 700 feet up the wash. Stay on the low trail and veer right at a juniper tree. If you are in the right location, you will have to descend on a rock slab or climb over a dead tree leaning against the base of the slab. The faint trail goes around several large boulders and over some slightly smaller ones. In any event, the sound of the water should provide you with a target point. The trick is to go past the falls and approach it from above. When you get next to the falls, if much water is present, go about 20 feet upstream and cross the stream at the far end of a boulder 25 feet wide with its top about 6 feet above the stream. Climb that boulder, walk to the far end, and drop down over the next two boulders to the very top of the waterfall. The view is quite dramatic.

To Return: Reverse your direction and follow the stream back to the wide, main trail about one mile from the trailhead. Don't worry about taking a wrong trail – just keep the creek close by on your left and eventually a ridge on your right. As the ridge on your right reduces to nothing, the trailhead area will be visible in front of you.

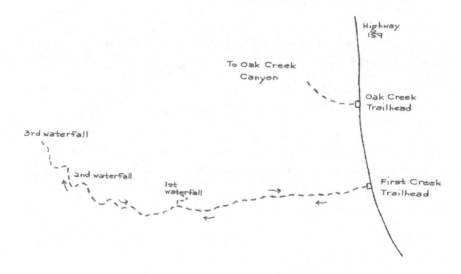

GRAPEVINE SPRING

How to Get There: From the west side of Las Vegas, take State Highway 159, the extension of Charleston Boulevard, and go by Red Rock Canyon and the town of Blue Diamond to the intersection with State Highway 160. From the rest of Las Vegas, take I-15 south about 1.3 miles past the junction with I-215 to Highway 160 (Blue Diamond Road) and go west on Highway 160 about 10.8 miles to the intersection with Highway 159. From the intersection, continue west on Highway 160 for 5.2 miles to Mile Marker 16 and turn right on the gravel road at that location. Park on the side of the gravel road, within 200 feet of leaving the highway. There is sufficient room for five or six vehicles at the site.

Starting Point: Marked sign with arrow giving direction to Late
Night Trail
Difficulty Rating: 2
Distance: 4 Miles
Elevation Gain: 240 Feet (on return)

Comments: Grapevine Spring is an excellent desert hike on the south end of the Red Rock Canyon Conservation Area. In addition to the spring for which the hike is named, there is an additional one about one-half mile farther along named Mud Spring. In the vicinity of Mud Spring, you will have the opportunity to see a large number of old petroglyphs that experts have not been able to date with any success. Although there is little overall elevation gain, the hike rolls through the desert and has a few minor vertical gains and losses. Much of the hike as described here is on bicycle trails and, since bike riders have the right-of-way, you need to watch out for them during the course of your hike.

Hike Description: Begin the hike by taking the narrow gravel trail that starts off in a southwest direction as it parallels Highway 160. There is a sign at the beginning of the trail that indicates the direction to the Late Night Trail, one of the main bike trails in the area. In about 1/8th mile, turn right at the sign that indicates the direction to Mustang Trail, another bike trail, heading to the northwest. There is a rock border at the trail junction and the trail surface is mainly dirt. As you approach ½ mile into the hike, another trail comes in from behind and to the right, joining the one you are on. A trail sign with green markers directs you straight ahead.

In about 330 feet, take a left at a trail junction with a sign pointing left toward Late Night Trail. This trail starts in a southwest direction and soon bends to the right, heading straight west. About 250 feet past the previous turn, take another left at the next junction. As you head across the desert, you pass the ridge on your right and Red Rock Canyon comes into view, with the La Madre Mountains in the background. After you cross a minor wash and gain the small ridge on the opposite side, an area with dark-brown boulders becomes visible in the distance in the lower area in front of the escarpment cliffs. Grapevine Spring is just in front of those boulders about ½ mile away and is your first destination.

As the trail continues toward the boulders, it crosses a double-track jeep road. One mile into the hike the trail crosses a gravel road and almost immediately crosses the Late Night Trail. Continue straight ahead across a few rocks blocking the way for the mountain bikers. The trail becomes rocky in sections and faint in others as it heads toward and crosses a gravelly wash. After you reach the top of the ridge on the far side of the wash, you will notice a wooden fence below and to your left. Continue on the trail as it bends to the right before completing a sweeping 180-degree arc back to the left that brings you to the grouping of dark-brown boulders, which you now realize are formed from caliche. You have hiked nearly 1-½ miles at this point. The spring area is about 60 feet off the trail on your left and is surrounded by fencing. If you

want to walk around the spring you may do so, but do not go inside of the fence as the spring is protected.

As you leave Grapevine Spring, return to the trail and continue to the left, heading to the northeast. You will soon cross a small creek and climb a ridge. About 1/3rd mile past the creek, take the trail that goes toward a horse-watering trough. Pass the trough and take the trail that makes a fairly steep climb up a ridge toward Mud Spring, about 1/10th mile away. You should notice a rubber hose that carries water from the area of the spring and brings it down to the horse trough as it runs along the trail. Since the spring functions year-round, there is always a supply of water available for horses.

Mud Spring is also a protected area and is fenced off to keep people from contaminating the spring. You are welcome to walk the perimeter but do not cross to the inside of the fence. On the north side of the spring, there is a rock slab with several undated petroglyphs and a sign giving some information about them. Look for a faint trail heading north from the spring that takes you to a much larger area of petroglyphs, as well as a more recent rock carving depicting a cowboy covered wagon. Be careful not to touch any of the ancient stone carvings, as they constitute an unknown but important aspect of the history of the area. These petroglyphs are located about 2.1 miles from the trailhead.

When you are done viewing the carved figures, return to the trail that leads back past the spring and drops down the ridge to the water trough. Take the trail that heads south, with an apparent trail sign at a junction about 25 feet away. As you come past the sign, you will notice that you have come to a corner for the Late Night Trail. Continue on the Late Night Trail in the same direction (south) that you were going when you joined the trail.

Stay on the Late Night Trail for about 0.6 miles as it crosses a gravel road twice. Shortly past the second road crossing, turn left at a trail junction and cross the gravel road again, following the sign that indicates the

direction to the Mustang Trail. This trail junction is the one you encountered at the one-mile point of the hike, so you have now closed a loop section of the hike and are returning on the trail you used in the beginning. In ½ mile, take a right at the sign that indicates the direction back to the trailhead. At the next fork, you can take either of the trails to return to the trailhead. The one to the right is the trail you used at the beginning of the hike. If you take this trail, remember to take a left on the trail that runs parallel to the highway when you come to a T-intersection so that you can return to your vehicle. If you take the trail to the left, with an arrow directing you to the trailhead, turn right onto the gravel road you encounter and follow it back to the trailhead. The second of these trails is slightly shorter by a few hundred feet getting back to your vehicle.

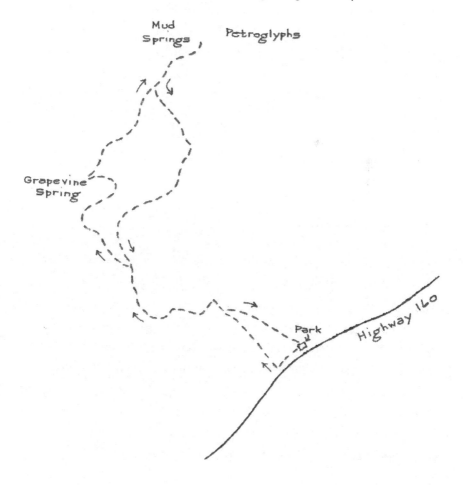

SOUTH COTTONWOOD VALLEY

How to Get There: From the west side of Las Vegas, take State Highway 159, the extension of Charleston Boulevard, and go by Red Rock Canyon and the town of Blue Diamond to the intersection with State Highway 160. From the rest of Las Vegas, take I-15 south about 1.3 miles past the junction with I-215 to Highway 160 (Blue Diamond Road) and go west on Highway 160 about 10.8 miles to the intersection with Highway 159. From the intersection, continue west on Highway 160 for 6.1 miles to a gravel road that goes to the left (south). There is a rustic restroom building at the end of a gravel parking lot just off the highway. Continue south on the gravel road past the first parking area for 0.8 miles to another parking area on the left side of the gravel road. This parking area has room for 10 or 12 vehicles.

Starting Point: Parking area as indicated above
Difficulty Rating: 2
Distance: 5 Miles
Elevation Gain: 640 Feet

Comments: This hike will introduce you to the area of Cottonwood Valley south of Highway 160. The trails located here are available to both hikers and mountain bikers, and the bike riders have precedence when it comes to right-of-way, so be aware of their potential presence on the trails as you are hiking. The basic hike I have described here is a loop; however, the last half on the hike is completely on a gravel road and many people dislike hiking on that kind of surface. Therefore, a good alternative to the loop hike is an out-and-back hike through the canyon that you enter at the beginning of the hike. If you choose to do this as an out-and-back hike, the distance will be about 4 miles.

Hike Description: Begin the hike at the south end of the small parking area by going south (away from Highway 160) on the trail that crosses the parking area. In the first 1/8th mile of the hike, the trail starts off angling away from the gravel road, bends to the right and almost intersects the road, and then bends to the left at a spot with a rock border indicating the second bend. The trail crosses a gravel-filled wash and soon enters a shallow canyon. At this point the trail begins a gradual climb that continues until it clears the back ridge of the canyon in about two miles.

The trail generally stays just to the right of the bottom of the canyon. At about ½ mile into the hike, you can look to the left about 20 feet and see where the drainage for the canyon has cut through the rock and there are six-foot walls on either side of the drainage. As you continue up the canyon heading south, the terrain begins to block your view of Highway 160 to the rear, giving you more of a sense of isolation on the hike. Through this stretch, you have been hiking on a section of a bike trail known as Deadhorse Loop.

Near the one-mile point of the hike, you come to a trail junction. The trail to the left climbs a hill over a series of switchbacks and brings you to a high spot on the trail known as Badger Pass (see next hike description). Although not part of the hike I am describing here, the Badger Pass Loop trail that is accessed at the pass is quite scenic and should be one of your next hikes.

To continue with the South Cottonwood Valley hike, stay to the right at the trail intersection. The trail maintains its gradual climb rate and its southerly direction. As you take water breaks on this part of the hike into the canyon, look back to the north for some excellent views of the upper part of Red Rock Canyon and the La Madre Mountains in the background.

Near the 2-mile mark of the hike, the ridgeline on the right that gave definition to the canyon reaches a high spot with some rock outcrop-

pings and ends suddenly. Just past 2 miles, the trail climbs out of the canyon into a broad, generally level area. There is an old signboard at this location with a trail map that allows you to review your progress. Be aware, however, that this is an old map and some of the trail names have been changed since the signs were installed. If you want to make this an out-and-back hike, this is the best spot to turn around and retrace your steps. The scenery on your return will be better than if you complete the loop portion of the hike and you will cut about one mile off your total distance.

To complete the loop, continue south on the trail for another 800 feet until it intersects a gravel road crossing at an angle in front of you. Turn slightly right on the road and continue for another 850 feet until you get to a T-intersection with another more defined gravel road. The road going to the left eventually brings you to the town of Goodsprings, from which you could access I-15 at Jean via a paved road. To complete the hike, take a right on the road, heading west. In a very short distance, the road bends to the right, heading north. Cottonwood Pass, at 4,922 feet the highest point on the road, is directly in front of you. Continue north on the road for an additional 2 miles to return to your vehicle and the end of the hike. One of the visual highlights on your return via the road is an unobstructed view of the top section of Mount Charleston. Based on the time of year that is best for this hike, you will probably see the peak completely snow-covered.

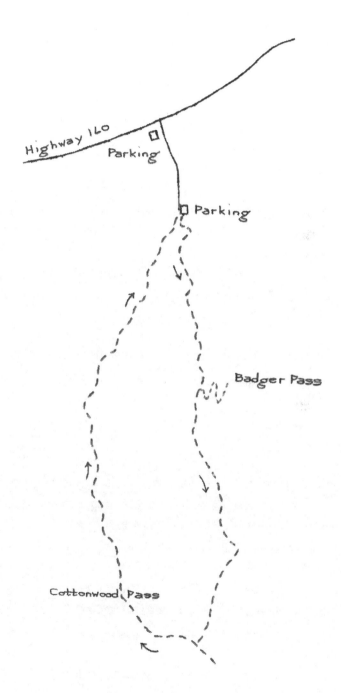

BADGER PASS

How to Get There: From the west side of Las Vegas, take State Highway 159, the extension of Charleston Boulevard, and go by Red Rock Canyon and the town of Blue Diamond to the intersection with State Highway 160. From the rest of Las Vegas, take I-15 south about 1.3 miles past the junction with I-215 to Highway 160 (Blue Diamond Road) and go west on Highway 160 about 10.8 miles to the intersection with Highway 159. From the intersection, continue west on Highway 160 for 6.1 miles to a gravel road that goes to the left (south). Turn into the first gravel parking area less than 1/10th mile off the highway. There is room for more than two dozen cars in this parking area, along with rustic restroom facilities.

Starting Point: Signboard with old trail map on north corner of park-
ing area
Difficulty Rating: 2
Distance: 5.3 Miles
Elevation Gain: 450 Feet

Comments: The hike route I have described here covers the middle distance for hikes accessing the Badger Pass Loop, a combination hiking and mountain biking trail. The short version, which covers a distance of 3 miles, begins and ends near the upper parking area used as the beginning point for the previous hike, South Cottonwood Valley. The longer version, traveling a distance of about 6 ¼ miles, begins and ends at the Late Night/Old Spanish Road trailhead on the north side of Highway 160 about 1 ¼ miles closer to Las Vegas than the trailhead used for the hike described here. The highest point of the trail provides an excellent panoramic view of Mount Potosi to the west, the Bird Spring Range to the east, and the Red Rock Canyon area to the north.

Hike Description: The hike starts at the north corner of the parking area by the signboard with the old trail map. Go back out onto the gravel road a distance of 250 feet toward Highway 160 and look for the trail crossing in the vicinity of the cattle guard barrier on the gravel road. Take the unmarked trail, known as the New 33 Trail, to the left, heading southwest. Continue straight for about 1/6th mile, where you will encounter a trail intersection with a triangular, rock-bordered area in the center. Turn left at this point. Even though there are no trail signs, you have just turned onto the Deadhorse Loop hiking and biking trail.

Slightly more than ½ mile from the start of your hike, the trail drops through a wash with a fairly steep climb out of the wash followed by a more gradual climb to a slight ridge. About ¼ mile beyond the wash, take a left at the next rock-bordered junction, heading northeast, with the upper parking area in view. The trail becomes an old jeep track and makes a few significant turns as it drops down a slight hill and meets an old abandoned gravel road 1.15 miles into the hike. Continue for another 1/10th mile until you intersect the main gravel road just north of the upper parking area. Cross the road, looking for a trail continuation slightly to your left. Do not head toward the parking area. Follow this trail around several bends for another 1/10th mile, crossing a wash, until you come to a T-intersection near the base of a rocky hill.

Turn right at the T-intersection. You are now on the Badger Pass Loop, and it is identified on the signage with a yellow trail indicator. In just 20 feet, turn left at the next trail junction rather than going to the right toward the parking area. As you come through this part of the trail, the parking area will be on your right and the hill on your left will have some small cliffs that show evidence of significant crumbling.

In a short distance, the trail begins to climb along the side of a slight ridge with a minor drainage on your right. At the top of the slight ridge, the trail turns left and ascends through another minor drainage. After two switchbacks bring you out of the drainage, the climb rate increases

and runs for more than one-half mile as it traverses to the east side of the ridge, reaches a saddle, and makes a short, steep climb over loose rock to the top of the ridge. From here, you can look down and see the Deadhorse Trail running through the canyon on your right with Mount Potosi in the far background. On your left is a group of mountains topping 5,300 feet known as the Bird Spring Range. From the top of the ridge, it is slightly more than ¼ mile with a descent of nearly 100 feet to the trail junction known as Badger Pass. At Badger Pass, you have hiked a distance of 2.5 miles.

Turn left at the pass, heading east, and descend into the canyon with the Bird Spring Range on the other side. As the trail turns north, the high ridge that you approached Badger Pass from is on your left, and you can see minor cliffs just below the top of the ridge. Straight ahead, you get an excellent view of the escarpment in Red Rock. The canyon you are in starts off fairly broad, but as you pass around a rocky promontory on your left, the canyon narrows considerably. In this section, the trail crosses the drainage twice, and you have to deal with loose gravel and rocks. The canyon empties into the lower plain, and 3.75 miles into the hike you come to a trail junction.

If you had opted for the shorter 3-mile loop hike, you would want to take a sharp left at this junction and return to the upper parking area. If not, you will continue straight ahead. About 250 feet further on your current trail, another junction is encountered. The trail to the right takes you to the Late Night/Old Spanish Road trailhead about 1.5 miles away. Assuming you are doing the basic hike described here, take the left fork, following the yellow trail indicator sign. In slightly more than 1/10th mile, the trail drops into a major wash and crosses it. Continue up the far side of the wash. As you approach Highway 160, the trail bends to the right for a short distance and then encounters the New 33 Trail, which at this point is an old jeep track running parallel to an upright power line and the highway. There is no descriptive sign at this junction identifying the trail but there is a metal trail indicator sign.

Take a left on the jeep track trail, heading to the southwest. In 0.3 miles, the trail crosses the gravel road near the point where you started your hike. Turn left on the gravel road and return to the signboard marking the starting point about 250 feet away.

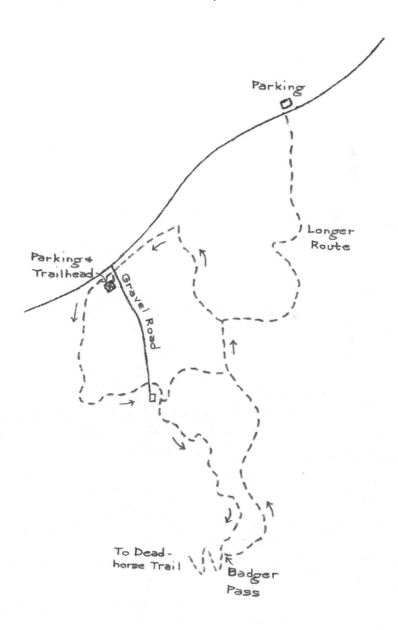

FOSSIL RIDGE

How to Get There: Drive one mile past the entrance to the Red Rock Visitor Center heading west on Highway 159. Park in the gravel area on the left side of the road by the "Horseback Riding" sign. The unmarked trailhead is at that location.

Starting Point: Overhead sign for "Horseback Riding" 100 feet off Highway 159

Difficulty Rating: 2

Distance: 2.8 or 3.6 Miles

Elevation Gain: 400 or 600 Feet

Comments: Fossil Ridge, along with all the other hikes on Blue Diamond Hill, is classified as a desert hike. The only trees you will come across in this area are Joshua trees, a member of the yucca family. There are two loop options for this hike, resulting in the different distances listed above. In both cases, the beginning and ending portions of the hikes are the same – you can choose whether to take the shorter middle section or to take the longer section with a few hundred more feet of elevation gain. There are many fossils in the rocks on the ridge, especially in the section above Fossil Canyon. If you spot any, please leave them for the next group of hikers to enjoy. Mountain bikers use this trail quite a bit, and trail rides coming from the stables at the base of the ridge can be seen quite often, especially on morning hikes.

Hike Description: Walk under the "Horseback Riding" sign at the end of the parking area and take an immediate right on the trail with a rock border that proceeds to the south. The trail starts off quite level. The surface condition is mixed dirt and sand that has been somewhat granulated

from all the horse traffic. About 1/3rd mile into the hike, the trail climbs up a slight ridge. There are scattered brown caliche boulders in the area and you will cross some lighter ones on the trail. At the top of the ridge, the trail angles toward the southeast. There is a slightly higher ridge with more caliche boulders on your left. At the far end of the ridge, the trail drops into a slight wash and stays in the wash for a short distance, until it bends back to the right (south) and climbs another ridge, this one about 100 feet high. At the top of the ridge you have hiked about ¾ mile.

The trail becomes level again as it meanders in a south or southeast direction. Slightly short of a mile, you may notice an old sign on the right hand side of the trail that someone has built a rock base around. This is one of the old mining property signs that warned people that the land beyond was private property, but the sign has become so faded that no message is visible any longer. At the one mile point, the trail swings east and points toward a large caliche boulder section on the point of a ridge.

In about 300 feet, you will come to a trail junction where you have to decide what distance you want to make the hike today. If you opt for the 2.8 mile loop, continue straight ahead about 1/5th mile, going around the point of the ridge with the caliche boulders, until you come to another

major trail junction, where you will take a left. The balance of the hike will be described after the next two paragraphs.

If you have decided to do the 3.6 mile loop, take a right at the first trail junction. The trail proceeds toward the southeast as it begins a gradual climb up a fairly long section to the top of a ridge. The steepest part of the Fossil Ridge hike is in this section. As you look around, notice how the barrel cactuses seem to thrive in the climate on Blue Diamond Hill. Their luxuriant appearance will be quite noticeable for the next mile and a half. At the top of the ridge, the gypsum mining operation can be seen to your right front. The top of the ridge also represents the highest point on the hike. Over the next $1/8^{th}$ mile, the trail starts getting closer to the obvious canyon that now lies on your left. Disregard two faint trails that go off at an angle to the right, staying on the main trail until it reaches a major trail intersection. Take a left at this junction.

The trail continues slightly downhill along the ever-deepening canyon on your right. For the next ⅓ mile, the trail will stay slightly below the top of the ridge on your left, heading toward the northwest. As you continue along, you will notice an area on the ridge to your left that is dominated by large, dark brown caliche boulders and rock formations. At the end of this section of rock is a major trail intersection, with the shorter Fossil Ridge loop trail coming in from the left. At this point, you have hiked slightly more than 2 miles on the longer loop.

Take a right at the junction and make the short climb on the trail to the top edge of the Fossil Canyon wall. The canyon floor will be about 100 feet below you, and will continue to deepen somewhat over the next ½ mile. This section of the trail is littered with rocks up to about one foot in diameter and also crosses several rock outcroppings, so watch your step. You will be traveling in a NNW direction on this part of the trail. The canyon below merges with Cave Canyon and the horse stables can be seen below the ridge you are hiking on.

At a distance of 3 miles (on the longer loop) there is a trail junction. The junction itself is less noticeable than the trail that drops down the side of the ridge toward the stable area. It is slightly shorter to take the trail straight ahead that drops down on the point of the ridge but, for this hike, I suggest taking the trail to the right. Come down the ridge and take a look at the trail riding operation before you continue on. It is a short walk on the gravel road to return to the starting point and your vehicle.

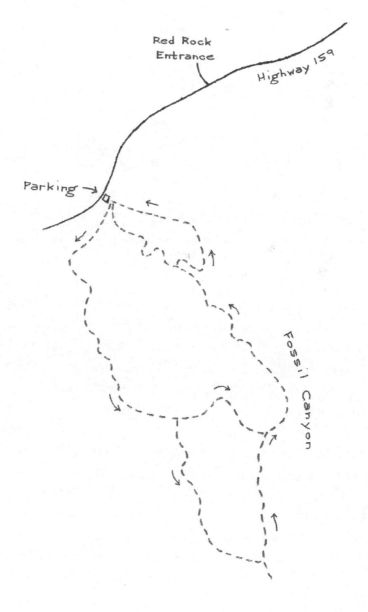

NORTH BLUE DIAMOND RIDGES

How to Get There: Drive one mile past the entrance to the Red Rock Visitor Center heading west on Highway 159. Park in the gravel area on the left side of the road by the "Horseback Riding" sign. The unmarked trailhead is at that location.

Starting Point: Overhead sign for "Horseback Riding" 100 feet off Highway 159

Difficulty Rating: 3

Distance: 6.2 Miles

Elevation Gain: 980 Feet

Comments: This is a truly great but little known hike on the doorstep of Red Rock Canyon. The views of the escarpment, especially from the higher sections of the trail, are about the best to be found in the Red Rock area. The hike route consists of trails on what are known as Skull Ridge and Fossil Ridge. Much of the existing trail was built by mountain bikers looking for a good area to ride relatively close to the Las Vegas metropolitan area. Since the bikers have the right-of-way on these trails, keep an eye out for them, especially on weekends. Also, about one mile of the trail towards the end of the hike is used by the trail rides coming from the stables located at the base of Fossil Ridge. It is not uncommon to see horseback riders on this section of trail in late morning. This hike is a good test of your trail climbing abilities before you tackle the harder hikes in Red Rock and the Spring Mountains.

Hike Description: Begin the hike by walking under the "Horseback Riding" sign and continuing on the gravel road toward the lower horse corral. Go around the corral to the right, picking up a trail at the corner

of the corral and continuing along the fence for a short distance. You will be heading northeast toward the Muffins, a stacked boulder formation you can see on the ridge directly in front of you. Past the corral, the trail crosses a wash, angling slightly left. The trail is very faint as you climb the far bank, but you will immediately come to a well-defined horse trail. Cross the horse trail and take the path that leads slightly to the right at the junction 20 feet beyond. You have now come ¼ mile.

In about 900 feet, the path you are on empties into a main horse trail. Go left at this junction. The Muffins are still in front of you and the ridge you will be climbing is on your right. The trail bends to the right around the ridge and you begin to get a view of a cliff wall at the south end of a canyon called Skull Canyon. As you come around the bend, at a point about ½ mile into the hike, a less-defined trail goes to the right and begins climbing the ridge. Take this trail.

This section of the trail is very steep, climbing 400 feet over a distance of 3/8th mile. This is the toughest climb of the hike, and you are getting it out of the way in the first mile. As you approach what looks to be the top, you encounter a distinctive area of rock outcroppings with several boulders that have broken off, littering the landscape of the ascent. These rock formations are mottled black and gray with some red coloration weaved in, and the rock surface is very jagged and rough. At the top, you are standing on a small plateau. Catch your breath and take in the view before continuing on.

The trail, which becomes faint at times over the next mile, crosses over an isthmus connecting the small plateau you are on with the higher ridge ahead. Skull Canyon is on your left and Cave Canyon is on your right. If you look to the left, you can see a trail climbing up the east side of Skull Canyon. This is part of the Las Vegas Overlook trail, the next hike described in this book. Cave Canyon on the right can be hiked, but there are no trails, so don't attempt to hike in the canyon floor without someone totally familiar with the area.

After crossing the isthmus, the trail begins to climb again. Slightly more than one mile into the hike, the trail approaches some large caliche boulders. Go past the boulders on the right and look for the trail turning to the right over some small rock outcroppings. Continue up the ridge, which levels out after an additional climb of 160 feet, about 1 ¼ miles into the hike. This is the second plateau. Cross the short and narrow isthmus that leads to yet another higher ridge, staying on the trail to the left side of the isthmus. The trail becomes easier to follow as you climb this third ridge, which has a long upward grade with an additional 390 feet of ascent. At 1.85 miles, the trail levels out as you reach the top of this ridge. The landmarks which now become apparent are a radio communications tower to your left, a large slag pile for the gypsum mine straight ahead, and a working area of the mining operation to your right.

At two miles, you encounter a trail junction with a three-cornered intersection and some rock borders. Veer to the right, staying level on

the ridge. In another ¼ mile, stay right at the next trail junction, not gaining any elevation. The trail to the left goes up to the tower you have been seeing for several minutes. As the hillside to the right begins to diminish, you will get some views down into sections of Cave Canyon. Also to the right you should see a bare dirt area toward the top of the canyon about 200 feet below with several trails leading into it. The trail that you are on takes you to that dirt area, but you will have to hike another 1.2 miles to get there.

In a little more than ¼ mile, the trail crosses the east fork of upper Cave Canyon, which no longer exhibits any cliff walls. As you climb to the top of the next ridge, separating the two upper forks of Cave Canyon, you arrive at the highest point of the hike. As the saying goes, it's all downhill from here. As you descend on the other side of the ridge, the trail bends to the northwest. When you get to the bottom of the drainage area in the east fork, look for the trail continuation about 20 feet to your right. The trail goes around a small ridge and arrives at the dirt spot mentioned in the previous paragraph. You have now hiked 3 ½ miles.

From this junction, take the trail to your left that heads up a shallow wash. It is ¼ mile up this trail to an old abandoned mining road that appears to have been plowed up to keep four-wheelers from getting onto this part of Blue Diamond Hill. On the way up to the road, you will go by two trail intersections marked with cairns. Stay to the left (straight ahead) at both of these intersections. Turn right on the trail as it follows the old mining road. Go about ¼ mile around two 90-degree corners and look for a large stone cairn on your right at the base of a small rise in the road. Take the trail to your right that starts at the cairn.

Almost immediately, you encounter another trail intersection with a rock pile marker. Take the left trail. There are some minor switchbacks as you descend along a slight drainage area, crossing the bottom of the drainage three times. There is a large cairn at the bottom of the third crossing, which is the beginning of Fossil Canyon. For the next ½ mile,

you will be hiking just below the ridgeline of Fossil Ridge as the floor of Fossil Canyon drops away to your right.

In about 1/6th mile you come to a trail junction. The trail going to the left is the approach trail covered in the preceding hike (Fossil Ridge). Stay on the trail to the right, which continues slightly downhill along the canyon. As you continue along, you will notice an area on the ridge to your left that is dominated by large, dark brown caliche boulders and rock formations. At the end of this section of rock, at a distance of 5 miles into the hike, is a major trail intersection. The trail to your left will lead back to the starting point, but it is much more interesting if you take the fork that goes to the right and makes a short steep climb up to the ridgeline.

Having gone to the right, you will now be treated to some awesome views looking down more than 100 feet into Fossil Canyon and across at the sheer walls on the other side of the canyon from your present location. An alternate name for the canyon is Echo Canyon, and you can test its echoing abilities when you get to the section with the vertical cliff walls. The canyon below merges with Cave Canyon and the horse stables can be seen below next to the ridge you are walking on. At shortly before the 6-mile mark, a trail goes down the hill toward the horse stable area where chuck-wagon barbecues are held. One option is to take that trail and return to the parking area by way of the gravel road. It is slightly shorter if you continue straight down the front of the ridge. Although the trail is rocky and steep in some places, you can at least avoid those things that seemed to be dumped by the horses on a trail ride. As you come down the final ridge, the parking area and starting point for your hike is directly in front of you.

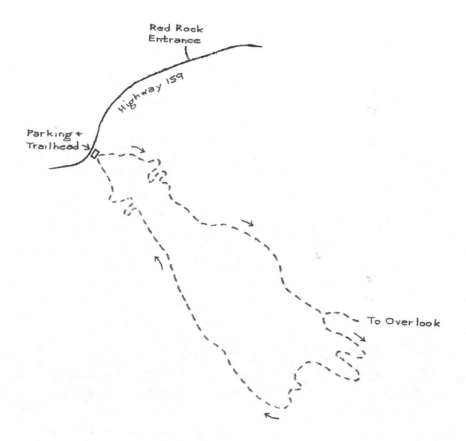

Red Rock
Entrance

Highway 159

Parking +
Trailhead

To Overlook

LAS VEGAS OVERLOOK

How to Get There: Drive one mile past the entrance to the Red Rock Visitor Center heading west on Highway 159. Park in the gravel area on the left side of the road by the "Horseback Riding" sign. The unmarked trailhead is at that location.

Starting Point: Overhead sign for "Horseback Riding" 100 feet off Highway 159

Difficulty Rating: 3

Distance: 6.5 Miles

Elevation Gain: 1,200 Feet

Comments: Of all the desert hikes described in this book, the Las Vegas Overlook is my favorite. The hike route consists of trails that were mostly built by mountain bikers looking for a good area to ride on Blue Diamond Hill relatively close to the Las Vegas metropolitan area. Since bikers have the right-of-way on these trails, keep an eye out for them, especially on weekends. Not many people are aware of this route, so you often can get a sense of solitude on this hike. There is some serious climbing over the first few miles, but the hiker is rewarded during the climb phase with fantastic views of the escarpment on the west side of Red Rock Canyon. Once at the eastern ridge of Blue Diamond, virtually all of Las Vegas is in view, all the way to Lake Mead. Parts of the trail contain quite a bit of loose dirt and small pebbles, so good hiking shoes with grip are a must. The first 2.25 miles of the route follows the same route described in the previous hike (North Blue Diamond Ridges). I hope you enjoy it as much as I do.

Hike Description: Begin the hike by walking under the "Horseback Riding" sign and continuing on the gravel road toward the lower horse

corral. Go around the corral to the right, picking up a trail at the corner of the corral and continuing along the fence for a short distance. You will be heading northeast toward the Muffins, a stacked boulder formation you can see on the ridge directly in front of you. Past the corral, the trail crosses a wash, angling slightly left. The trail is very faint for 30 feet past the wash, but simply climb out and you will immediately see a well-defined horse trail crossing in front of you. Cross the horse trail and look for a path that heads to the east. In about 20 feet, a fainter trail takes off to the right. Follow this fainter trail. You have now hiked about ¼ mile.

In about 900 feet, the path you are on empties into a main horse trail. Go left at this junction. The Muffins are still in front of you and the ridge you will be climbing is on your right. The trail bends to the right around the ridge and you begin to get a view of a cliff wall at the south end of a canyon called Skull Canyon. As you come around the bend, at a point ½ mile into the hike, a less-defined trail goes to the right and begins climbing the ridge. Take this trail.

This section of the trail is very steep, climbing 400 feet over a distance of 3/8th mile. This is the toughest climb of the hike, and you are getting it out of the way in the first mile. As you approach what looks to be the top, you encounter a distinctive area of rock outcroppings with several boulders that have broken off, littering the landscape of the ascent. These rock formations are mottled black and gray with some red coloration weaved in, and the rock surface is very jagged and rough. At the top, you are standing on a small plateau. Catch your breath and take in the first of many great views before continuing on.

The trail, which becomes faint at times over the next mile, crosses over an isthmus connecting the small plateau you are on with the higher ridge ahead. Skull Canyon is on your left and Cave Canyon is on your right. If you look to the left, you can see a trail climbing up the east side of Skull Canyon. This is your return trail on the last downhill leg of this

hike. Cave Canyon on the right can be hiked, but there are no trails, so don't attempt to hike in the canyon floor without someone totally familiar with the area.

After crossing the isthmus, the trail begins to climb again. Slightly more than one mile into the hike, the trail approaches some large caliche boulders. Go past the boulders on the right and look for the trail turning to the right over some small rock outcroppings. Continue up the ridge, which levels out after an additional climb of 160 feet, about 1 ¼ miles into the hike. This is the second plateau. Cross the short and narrow isthmus that leads to yet another higher ridge, staying on the trail to the left side of the isthmus. The trail becomes easier to follow as you climb this third ridge, which has a long upward grade with an additional 390 feet of ascent. At 1.85 miles, the trail levels out as you reach the top of the ridge. The landmarks which now become apparent are a radio communications tower to your left, which is your next short-term destination, a large slag pile for the gypsum mine straight ahead, and a working area of the mining operation to your right.

At two miles, you encounter a trail junction with a three-cornered intersection and some rock borders. Veer to the right, staying level on the ridge. In another ¼ mile you come to another trail junction with a similar intersection. This junction is the point where you will separate from the hike route described previously in North Blue Diamond Ridges. Take the trail to the left (east), which brings you to the previously mentioned radio tower in 0.4 miles.

Continue on the trail past the radio tower, still heading to the east. In about 500 feet, the trail continues on what is now a faint but apparent old jeep track. The trail bends to the left (northeast) and heads toward the high eastern ridge of Blue Diamond Hill. A smaller communications antenna now appears on the ridge. Continue hiking straight toward that antenna. The eastern edge of the ridge is about 30 feet beyond, and is the highest point of the hike. You have now hiked 3 miles, and you

couldn't find a better place to replenish your energies and soak up the view of Las Vegas. If you don't want to sit directly on the rocks, there are a few boards at this spot that people have used for benches to sit and admire the scenery.

After you finish your snack and are ready to move on, go back to the antenna and turn right on the trail that heads to the north between two rock outcroppings. Framed between the outcroppings are a couple of remote peaks behind the community of Calico Basin. Kraft Mountain, with its deep rose color, is the nearest. Behind it you get a view of Gray Cap Peak, which appropriately has a gray cap sitting on top of cream-colored sandstone with the eastern part of the mountain a deep red color. The La Madre Mountains are in the background. As you bend left on a slight climb, two of the larger mountains in the higher Spring Range come into view. These are Griffith Peak on the left and Mummy Mountain on the right. Both of these have elevations in excess of 11,000 feet above sea level, and snow is present on their slopes for about half of the year.

Continue on the trail near the edge of the ridge for about another ½ mile. In this stretch, you will continue to be treated to spectacular views of the Las Vegas valley on your right, the larger peaks of the Spring Mountains to your front, and the cliffs of the escarpment to your left. At the end of that ½ mile, the trail descends over some rock outcroppings to a notch on the ridge that represents the lower Las Vegas Overlook. This will be your last view of the city.

At the notch, the trail bends to the left (west) and drops into a small valley. It then climbs to the top of the ridge on the other side of the valley, with a few switchbacks to ease the climb. A cairn marks the top of the ridge. Cross the ridge on the trail, descending into the drainage below. From this point and for the next two miles, you will be descending in or alongside the drainage of what is called Skull Canyon. The canyon received that name from "Cactus" Jack Ryan, who many years ago found most of a skeleton from a wild burro, including the skull, farther down in the canyon.

At the bottom of the first section of drainage, about 4 miles into the hike, the well-defined trail begins to climb up to a ridge on your left. Look for and turn onto a faint trail that drops down into the drainage on your right, starting out through a grassy area that obscures any definition to the trail. As the trail becomes slightly more defined, it proceeds on the right side of the drainage but soon moves to the center. About 600 feet down from the trail junction, the trail crosses onto the left side of the wash at an area of gray rock and soon returns to the center of the drainage. In about 350 feet, you encounter a 3-foot rock waterfall. The trail, very faint at this point, continues on the left side of the drainage. A couple of switchbacks ease the descent rate, and the trail becomes more defined as it drops to the bottom of the wash and crosses to the right at 4.3 miles.

In about 800 feet, you come to a spot where the drainage you are in converges with another drainage coming in from the left. Turn down

the drainage to the right, looking for a cairn on the left side. Go down the drainage, heading north. For the next ¼ mile, the trail crosses over the middle of the wash several times without deviating very far from the bottom. At the end of that ¼ mile, the trail crosses to the left at a spot with some large boulders and a cairn marking the trail continuation. In about 400 feet, you are back in the center of the drainage, crossing some grayish-blue rock slab formations. After 450 feet of hiking on these rocks, the trail climbs onto the left bank near some large boulders. This is the site at which the burro skeleton was once found that resulted in the name of Skull Canyon.

After another 400 feet, the trail drops back into the center of the drainage onto some more grayish-blue rock slabs, and crosses to the right side. Across the drainage, you may notice several spots where rockslides had occurred at one time. Continue on the right for about 1/6th mile, and drop onto another section of grayish-blue rock slabs. In 15 feet, the trail climbs out on the left, and stays on that side for about 1/8th mile, until it swings back through the drainage over a pile of gravel and crosses to the right. This is the last crossing of the drainage until you get to the bottom of the canyon.

As the trail starts to descend more, about 200 feet beyond the last crossing a trail goes off to the right that goes to an overlook area. The overlook trail climbs a short rise and comes to a dead-end, so take this trail only to catch the view. The main trail continues straight and then goes into a gradual 270-degree arc around a rocky point above you as the descent rate increases. The canyon on your left begins to fall away from you even faster. Take note of the dark-brown cliffs to the left on the other side of the canyon. Just beyond this spot the Red Rock Visitor Center comes into view across Highway 159.

A series of several switchbacks takes you down the side of the hill you are hiking, eventually dropping into the drainage of the spent canyon about 5 ¾ miles into the hike. A cairn marks the spot where a faint trail

continues on the other side, climbing 15 feet through an area of desert grasses. In 100 feet, the faint trail intersects one of the main horse trails for the area. Take a left on the horse trail, walking around the ridge on your left that was your first serious climb on this hike.

As you continue around the ridge bending to your left, you will see the parking area with the large sign that you walked under to start the hike. About ¼ mile after getting onto the horse trail, you will find the faint trail going off to your right that brings you back past the horse corral. Take the trail to the right, heading west through a large grove of Joshua trees. Continue straight on past the horse corral and return to the parking area on the gravel road.

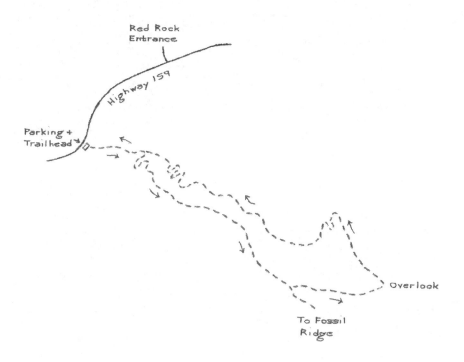

MOUNT CHARLESTON
AREA HIKES

FLETCHER CANYON

How to Get There: Take U. S. Highway 95 north from Las Vegas to State Highway 157. Turn left on Highway 157, proceeding into Kyle Canyon, and continue one-half mile on Highway 157 past the intersection with State Highway 158. The sign indicating Fletcher Trail is on the right side of the highway. There are several pull-off areas on the left side of the road in close proximity to the trailhead. If you pass the Spring Mountain Visitor Center or the sign indicating an elevation of 7,000 feet, you have gone slightly too far.

Starting Point: Marked trailhead sign for Fletcher Trail
Difficulty Rating: 2
Distance: 4 Miles
Elevation Gain: 430 Feet

Comments: Fletcher Canyon is a great place to hike anytime from spring until late autumn, because temperatures are more moderate in this canyon than in the upper reaches of Kyle Canyon. The hike is most impressive when water is flowing in the creek through the canyon, which is early in the hiking season for the Mount Charleston area. Be prepared for the possibility of getting your feet wet when water is flowing, especially in the narrow part of the lower canyon. Under dry conditions, it is fairly easy to negotiate the rock scrambling required to get to Obstacle Rock at the back end of the lower canyon. Take a camera along because the scenery is spectacular.

Hike Description: The hike begins at the Fletcher Trail sign just off State Highway 157. Proceed along the trail, heading in a northerly direction. As you pick up the creek bed on your right about 1/10th mile into the

hike, the trail begins to climb slightly. In another 1/10th mile, the trail crosses the drainage and in a short distance bends left, heading to the northwest. This will be the general direction of the hike until you reach the narrow part of the canyon more than a mile away.

About ½ mile from the start of the hike you "officially" enter the Mount Charleston Wilderness area. A sign marking the wilderness boundary is located alongside the trail at the appropriate spot. In the next 1/5th mile, the trail, which includes sections where the surface consists largely of loose gravel, crosses the drainage on two more occasions. At the ¾ mile mark, a large tree trunk spans the drainage on your left.

About 1.3 miles into the hike, the trail crosses the drainage and begins the first of four short, steep climbs in the next ¼ mile on the southwest side of the drainage. As you reach the top of the second climb, you will notice the walls of the canyon converging, with the tops of the walls less than 200 feet apart. After the third climb the trail bends to the southwest through an area of dense foliage and crosses the drainage twice. Just past the second of these crossings, the trail turns right through an area of loose rock and makes the last of the short climbs. At the end of this climb, the trail drops slightly past a couple of boulders, drops into the drainage, and essentially comes to an end.

At this spot, the canyon walls have narrowed to the point where the canyon is less than 50 feet wide. If you choose to do the last 0.4 miles up to Obstacle Rock, which is normally considered to be the end of the lower canyon, you will be hiking up the streambed and will need to do some minor rock scrambling in dry conditions or some more significant bouldering if much water is flowing down the canyon. In any event, the scenery is worth the effort.

When you first enter the streambed, the canyon bends to the left, heading south for a short distance before taking a 130-degree turn to the right toward the northwest. As the canyon continues to narrow and bend

back and forth you will encounter several tree trunks in the streambed. Some of these have been lodged in their present locations by significant water flowage in the past, demonstrating the power that can be exerted by heavy rainfalls over a short time period in a confined area. A couple of these tree trunks actually serve as ramps in your climb through the canyon.

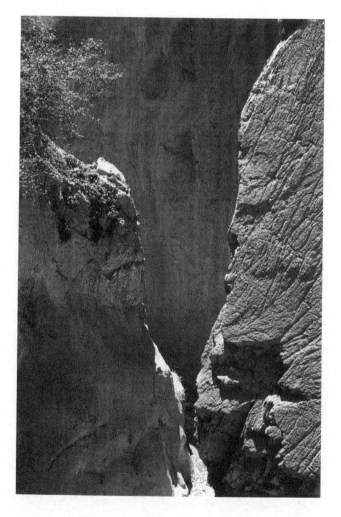

About 0.3 miles into the streambed section, the canyon makes a fairly steep climb over a rocky area of the stream and turns left into the narrowest part of the canyon. From here to the small open area near Obsta-

cle Rock, the canyon walls tower nearly 100 feet above the canyon floor, which is only about five feet wide. The slight color variations within the rock, combined with the contrast of sunshine and shadow in the canyon, result in some fantastic photographic opportunities. Continue through the narrow section to the location where a seasonal waterfall slides down a trough in an 8-foot boulder. The boulder can be climbed on the right side and a more impressive seasonal waterfall can be seen above, dropping about 15 feet on the right side of Obstacle Rock. You have arrived at what I believe is the most scenic spot in the Spring Mountains. Take the time to enjoy the setting and have your snack before you think about heading back down.

To Return: Reverse your direction and return to the trailhead. Even though you will be going downstream on the return, you need to exercise great care in the narrow part of the canyon until you get back to the trail and also on the four short, steep downhill sections of the trail.

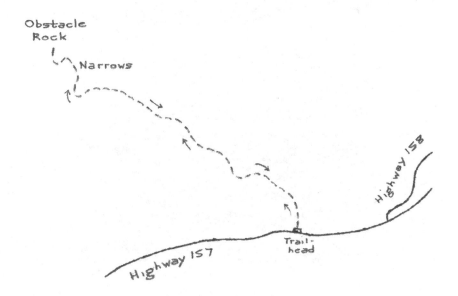

TRAIL CANYON

How to Get There: Take U. S. Highway 95 north from Las Vegas to State Highway 157. Turn left on Highway 157, proceeding west into Kyle Canyon, and drive 20.5 miles to Echo Drive, which goes to the right at the hairpin turn of the highway before it ends at the Charleston Lodge about ½ mile farther on. After turning right on Echo Drive, go about 0.6 miles, or 0.1 miles past the gravel road to Mary Jane Falls (see next hike). The trailhead is located on the left side of the road at a sharp bend to the right. There is off-road parking for about six to eight vehicles at the trailhead. Unless posted, parking along the road near the trailhead is allowed.

Starting Point: Signed trailhead on left (north) side of road
Difficulty Rating: 3
Distance: 4.3 Miles
Elevation Gain: 1,500 Feet

Comments: The Trail Canyon trail is often thought of as a connector route that feeds into the North Loop Trail, providing the shortest one-way distance by trail to the peak of Mount Charleston. By taking the North Loop Trail east at the junction, one can hike to Raintree, a 3,000 year old bristlecone pine, about 1 ½ miles farther with an additional 600 feet of climb. A third option from the junction is to turn south and head out onto Cockscomb Ridge, a short but difficult out-and-back hike that requires climbing around rock formations on steep and loose sections of trail. On its own, Trail Canyon trail provides a steady climb over reasonably steep terrain in a relatively short distance. Although most of the hike is in the pine and aspen forests, there are some surprisingly good views of the surrounding mountains in the last 1/3rd of the hike.

Hike Description: The Trail Canyon trail begins at the information kiosk just beyond some boulders on the north side of Echo Drive. Proceeding around the boulders, the trail starts to the north, the general direction for the entire climb portion of the hike. The initial climb rate is fairly moderate and the trail surface consists of dirt with many sections containing loose gravel. Almost immediately, rocky cliff walls begin to rise on the left across the drainage for the canyon, while a steep dirt slope rises on the right toward the higher cliffs on that side. Shortly after the hike begins, the trail passes through an open meadow with only small foliage before entering the heavier forested area that mainly surrounds the trail for the rest of the hike.

Slightly past ¼ mile, a pine tree on the left exhibits a deep lightning scar running from the ground upward for about 15 or 20 feet. The tree is still alive, however, and its branches are filled with pine needles above the scar. In another 1/8th mile, you encounter a Mount Charleston Wilderness sign on the right side of the trail. At about 2/3rd mile, the trail crosses the drainage and the climb rate increases as it continues north with only a few minor bends. Around 4/5th mile into the hike, the cliffs on the left, which have been relatively close to the trail, pull away and the canyon opens up into a much wider area. Directly to the right and up on the horizon is the highest point of Cockscomb Ridge.

The trail maintains its relatively straight heading to the north for an additional ½ mile. At 1.3 miles into the hike, you finally arrive at a few significant bends that indicate the start of a series of more than a dozen switchbacks taking the trail the rest of the way to the top of a saddle. Several of the downhill sides of the trail through the switchbacks have been retained by logs to provide an element of erosion control, since this trail is subject to runoff damage during periods of heavy rain. Also, note the number of tree trunks in the vicinity of the trail that are charred from past lightning strikes.

As you continue through the switchback section, the trail climbs high enough relative to the ridge on your left that once again you are able to see the peak of Mount Charleston to the west. These views improve as the trail continues to gain elevation, especially around the 1.8-mile mark. Beyond this point, the trees begin to thin slightly and the view upward toward the North Loop ridge improves. A large area toward the ridgeline shows signs of an old forest fire. The remains of several burned pine trees stand as sentinels among the sea of aspen that has taken seed and grown since the fire, now dominating the area. In the vicinity of the trail, you will see occasional bristlecone pines, since you have climbed above 9,000 feet elevation.

At the top of the saddle, Trail Canyon trail passes between two old tree trunks that are showing significant evidence of decomposition and ends at the North Loop Trail. You have come a distance of slightly more than two miles from the trailhead. As you sit on one of the logs and have a snack, look around at the peaks dominating the horizon. Mummy Mountain takes in about 90 degrees of sweep directly to the north, with the smaller toe section on the right. To the east lies Fletcher Peak, behind a few trees. Cockscomb Ridge runs to the south and hides any potential view of Griffith Peak. Mount Charleston is clearly visible to the west. Also impressive are the lower cliffs across Kyle Canyon below the ridge that runs from Griffith Peak to Mount Charleston.

To Return: Reverse your direction and return down the trail to the trailhead. About ½ mile into the return you will be treated to a great view of Griffith Peak to the south. You may have seen this on your way up the trail, but you probably had your back turned to it as you worked your way up the switchbacks.

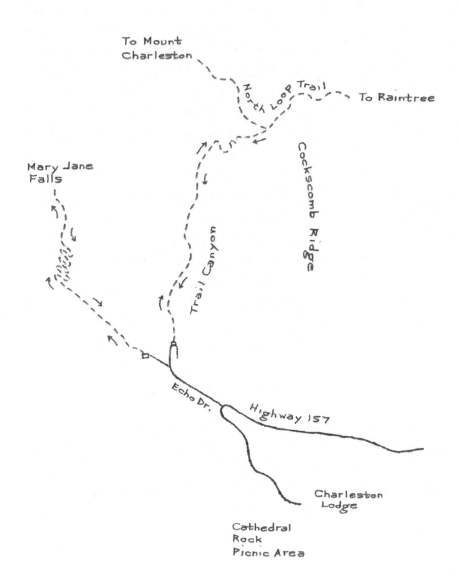

To Mount
Charleston

North Loop Trail

To Raintree

Mary Jane
Falls

Cockscomb Ridge

Trail Canyon

Echo Dr.

Highway 157

Charleston
Lodge

Cathedral
Rock
Picnic Area

MARY JANE FALLS

How to Get There: Take U. S. Highway 95 north from Las Vegas to State Highway 157. Turn left on Highway 157, proceeding west into Kyle Canyon, and drive 20.5 miles to Echo Drive, which goes to the right at the hairpin turn of the highway before it ends at the Charleston Lodge about ½ mile farther on. After turning right on Echo Drive, go about ½ mile to a dirt road on the left with a sign indicating the direction to Mary Jane Falls. Turn left on the gravel road and proceed about 1/5th mile to the parking area, which has room for about 30 vehicles.

Starting Point: Signed trailhead at northwest corner of parking area
Difficulty Rating: 3
Distance: 3 Miles
Elevation Gain: 920 Feet

Comments: Mary Jane Falls is one of the most popular hikes in the Charleston area in May and June because its exposure to the sun provides for good trail conditions, free from snow, earlier than most of the other trails in the area. If winter snowfall amounts on the north ridge to Mount Charleston have been heavy, water will cascade down over four separate sections of the falls, which are about 100 feet in height. Swirling breezes at the base of the cliff wall will sometimes disperse the water into a fine mist. Although the elevation gain on this trail results in a level 3 rating, the hike generally seems easier than that because of the excellent trail conditions, use of switchbacks to ease the climb rate, and shorter distance.

Hike Description: The trail starts off with a very gradual elevation gain as it heads WNW and follows a slight drainage through the red pine for-

ests of the lower areas below Mount Charleston. The trail surface consists of dirt and gravel with some occasional small imbedded rocks. There are several sections of rock border and some minor rock steps in the early part of the hike.

About 3/4 mile from the trailhead there is a blank signboard near the trail, and just 75 feet beyond is the first of a dozen switchbacks that take you up to the waterfall. In the area between the signboard and the switchback several faint trails go off to the left, continuing to parallel a significant drainage that has been on your left through the first part of the hike. These trails come together and run for about ¼ mile to the base of the drainage coming from Big Falls, on the other side of the canyon from Mary Jane Falls. If you are into off-trail hikes up creek beds, Big Falls is an excellent test of your rock-scrambling abilities. Because of the dangers involved when running water is combined with significant snow depths, do not attempt Big Falls until the channel is clear of snow.

To get to Mary Jane Falls, continue on the main trail around the first switchback going to the right. As you continue climbing over the switchbacks, you will notice several large sawed sections of tree trunks along

the sides of the trail. These tree trunks had fallen onto the trail at some points in the past and needed to be cut to unblock the trail and allow for access to the falls. Also, several of the corners of the switchbacks have rocky sections that form stone steps.

About 1.2 miles into the hike, you will pass a signboard advising you to stay on trail and not cut any switchbacks. In less than 200 feet, as you arrive at the last switchback, a faint spur trail heads to the right to the base of a cliff that provides an excellent view of the top section of Kyle Canyon. Be careful if you take this trail, as it is steep and contains a lot of loose rock. As the main trail continues on toward the waterfall, after another 1/5th mile look across Kyle Canyon to the southwest for a great view of Big Falls and the short canyon that carries the drainage of the creek from the bottom of that falls. A long flight of stone steps brings you up to the level directly below the base of Mary Jane Falls. Take in the spectacle as you take a break and replenish your energies.

About 500 feet beyond the base of the waterfall is an interesting cave that can be accessed by a faint trail along the base of the cliff to the left of the falls. The hike to the cave involves dropping about 35 feet in elevation as you go along the cliff wall and climbing up to the cave through a rocky approach. There is a great photographic opportunity inside the cave that catches the cave's slanting roof, with a very scenic view of Kyle Canyon in the background. Use care in getting to and returning from the cave, as the ground is quite rocky and uneven in several spots.

To Return: Reverse your direction and return along the route you took to climb to the waterfall. A rock border turns you to the left when you come down through the last switchback. From there, it is an easy 3/4 mile back to the parking area.

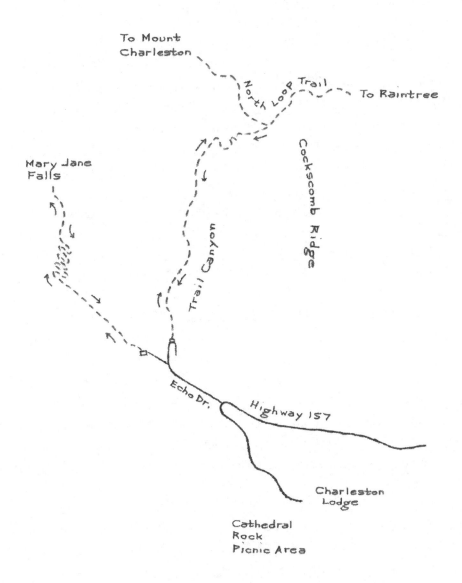

CATHEDRAL ROCK

How to Get There: Take U. S. Highway 95 north from Las Vegas to State Highway 157. Turn left on Highway 157, heading west into Kyle Canyon, and drive 20.9 miles to the public parking trailhead for Cathedral Rock, located on the right side of the highway. This parking area has spaces for 12 cars. There are restroom facilities at the south end of the parking area. If the lot is full, there is additional parking and another trailhead inside the Cathedral Rock National Recreation Picnic Area on the right a few hundred feet beyond the first trailhead. There is a charge for each vehicle entering the picnic area. It is recommended that you do not park on the shoulder of the highway, as this is a posted offense and there is an aggressive policy for ticketing violators. For the best chance of parking free, plan this hike for early in the day.

Starting Point: Bottom of stairway at the center of the public parking area. An informational kiosk near the restroom facilities provides a map and additional information.

Difficulty Rating: 3

Distance: 3 Miles

Elevation Gain: 950 Feet

Comments: The trail for this hike crosses an avalanche chute in Mazie Canyon, which stretches from Cathedral Rock south to the Echo Cliffs. During the winter before this book was written, an extremely large avalanche rumbled through this area, causing extensive damage to the aspen forest in the immediate vicinity and also depositing a considerable amount of debris from the higher pine forests. While the level of damage was highly unusual, it is normal to have at least minor avalanches in this area. Check with the U. S. Forest Service at the Mount Charleston Visi-

tor Center to find out if the trail is open if you are planning on hiking this trail in early spring following a heavy snow season.

Hike Description: Begin the hike by climbing the stairway located near the middle of the parking area. At the top of the stairs, turn left as indicated by the sign. The trail, which consists mainly of a dirt surface, with occasional rocks and tree roots as minor obstacles, begins to climb almost immediately as it heads toward the southeast. Near 1/5th mile into the hike, the trail becomes much steeper for a short distance and passes a large, partially decaying tree trunk on the left side of the trail. Near the ¼ mile point, there are two switchbacks that continue the climb toward the base of the cliff that is the front edge of Cathedral Rock. As you straighten out from the second switchback, you will be heading south.

In a short distance, you will intersect the trail coming from the alternate trailhead located in the picnic area as it makes a sharp bend to the left. Continue straight ahead at this point. There is a rock border in the vicinity of this junction. Take a good look at this junction from the other side, as it is easy to miss on the return trip.

Once you get past the junction of the two main trails, the surface condition changes to predominantly small gravel, with several sections that have larger rock borders. The trail makes several sharps turns, varying in direction from south to west, as it climbs through the aspen forest area. About 0.8 miles into the hike, the trail makes a sharp right turn in the vicinity of a spring. There is a short side trail that leads toward the spring and the seasonal waterfall that carries runoff down from the Echo Cliffs. During the early part of the year, this waterfall can be quite impressive.

Past the area of the waterfall, the trail takes a few more sharp bends as it heads across Mazie Canyon. This part of the hike includes a section of stone steps as you continue to gain elevation. About one mile into the hike, the trail joins an old abandoned road and bends to the right, heading north. The road section continues to climb slightly for about

132

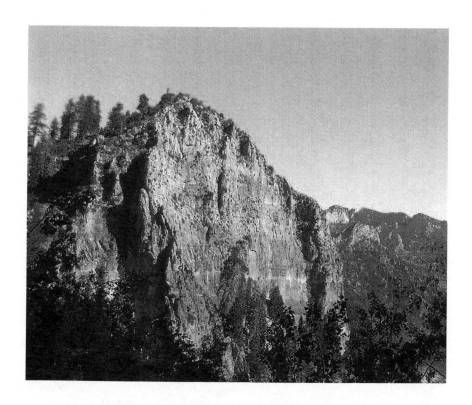

¼ mile, arriving at a point where a narrower trail goes to the right at a signpost and runs down a slight slope to a saddle on the west side of Cathedral Rock. An interesting side hike is to continue on the road trail for about 1/3rd mile to a spring and waterfall in the canyon above Little Falls. The road comes to an end at that point and you must retrace your steps to return.

To get to the top of Cathedral Rock, take the narrower trail to the right, crossing the saddle. The trail begins the final ascent to the top, going over several rock outcroppings and about five switchbacks as it makes the climb. There is a steep climb following the third switchback, and the fourth one is located in the middle of a rocky area with stone steps. As you come out on top, you are rewarded with an exceptional view down the entire length of Kyle Canyon, as well as excellent views of the major peaks surrounding your location. The area on top is fairly large, but if you brought any children along, maintain a watchful eye as there are

dangerous cliffs on three sides. You should plan on spending at least 15 minutes at the top admiring the scenery and having a snack.

To Return: Reverse your direction and return to the trailhead. Under normal circumstances, the only spot where your direction may not be clear is where the trail branches off that heads toward the picnic grounds. If you are returning to the public parking area, stay left (straight) at this junction.

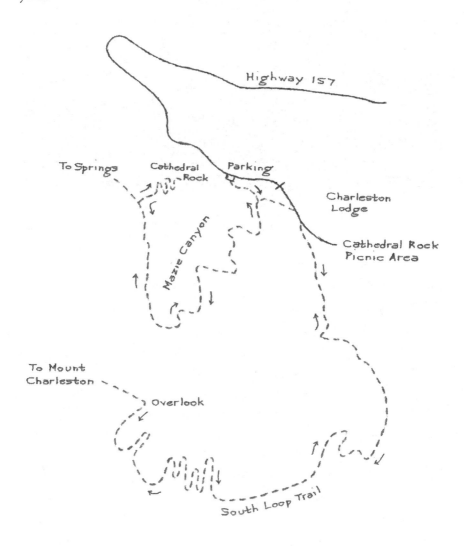

SOUTH LOOP OVERLOOK

How to Get There: Take U. S. Highway 95 north from Las Vegas to State Highway 157. Turn left on Highway 157, heading west into Kyle Canyon, and drive 20.9 miles to the public parking trailhead for Cathedral Rock, located on the right side of the highway. This parking area has spaces for 12 cars. There are restroom facilities at the south end of the parking area. If the lot is full, there is additional parking inside the Cathedral Rock National Recreation Picnic Area on the right a few hundred feet beyond the public parking area. There is a charge for each vehicle entering the picnic area. It is recommended that you do not park on the shoulder of the highway, as this is a posted offence and there is an aggressive policy for ticketing offenders. For the best chance of parking free, plan this hike for early in the day. The official trailhead for the South Loop Trail is located within the picnic area less than 100 feet from the alternate trailhead for Cathedral Rock.

Starting Point: Parking area outside picnic area for Cathedral Rock
Difficulty Rating: 3
Distance: 4.8 Miles
Elevation Gain: 1,425 Feet

Comments: The South Loop Overlook hike provides an excellent opportunity to test your climbing abilities and stamina in the higher sections of the Spring Mountains. The full trail climbs to a saddle between Griffith Peak and Mount Charleston, then turns north and climbs to the peak of Mount Charleston. The lower section of the trail crosses an avalanche chute in Echo Canyon twice before climbing a series of switchbacks to the top of the overlook. A large avalanche and the high winds that occurred during the winter prior to the writing of this book

caused extensive damage along sections of this trail. Check with the U. S. Forest Service at the Mount Charleston Visitor Center to find out if the trail is open if you are planning on hiking this trail in early spring following a heavy snow season. Most references to total distance for this hike are measured from the Cathedral Rock parking area, not the South Loop trailhead.

Hike Description: From the public parking area for Cathedral Rock, begin by walking about 1/8th mile up the paved road to the Cathedral Rock Picnic Area and turning right onto the main paved road for the picnic area. On the other side of the road near the start is a sign listing the elevation as 7,650 feet. Continue on the picnic service road just past the alternate trailhead for Cathedral Rock to the kiosk that represents the trailhead for the South Loop Trail. This is a distance of 3/8th mile from your starting point, leaving a distance of two miles to the over-look.

The trail begins reasonably steep as it generally heads in a southerly direction and pulls away from the picnic area service road. It continues to meander through the pine forest as it gains elevation, crosses some rocky areas, and makes a sharp bend to the left at a minor drainage area about ¾ mile into the hike. At 0.9 miles, the trail crosses Echo Canyon near the bottom of what is considered the avalanche zone.

It then heads east for a short distance along an open part of a ridge that provides views back into the heart of Kyle Canyon. This part of the hike runs through a section of forest dominated by aspen trees, which can resist the forces of an avalanche better than the bigger and more brittle pine trees.

The trail continues around several sharp bends and about 1.2 miles into the hike makes a right turn just before arriving at a section of trail that utilizes a stone and log stairway. The steepest part of the hike begins below the stairway and lasts for about ¼ mile as it climbs along the north

side of one of the Echo Cliffs. Exercise caution on this stretch, as there is a considerable amount of loose rock on or near the trail. As the climb rate moderates, the trail comes close to the cliffs and advances toward a sharp bend to the right at the edge of the avalanche zone of the canyon. If you look up to the left, you will see a small cave about 20 feet up into the cliff. This cave, about 12 feet deep, can be reached from the area of the sharp bend or from slightly higher on the trail, as indicated in the next paragraph. Although the distance to the cave is very short, you will need some technical scrambling abilities to reach it. The view from inside the cave is quite interesting.

As you cross the avalanche zone, you are approaching a series of 14 switchbacks, over a distance of more than one-half mile, that will take you up to the overlook area. To this point, you have gained about 900 feet of elevation and will gain another 500 in the switchback section. At the point of the second switchback, a faint trail leads across to the cave. This approach is trickier to negotiate than an alternate approach at the point of the sixth switchback. If you want to visit the cave, I suggest you do so utilizing the latter approach on your way down and continuing straight down to the trail from the cave.

At the seventh switchback, look down at a flat rock on the inside of the turn. This 2-foot long rock is loaded with seabed fossils from the days when low inland seas dominated the area, prior to the geologic activity that caused the mountains to uplift. Normally, the rock gets slightly coated with dirt, but a sprinkling of water on the rock will help you to see the fossils much better. Up until the eighth switchback, the steep hillside has exhibited rather sparse vegetation. Past the eighth switchback, you find yourself back in the heavy pine forest area that surrounds the trail for most of its remaining climb up to the saddle on the South Loop ridge. Through this remaining section of switchbacks, until you arrive at the overlook, you will see considerable evidence of past winter storms as logs and tree trunks that had blocked the trail were cut through and pushed to the edge of the trail.

From the last switchback, it is slightly more than 1/5th mile to the overlook. At the overlook, you have arrived at an elevation of 9,075 feet above sea level. A red metal stake indicates the 2-mile mark of the trail, measured from the South Loop Trailhead inside the picnic area.

The long section of Kyle Canyon stretches out before you to the ENE, with Gass Peak across the main valley north of Las Vegas. Following the panoramic view around in a circle to your right, Harris Peak lies to the east, Griffith Peak to the south, the very top of Mount Charleston to the WNW, Mummy Mountain generally to the north, and Fletcher Peak just to its right, also in a northerly direction. The top of Cathedral Rock (see previous hike description) is to the Northwest about 500 feet lower in elevation than your current position. This full panoramic view is perhaps the best mid-level view in Kyle Canyon, because every one of the major peaks is visible. Soak in the view and have a snack before heading down.

To Return: Reverse your direction and return to the starting point. The trail is well marked and easy to follow.

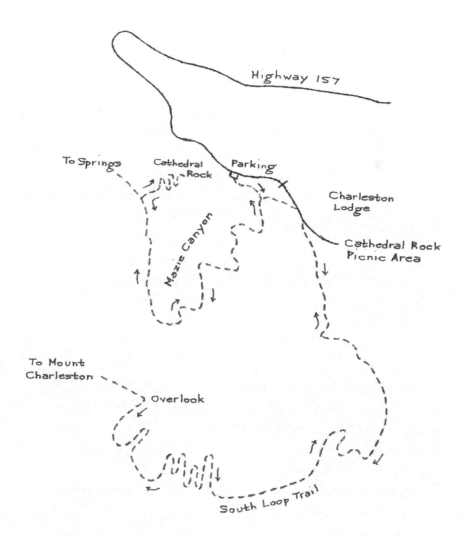

RAINTREE

How to Get There: Take U. S. Highway 95 north from Las Vegas to State Highway 157. Turn left on Highway 157, heading west into Kyle Canyon, and drive 18 miles to the intersection with State Highway 158. Turn right on Highway 158 and drive 4.9 miles to the North Loop Trailhead. This trailhead is located at the high point of Highway 158 just before the sign that indicates an elevation of 8,437 feet. There is a small parking area on the left side of the road at the trailhead with room for about 12 or 15 cars. The nearest restroom facilities are located at the Spring Mountain Visitor Center on Highway 157 about one-half mile beyond the intersection with Highway 158.

Starting Point: Marked trailhead for North Loop Trail
Difficulty Rating: 3
Distance: 6 Miles
Elevation Gain: 1,500 Feet

Comments: The Raintree is the oldest living bristlecone pine in the Spring Mountains. Although they have declined to core date the tree for fear of causing damage, experts have estimated the tree to be at least 3,000 years old. It is located along the North Loop Trail, a hiking trail that runs west from Highway 158 to the top of Mount Charleston. Raintree is located three miles from that trailhead. The hike is described here as an out-and-back route.

Hike Description: Begin the hike from the trailhead along the parking area by passing the information kiosk that is located about 20 feet up the trail from the center of the parking area. The trail makes a short initial climb as it heads to the west at a slight angle away from the highway. Just

before the trail turns left, you should be able to spot the green elevation marker indicating the highest point for the highway at 8,437 feet elevation. The trail then meanders through the forest for a short distance without gaining any significant elevation. This part of trail even includes a few short downhill sections.

About 0.3 miles into the hike, the serious part of the climb begins with a noticeable uphill section. You now encounter a few switchbacks and several other wider turns as the predominant direction for the hike turns toward the south and continues to climb. As you hike through this section of trail up to a meadows area more than a mile ahead, take note of the extensive work that has been done on this trail, including a nearly continuous rock and log border and a dirt surface that almost looks as though it has been manicured. Juveniles from the Spring Mountain Youth Camp, a facility that represents many young offenders' last chance before prison, spend the summer months doing restoration work on the trails in the higher mountains. The fantastic condition of the trails you will probably hike during the summer is the result of their efforts. If you happen to see their work groups on your hikes, make sure that you express your gratitude for the great service they perform for our benefit.

As you climb past the one-mile point of the hike, openings in the trees will allow you to look east toward a radar dome site on the peak across the way. The youth camp facilities are located on the same peak, just below the radar dome.

Near 1.2 miles, you encounter a few more switchbacks in quick succession, followed by several wider bends as the trail turns toward the west and the climb rate becomes steeper. Just past 1.5 miles into the hike, the trail climbs to the point of a rocky ridge that has significantly less vegetation than the lower portion of the trail. From the point of the ridge, you can see a large part of the northern section of the Las Vegas metropolitan area, with the Stratosphere visible in a notch of a low mountain in an ESE direction. In the background, on a clear day, you may be able to see a part of Lake Mead. The higher mountains in the background are across the state line in Arizona. If you turn and look to the south, a mountain with a double peak can be seen to the left of another apparent, and much closer, peak. The distant mountain is Fletcher Peak and what appears to be a peak to its right is not much more than a high spot on the ridge. The vicinity of that high spot is your next destination.

From the rocky point of the ridge, the trail passes through an open space, sometimes referred to as a meadows area, and turns southwest. As you exit the meadows area, the trail becomes very steep. About 1.85 miles into the hike, you arrive at the first of a series of twelve switchbacks that bring you up to a saddle just below the high point on the ridge that you viewed earlier. There is a distance of nearly ½ mile between the first and the last switchbacks. As you go through this switchback section, you will encounter several old tree trunks that had fallen in years past in the vicinity of the trail. Past the last switchback, the trail heads in a southeast direction to the saddle. This is the highest point of the hike, with an elevation of slightly more than 10,000 feet elevation.

The trail turns right (southwest) and proceeds slightly downhill in a few stretches. One-quarter mile from the saddle, the trail passes two old tree trunks that had blocked the trail at one time and needed to be sectioned and pushed off to the side. At the second of these sawn tree trunks, a faint trail goes off to the left at a 135-degree angle across a log and heads toward Fletcher Peak, nearly one mile away. This is probably the easiest of the major peaks in Kyle Canyon to climb, but the route, using intermittent minor trails, is not easy to follow. Several organizations, including the Red Rock Canyon Interpretive Association, offer guided hikes to the top of the peak. If you are interested in advancing your hiking abilities, climbing Fletcher Peak is one of the places you should consider as a first step.

Raintree is just ¼ mile ahead on the North Loop Trail. As you approach the tree from slightly above on the trail, the wide main trunk and the extensive root system become the focal point of your view. Raintree also has a subsidiary trunk immediately behind the primary one that, by itself, is larger than most of the other bristlecones in the area. To the south of the tree is a logged-off courtyard where you can sit and have some refreshments before beginning the return journey. From the vicinity of the tree, the North Loop Trail continues its course to the west toward Mount Charleston.

To Return: Reverse your direction and return to the trailhead. This is perhaps the best-maintained trail in the Spring Mountains and is very easy to follow. This is a great opportunity to experience a long, fairly steep downhill hike with excellent conditions providing the maximum in safety.

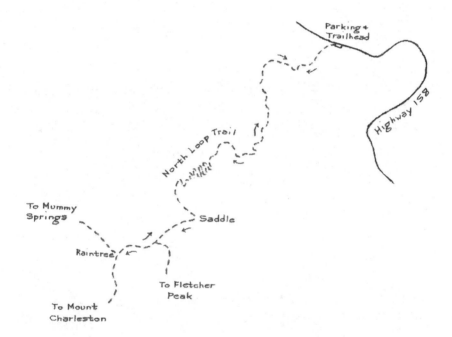

BRISTLECONE TRAIL

How to Get There: Take U. S. Highway 95 north from Las Vegas, continuing 14 miles past the intersection with State Highway 157 until you reach the intersection with State Highway 156. Turn left on Highway 156 and continue for 18 miles to the Las Vegas Ski & Snowboard Park. Continue around the sharp bend to the right past the entrance to the ski resort and park near the helicopter landing area at the very end of Highway 156. The upper Bristlecone Trail starts from this location.

Starting Point: Information kiosk (with map) at the edge of the upper parking area

Difficulty Rating: 2

Distance: 6 Miles

Elevation Gain: 750 Feet

Comments: The Bristlecone Trail is one of the most popular hikes in the Mount Charleston area. In addition to being a hiking trail, it is the only trail in this part of the Spring Mountains where mountain biking is allowed, so be aware of the possible presence of bikes. It is located at the top of Lee Canyon next to the seasonal ski resort, at the base of the north ridge running to Mount Charleston. The hike is described here as a loop, which requires walking on the shoulder or paved surface of Highway 156 for the last ¾ mile of the hike. After you have familiarized yourself with the route, you may consider starting the hike from the lower trailhead, going counter-clockwise on the loop, or doing an out-and-back hike from either of the two trailheads.

Hike Description: Start the hike by going around the corner of the information kiosk at the edge of the helicopter landing area and head-

ing southwest along the ski resort property. After the initial section of trail leads up a slight, rocky ridge, the trail widens considerably as it is joined by an old service road from the ski resort. The trail makes a steady, gradual climb as the trees become denser on both sides. Near ½ mile into the hike, the trail narrows to a single track and proceeds along a minor drainage. Just past the ½ mile point, a couple of switchbacks continue the climb along the drainage. Through this section, the trail surface consists of dirt and the surrounding foliage is very dense. As you near the one mile point of the hike, there is a sharp bend to the right in the vicinity of an old trail, sometimes referred to as No Name Trail, that has been obscured to keep mountain bikers and casual hikers from potentially getting lost or injured in the wilderness area.

Shortly beyond the sharp bend to the right, the Bristlecone Trail turns left, heading northwest, with a gradually deepening drainage on the right. The next section of trail contains the steepest part of the climb as it winds its way up a ridge to a saddle above the drainage. At the top of the drainage, the trail comes to an overlook area on the corner of the ridge where most of the upper portion of Lee Canyon is visible. Take a moment to soak in the wonderful view across to Mummy Mountain from this location. The overlook is about 1.5 miles into the hike. From the overlook area, the trail proceeds almost straight west for a short distance before beginning a gradual arc to the right, eventually heading northeast and picking up the remnants of an old forest service road. Near the 2.5-mile point of the hike, the trail comes to a clearing at the trailhead for the Bonanza Trail, a 13-mile route heading north along the spine of the Spring Mountains.

From the Bonanza trailhead area, the Bristlecone Trail heads east following the forest service road. As you leave the trail junction, there is an excellent view looking to the south that includes the back section of the top of Mount Charleston, the highest point in southern Nevada. The peak can only be seen for about ¼ mile along the trail, as the highest outcroppings on the north ridge soon block the view.

The road (or trail) continues toward the east for about ¾ mile, making several big turns along the way. The road then begins a sweeping turn to the left around the point of a ridge that heads you back in a westerly direction for about ½ mile. A fairly sharp turn to the right points you back to the east and into a very gradual bend to the right, lasting over one mile, that brings you out to the lower trailhead area.

Along the last couple miles of this road, you will be treated to almost continuous views of an extremely rocky double peak to the east known as South Sister. As you look at the rocky cliff sections on the top, imagine yourself scrambling up to get the fantastic view of Lee Canyon that you would get from over 10,000 feet elevation. Although a difficult hike, this peak is offered as a guided hiking destination in the summer by several organizations, including the Red Rock Canyon Interpretive Association.

As you come down the final stretch of the old forest service road, there is a steel barrier across the gravel road to keep casual off-road drivers from getting onto the trail, and an information kiosk on the right side. A fairly large gravel parking area on the left can be used to access the lower portion of the trail from this spot. A few hundred feet farther down, the gravel road intersects with Highway 156. Turn right onto the highway and walk the remaining ¾ mile uphill to return to the parking area at the top of the road, which was the starting point of your hike.

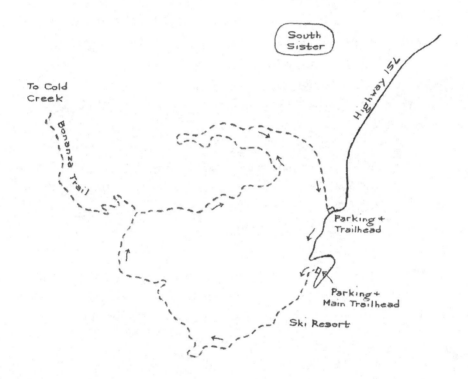

South Sister

Highway 151

To Cold
Creek

Bonanza Trail

Parking +
Trailhead

Parking +
Main Trailhead

Ski Resort

LAS VEGAS VALLEY HIKES

PUEBLO PARK

How to Get There: Pueblo Park is in the northwest part of Las Vegas near the intersection of West Lake Mead Boulevard and North Buffalo Drive. From the downtown area, head north on Highway 95 to Lake Mead Blvd. Travel west on Lake Mead about one mile to the intersection with Buffalo. You will have to drive west past Buffalo and make a U-turn to access the parking area for the park, which is on the south side of Lake Mead Blvd. At the park entrance, there are monument signs on both sides of the entrance road. There is parking room for about 30 cars.

Starting Point: Main picnic area for the park
Difficulty Rating: 1
Distance: 3 Miles
Elevation Gain: 100 Feet

Comments: Pueblo Park is more of a walk than a hike, since it is on sidewalk the entire length. However, the distance provides a chance to get some reasonable exercise and, because the entire length of the trail is laid out in a working desert arroyo, it is a chance to see how nature can survive quite well adjacent to big city development. The picnic facilities and playground areas are outstanding, and there are restroom facilities at the main location, so a family or group outing can be held there. From the starting point, the trail heads west for 1 ½ miles before ending near the east side of the TPC Summerlin Golf Course and Rampart Blvd.

Hike Description: Begin the hike by heading west on the sidewalk trail. Some individual has marked a starting point on the sidewalk with blue paint, and has also painted the ½ mile and 1-mile locations on the sidewalk, so you can check your progress on the way. The sidewalk

goes around an open grassy area suitable for football or baseball, and approaches an open picnic area to the east of Pueblo Vista Drive, which crosses the park. There is a small bridge crossing the wash just beyond that picnic area. In slightly more than ¼ mile, you will get to Pueblo Vista Drive. If you stay on the sidewalk to the left, you can go through a road underpass to access the west side of the park. There is an elementary school and two churches in the vicinity.

As you continue on to the west, you will go by an outdoor basketball court, a small playground, and a pavilion on the left. You will also encounter signage that warns you not to enter the park during a rainstorm. The reason for this soon becomes readily apparent. For the next ¾ mile, you will cross the bottom of the arroyo at grade several times. The arroyo acts as a natural run-off channel for the golf course area to the west and in a significant rainfall event can contain as much as a foot of water rushing down the course of the drainage. Note the use of large landscape rocks along the sidewalk at these low crossing points to mitigate the effects of rushing water on the pathway.

As you approach the 1-mile mark of the walk you will see the boundary fence for Meadows School on your right. Continue past this point another ¼ mile and you will cross the arroyo on a small bridge with a culvert below it providing for drainage. Just beyond that is a small picnic area and an exercise and stretching area called "VitaCourse." This course includes stationary apparatus such as parallel bars, monkey bars, and low benches, with signage indicating how to use each. The course has been placed on a spongy, rubberized surface to maintain low impact on the legs and body while you perform the exercises.

Continuing west from the "VitaCourse," you will notice a stucco wall above and to your right. This is the maintenance area for the TPC golf course on the west side of Rampart Blvd. As you reach the west end of the park, you will come to a pedestrian underpass below Rampart. Just before that underpass is a sign that explains how a desert arroyo func-

tions. Cross under Rampart and sit for a moment on the bench on the side of the hill that looks out over two of the TPC golf holes. Try not to pay any attention to the constant hum of traffic going by just above and behind you on Rampart.

To Return: Reverse direction to starting point.

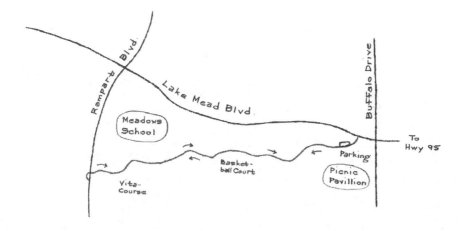

LONE MOUNTAIN

How to Get There: Lone Mountain is in the northwest part of Las Vegas. Head north on Highway 95 until you get to Craig Road (9 miles north of the Rainbow Curve). Head west on Craig until it dead-ends at Jensen Street. Clark County's Lone Mountain Park is directly in front of you. Turn left on Jensen and turn right into the parking area on the south end of the park.

Starting Point: South parking lot at Clark County Lone Mountain Park

Difficulty Rating: 2

Distance: 3.3 Miles

Elevation Gain: 700 Feet

Comments: Lone Mountain is a really good short hike to test your climbing abilities before you move on to the more significant elevation gains in Red Rock and the Mt. Charleston area, or an excellent workout if you only have a few hours to hike and need something close on the northwest side. Much of the climb portion of this hike is done on rock surfaces, which provide better traction, but also tend to obscure the trail and make it difficult to follow. The view from the top is a great reward for your efforts.

Hike Description: From the parking lot on the south side of Lone Mountain Park, go around the chain link fence enclosing the park area and head northwest along the side of Lone Mountain. Stay on the gravel road that essentially parallels the base of the mountain. The road appears to head straight for an overhead flasher in the distance, advising drivers on County Road 215 of the impending intersection with

Lone Mountain Road. Beyond that and to the left, you should see some aggregate piles from the gravel pits in the distance. As you get to a chain link fence for the Highway 215 right of way, keep the fence to your right and the mountain to your left. As you come around the north end of the mountain, you have hiked ½ mile.

As you turn to head south, the easiest choice is to enter a slight rocky wash on the left and pick up a somewhat obscure trail that goes between two boulders and hugs the slope on the left side. In 1/10th mile, the trail ends at a wash. Continue through the wash a short distance and take the dirt road that goes up a small hill on your left. When you reach the crest of the first rise, the trail to the peak begins to climb on your left (heading east). From here on, much of the trail surface until you get to the top is rocky. About 1/6th mile up the trail is a fairly broad saddle. This saddle provides your first good views looking back to the strip and downtown areas of the city. At this point you have hiked about 0.9 miles. There is a bench on the saddle about 40 feet to your left if you need a moment of rest and want to enjoy the scenery.

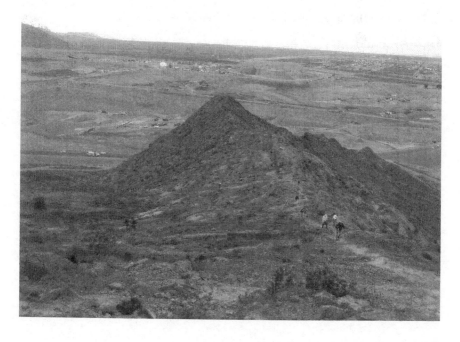

At this saddle, the trail turns at a right angle and starts climbing south to the peak, which is slightly more than 1/3rd mile from your current position. The actual peak is still hidden from your view. The trail stays on the left side of the ridge as it begins to climb. In a short distance, the trail, which is faint at this point, actually divides for about 400 feet until the two sections rejoin. When I hike this, I usually wind up climbing on the trail to the left and returning on the other trail, but either way is fine. Your destination is the highest point you can keep walking toward, so even if you can't find the trail from time to time, just find what appears to be the easiest way up.

About 1 1/8th miles into the hike, the actual peak comes into view. First, however, you must climb up to a short and narrow ridge that appears to be reasonably level. The final climb to the peak is short but steep. As you reach the top section, stay in the middle of the rocky ridge that runs the length of the peak. A spike has been driven into the rock to signify the highest point on the peak. The best spots to sit and enjoy the view are at the far end of the top section past the spike. Don't forget to look west to the top section of Mt. Charleston, which normally is completely covered with snow from November until May. The distance to the peak was 1.25 miles.

To complete the hike, descend from the peak using the same trail that you came up on. When you get to the base of the mountain where you started the climb, you will see an old gravel road going off to the left (south). Turn left on this road. At 2 miles into the hike, or about 750 feet on the gravel road, there is an apparent road junction with a dirt track continuing south along the base of the mountain. Take this dirt track.

The rest of the hike is not on any well-defined trail system, but is on a series of gravel roads and through some minor washes. Keep the slope of Lone Mountain as close on your left shoulder as the terrain allows, and work your way around the south end of the mountain. As you come around the south end, the terrain leads directly toward a sidewalk, with

a tall retaining wall alongside, that proceeds along the north side of Alexander Road. Take the sidewalk for a short distance until the retaining wall ends, and look for an old gravel roadbed that veers off to the left in the direction of Lone Mountain Park. You will now be able to see the park area, which is less than ½ mile away. The trail (old roadbed) passes behind a private residence on its return to the park. On your way back to your vehicle, take a look at the terrain on this section of the mountain going toward the peak. Some sections contain steep enough areas to allow people to practice their rope climbing techniques.

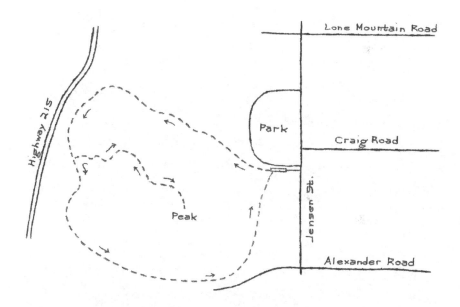

WETLANDS PARK NATURE PRESERVE

How to Get There: Take I-515 southeast from downtown Las Vegas and exit on Tropicana Avenue. Proceed east (left) on Tropicana for 2.8 miles, going past Boulder Highway. As Tropicana bends to the right and becomes Broadbent Boulevard, there is a left-turn lane for Wetlands Park Lane. Take this left and continue for ½ mile to the entrance for the Wetlands Park. There is a parking area on site of sufficient size to accommodate 30 vehicles. This is a county park and, at the present time, there is no fee for entry into the park.

Starting Point: Informational kiosks at southeast corner of parking area across from the modular building that serves as a temporary information center

Difficulty Rating: 1

Distance: 1 to 6 Miles

Elevation Gain: None

Comments: The Wetlands Park is an ongoing project of Clark County to restore an area of wetlands adjacent to the Las Vegas Wash for the benefit of the native birds and animals, as well as natural plant life. On the drawing board for sometime in the distant future is a plan to provide a trail system that will proceed along the Las Vegas Wash from the Wetlands Park for about 10 miles east to Lake Las Vegas. As the park currently exists, there is a closed-loop concrete sidewalk around the perimeter, with several dirt paths crossing that allow viewing of the park's different features. The perimeter loop sidewalk is about 1.7 miles long, with a shorter loop consisting of concrete sidewalk that is 0.8 miles in length. Because each individual can decide how many of the crisscrossing dirt trails to include, and therefore determine the distance

of the hike, my hike description does not provide for an orderly progression referencing any distances relative to the starting point. Refer to the trail map for your options. Even so, every person should strongly consider this hike because the presence of these wetlands seems so out of place in the desert. Don't do this as a power hike, but take your time and enjoy the scenery.

Hike Description: From the information kiosk, the sidewalk heads toward the east for a few hundred feet before accessing the actual perimeter loop. When you get to the point where concrete sidewalks go off in two directions, you will have arrived at the loop. Continuing east, you immediately pass the lower pond, the largest of five ponds in the park, on your left. On a small island in that pond is an observation structure that you can access from one of the dirt paths. At the southeast corner of the pond is an outfall for a Ducks Unlimited wetlands project that has been proposed for development.

At this outfall, the sidewalk turns north and heads along one side of the pond toward the Las Vegas Wash. Part of this sidewalk was destroyed by a flood in early 2005 and had not been rebuilt when this was written, so check for possible closures. As the sidewalk runs parallel to the wash, there are three lookout points where you can view the progression of water going downstream in the wash. The first lookout point is in a narrow area with some elevation change, so the water is surging along with a certain amount of force. The third lookout provides a definite contrast, accessing a quiet pond area where you may be able to view some fish swimming in the gently moving waters.

As the sidewalk pulls away from the wash, you will come to the upper pond. This pond is often populated by ducks swimming leisurely on the surface, and there is a bird blind just off the sidewalk on the south side of the pond where you may be able to view these activities. After you leave the bird blind area, the sidewalk runs along one of the small channels carrying water through the park and goes by an amphitheater

that is used for programs in conjunction with school field trips to the wetlands. As you wind your way toward the end of the loop, you will cross small channels for water passage on several occasions. Just before you get to the end of the loop, there is a viewing area on your left for the lower pond that includes several bench seats. Just beyond that area, turn right and return to the parking area.

If you want to continue your exploration of the area, there is another trailhead on the road just outside of the entrance sign for the parking area that provides a short, pleasant hike through the marsh grass. This is the **Duck Creek Trail**, a 1.5 mile loop that is the oldest part of the wetlands park area. The trail runs south from the trailhead, picking up the Quail Run Loop, which has an access point on Broadbent Boulevard before turning east to complete the loop portion. This area is interesting because it was the site of a large grass fire in 2002 that sent huge clouds of black smoke into the skies above Las Vegas that could be seem throughout the valley. Today, the only reminders of that fire are the charred upper branches of the trees in the area that burned. Marsh grasses have since grown to such a height that evidence of the fire is mostly obscured. If you decide to go on this trail, it is essentially a closed loop that, with the exception of the Broadbent access mentioned above, naturally brings you back to the starting point.

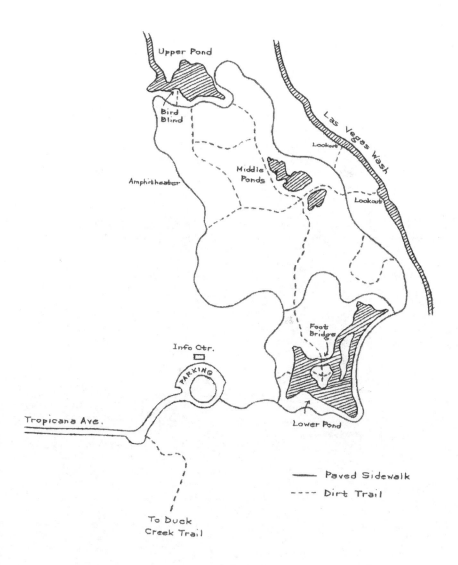

Upper Pond

Bird Blind

Las Vegas Wash

Lookout

Middle Ponds

Amphitheater

Lookout

Foot Bridge

Info Ctr.

PARKING

Tropicana Ave.

Lower Pond

Paved Sidewalk
Dirt Trail

To Duck Creek Trail

LAKE MEAD AREA HIKES

ANNIVERSARY NARROWS

How to Get There: Take I-15 north from the center of Las Vegas about two miles past the U. S. Highway 95 interchange and exit at Lake Mead Boulevard. Go right (east) on Lake Mead Boulevard about 15 miles to the fee booth entrance for Lake Mead National Recreation Area. There is a fee, either on a daily or yearly basis, for entering the recreation area, but the National Parks Pass and Golden Age Pass will also get you through. Continue on Lake Mead Boulevard for another two miles until it ends at Northshore Road. Go left on Northshore Road for 12.5 miles. When you get to the Mile 16 marker on the highway, turn left onto the gravel pullout, which can accommodate 15 or 20 vehicles, and park at your earliest convenience. There is a sign for a gravel road, designating it as Callville Wash North. This road is subject to massive erosion from large amounts of storm runoff.

Starting Point: Road sign for Callville Wash North
Difficulty Rating: 2
Distance: 5+ Miles
Elevation Gain: 300 Feet or Less

Comments: This hike is like the story of the ugly duckling that turned into a beautiful swan – it starts out going through nondescript desert and ends at a really interesting historical mining site and the sensational slot canyon known as Anniversary Narrows. This amazing slot canyon winds through the rock formations on either side for a distance of more than 1/3rd mile, with cliff walls sometimes in excess of 100 feet and the canyon width as narrow as five feet. If you hike directly to the narrows and pass through to the spot where it begins to widen and then retrace your steps, your total distance is about 5 miles. It is possible to reduce the hike dis-

tance to 3 miles by taking a 4-wheel drive vehicle off-road through the Callville Wash to the Oar Car Mine site. However, there are so many interesting little side trips that you can easily add more distance to the hike. Your actual distance is dependent on your desire to explore.

Hike Description: Begin the hike by heading ENE on the road for Callville Wash North. This road is subject to massive erosion from large amounts of storm runoff and does not carry a very high priority with the county, so you may encounter a situation where the road surface has been obliterated. If so, drop into the wash, looking for the safest place to do so. You are now in Callville Wash. Follow the wash as it bends left (north) heading toward a pyramid-shaped peak in the distance. The wash continues to bend to the left, and ultimately your direction of travel will be toward the northwest, with a range of red and gray mountains in the background.

At about 1/3rd mile into the hike, the gravel road becomes recognizable again as it exits to the left from the wash, continuing to bend gradually to the left until it is headed almost directly toward the west. The road is easy to follow as it remains on high ground for another ½ mile, where it crosses the wash and bends to the right (northwest). At 1.1 miles into the hike, the road passes an area that is frequented by rock hounds trying to find agates on the desert floor. There is a sign titled "Welcome to the Ore Car Mine", which explains the procedures you must follow if you are planning to remove any potential agates from the site.

Past the sign, the road bends slightly to the left and climbs a small hill. At the top of the hill, the road heads in the general direction of a pyramid-shaped pile of pink mining tailings about a half-mile away that is noticeable from your current location. About 1.6 miles into the hike, the road arrives at the edge of a deep wash, known as Lovell Wash, bends to the right and drops down the side of a ridge toward the bottom of the wash. Part way down, a short gravel road goes off to the right about 100 feet to a wooden board bench overlooking the area. Continue down the main road to the bottom of the wash. Your hike distance so far is about

1.8 miles. If you wish to proceed straight toward the narrows, turn right and head for the concrete pilings mentioned after the next paragraph.

Across the wash by a large cairn is an opportunity for an interesting side hike of about one mile. Go past the cairn and take the road that starts climbing to the left. The road makes a gradual climb for nearly ¾ mile, winding around to the west of the pink tailings pile and finally reaching the level directly behind the tailings. On that level, there are several foundations and slabs for old buildings that were the center of the ore processing activities for the largest of the mines in the area. One of the buildings still shows evidence of being some kind of cookhouse, with burnt wood chips similar to charcoal in the base of a central shallow pit. The vertical gain from the wash to this area is about 200 feet. Instead of returning down the road, access the wash by a shorter route that starts from the eastern side of the processing area past a few smaller gray slag piles. Look for a faint trail that drops quite steeply into the wash. The trail goes over some uneven terrain as it heads east and drops over the point of a ridge into the wash.

As you drop to the bottom of the wash, you can see the concrete pilings and some timber supports for a structure that stored unrefined ore prior to processing. Above what is left of the structure are two short tunnels that were dug to place a narrow gauge track accommodating ore-cars, which hauled the unrefined ore from the mine itself. You can climb around to the right of the building remnants and walk through the tunnels. Be careful as the faint trail is narrow and you could slip down the bank for 15 or 20 feet, which might hurt.

Just past the tunnels is the top of an old dam structure. This is built on top of a knob about 20 feet above the floor of the wash. There is some evidence in the wash that a full wooden dam stretched across the entire width of the wash, thus providing a continuing source of water for the mining operation. Continue up the wash for a few hundred feet and the remains of the Anniversary Mine is on the hill to your right. This mine

operated from 1922 until 1928, and a couple of the shafts are open and can be explored at the present time. Make sure you bring a flashlight and some friends if you intend on exploring the old mine.

From the time you dropped into Lovell Wash, you have probably noticed the extreme tilt to the various strata of rock on either side of the wash. This is evidence of some pretty extreme geologic activity in the past. Also of note, many of the rock formations are formed of extremely thin and distinct layers of sedimentation, some of which seem to be hardly thicker than an ordinary piece of paper.

Continue past the mine for another ¼ mile and you will come to the narrows, probably the most picturesque slot canyon in southeastern Nevada. It is amazing to think that this canyon, which runs for a distance of more than 1/3rd mile, was literally dug out of the mountain to a depth approaching 100 feet and a width in places of only five feet. The narrows also contain some sections of rock exhibiting extreme tilt, and now you have the opportunity for a closer examination of pressures exerted through geologic activity.

The canyon contains several sections where you have to climb over rocks. The vertical gain in these rock sections can be anywhere from one foot to perhaps as much as six feet. If there has been any precipitation in the area prior to the time of your hike, you may encounter water flowing through the narrows. Generally, you should be able to get around any water without getting your feet very wet. Any significant rainfall, however, could result in a rather large water surge, because the narrow canyon is the conduit for a much larger drainage area higher up.

If you have brought along any food, there are a few wider spots within the narrows that are excellent locations for taking a short break and replenishing your energies. There is also a popular area as you come out of the narrows into the upper wash, with great views of the rugged mountainous terrain in the background.

The distance from the trailhead to the far side of the narrows, not counting any side explorations, is about 2.5 miles. There are some additional hiking opportunities in the wash above the narrows. One option is to stay in the wash, following a route through the rocks and gravel at the bottom of the wash. There are some cairns marking the route, and you can decide along the way how much additional distance you want to add to the hike. There are also some routes that will take you over a ridge to the east, into the South Bowl of Fire, an area known for its deep red sandstone rock formations, or over the top of some unnamed peaks. These hikes are very strenuous, however, and require a high level of navigation skills. If you are interested in attempting either of these, look for a group hike led by the Sierra Club or the Lake Mead Recreation Area staff, as they will be familiar with the area.

To Return: Reverse your direction back through the narrows and past the old mining operation. As you get back to the big cairn on the right that marks the road climbing up to the processing area, you have a choice to make. Just past the cairn, you can either turn left on the road you used to access the narrows, climbing the hill on the ridge above Lovell Wash, or you can continue down the wash. The road will take you back past the Ore Car Mine sign and eventually into Callville Wash, where you began the hike. If you elect to stay in Lovell Wash, you will eventually intersect the Northshore Road about 1/3rd mile to the west of where you parked your vehicle. Simply turn left and follow the paved highway back to your starting spot. The distance is about the same for both routes.

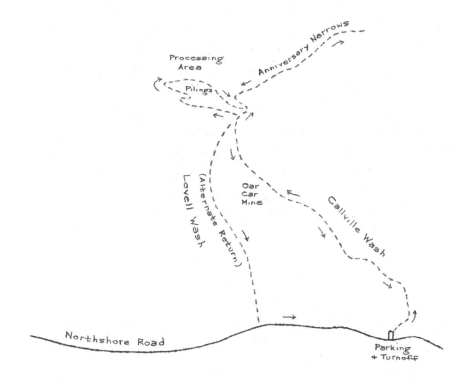

Anniversary Narrows

Processing
Area

Pilings

Oar
Car
Mine

Callville Wash

(Alternate Return)

Lovell Wash

Northshore Road

Parking
+ Turnoff

BLUFF TRAIL

How to Get There: Take I-515 south from the downtown area of Las Vegas or I-215 east from the area of McCarran International Airport to the intersection of the two roads. From that intersection, proceed east on Nevada Highway 564 past Lake Las Vegas to the fee booth entrance for Lake Mead National Recreation Area. Continue straight as the highway becomes Lakeshore Road for 2.1 miles to the turnoff for the Las Vegas Bay Marina & Campground. Turn left and proceed about 1/10th mile, going past the old Ranger Station in the process, and turn left on the campground road. As you enter the campground 0.8 miles later, look for the information kiosk on the right side of the road. There is a parking area that will hold about four vehicles at the site.

Starting Point: Information kiosk at Las Vegas Bay Campground
Difficulty Rating: 1
Distance: 2 Miles
Elevation Gain: 200 Feet

Comments: This old but little known hike originates at the campground and run along the top of a bluff overlooking the Las Vegas Wash. When water levels in Lake Mead are closer to normal, water backs up into the section of the wash at the top of Las Vegas Bay. Wildlife viewing is often excellent, especially birds, including the elusive wild roadrunner. Coyotes and rabbits also roam the area. At the far point of the hike, there are panoramic views on all sides of the horizon. As described here, this is an out-and-back hike.

Hike Description: From the information kiosk at the entrance to the Las Vegas Bay Campground, take the service road by the sign that indicates the direction to campsites 77 through 85. Continue past these

sites and look for a short service road leading to the campsites numbered in the low 70's. The Bluff Trail begins as a rock-bordered trail between campsites 72 and 74, going off to the left. There is a brown sign that directs you toward the campground trail and amphitheater at the trailhead.

Proceed on the trail, which starts off as gravel but soon changes to dirt, as it heads in a northwesterly direction. The first half of the trail is on the southwest bluff overlooking the Las Vegas Wash just before it flows into Las Vegas Bay. This is a rare opportunity to see water flowing rapidly year-round in a desert drainage. Do not attempt to hike down to feel the water, however, as it carries the entire runoff from the Las Vegas valley and is highly contaminated with chemicals and other pollutants.

About ½ mile into the hike the trail crosses a slight wash with evidence of erosion on the right as this minor wash drops toward the Las Vegas Wash. It appears very easy to walk about 20 feet to the edge of the drop-off in the minor wash. It is questionable, however, whether this particular area is stable enough to carry any amount of weight. If you go past the wash, the trail bends to the right and your view of the edge shows that it is really a ledge with no supporting dirt underneath.

About ¾ mile into the hike, the trail begins to pull away from the ridge as it turns in a southwest direction. There is a large pile of rocks on the right as you go another 1/10th mile. As you approach the one-mile mark, the trail climbs a short knob and ends at the top. You may notice that much of the rock where you are standing is volcanic in origin. Take a moment to look around. Lake Mead appears to the east with Fortification Hill at the south end of the lake, the River Mountains are to the south and part of the community of Lake Las Vegas is to the southwest. To the northwest is Lava Butte, a dark-brown peak about 1,000 feet high, with Frenchman's Peak in the background. To the northeast, you can see over to the area of Valley of Fire and the Muddy Mountains. Another

higher knob about 0.4 miles to the north provides even better views of the horizon, but there is no trail continuation, and the only cairns are at the very top of the other knob.

To Return: Turn around and retrace your steps. The return trail is very easy to follow.

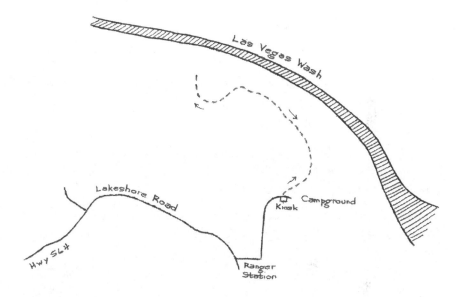

RED MOUNTAIN

How to Get There: Take U. S. Highway 93 southeast from Las Vegas to Boulder City. When the highway turns left at the stoplight and proceeds down the long grade toward Lake Mead, look for the signs about ½ mile from the intersection on the left side of the road that say "River Mountain Trails." If you go past St. Jude Children's Ranch, you have gone too far. Turn left between the signs and enter the parking area. There are no restroom facilities at this trailhead.

Starting Point: Signed trailhead at far end of parking area
Difficulty Rating: 3
Distance: 5.7 Miles
Elevation Gain: 1,225 Feet

Comments: The trail for this hike is actually a park maintained by the city of Boulder City. It is generally kept in a high state of repair and the trail conditions are excellent. The trail climbs to a saddle between Red Mountain and Black Mountain (see next hike), from which you can access either peak. Red Mountain is a mountain biker's paradise, and hikers have to be aware of the potential for bike traffic on the last climb to the peak. The view from the overlook on Red Mountain is marginally better than the view from Black Mountain, because of the higher elevation and the unobstructed view to the west.

Hike Description: Go around the informational sign that serves as the trailhead and take the path along the concrete spillway that is part of the flood control system for the Red and Black Mountain drainages. Head around to the left of the 15-foot deep water retention basin behind the spillway. A well-defined rock border has been installed for much of the

trail, so watch for it as you cross a few old gravel roads that are primarily used by recreational vehicles. The trail surface generally consists of sand and fine gravel. Through this section past the water retention basin, your hike direction will be toward Red Mountain.

At ½ mile into the hike, you enter an area of low hills where the trail meanders in between several of the hills in what appears to be a slight wash. The next ½ mile will be spent winding around, through, and behind the hills until you clear a small ridge and look straight up the canyon that separates Red Mountain from Black Mountain with the saddle in the background.

The trail now runs along the left side of the main wash for the canyon, going up and down as it crosses two minor washes coming in from the left. Your general direction toward the saddle is northwest. At 1.2 miles, the trail levels out slightly for a distance as it continues up the canyon. At 1.6 miles, you get to a section of the trail with four switchbacks as the climb rate begins to increase. The trail continues to climb along the base of Red Mountain.

At two miles, you come to an 8-foot boulder on the right side of the trail. Just beyond that rock is a set of eight switchbacks that take you to the saddle. As you arrive at the saddle, you have hiked a distance of 2.25 miles and climbed 880 feet. If you look up toward the peak of Red Mountain, you will be able to see a black-and-white pole that sits on top of the observation point for the hike. That pole is your ultimate goal. Turn left onto the trail that goes around the sign on the saddle and head for the summit of Red Mountain. The trail takes a few switchbacks and in slightly more than 500 feet intersects the service road that is used by mountain bikers transporting their bikes to the top for the ride down.

Just up the road, look for the sign that reads "Downhill Trails" and take the trail that begins a fairly steep climb toward the black-and-white pole at the top of the overlook area. There are a few switchbacks in this steep

section, and the trail crosses several rock outcroppings. It is about ¼ mile from the sign to the crest of a saddle. At the saddle, look to your left and you will see a wooden ramp built by the bikers to give them a little extra speed on the initial part of their descent down the mountain. It is another 300 feet by trail to reach the pole that marks the overlook area. The view from the top is sensational, from Lake Mead to the northeast, Boulder City to the southeast, and Las Vegas and the high peaks of the Spring Mountains to the west (on a clear day).

To Return: Reverse your direction and head down to the starting point. If you feel like you haven't hiked enough, take the trail at the saddle that heads toward the Black Mountain Overlook. Doing so will add another 1.5 miles to you hike. On the way down from the saddle, use the rock borders as a guide as other trails cross the one you are on.

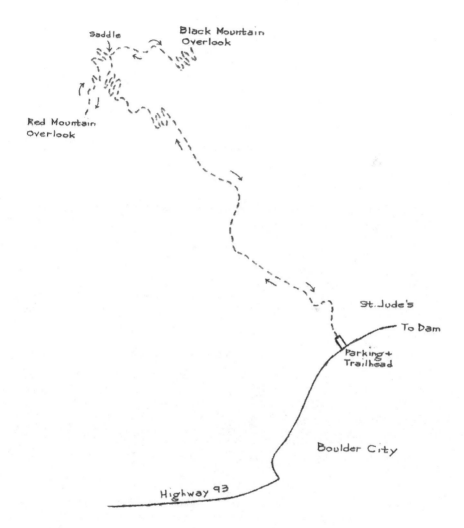

Saddle

Black Mountain
Overlook

Red Mountain
Overlook

St. Jude's

To Dam

Parking &
Trailhead

Boulder City

Highway 93

BLACK MOUNTAIN

How to Get There: Take U. S. Highway 93 southeast from Las Vegas to Boulder City. When the highway turns left at the stoplight and proceeds down the long grade toward Lake Mead, look for the signs about ½ mile from the intersection on the left side of the road that say "River Mountain Trails." If you go past St. Jude Children's Ranch, you have gone too far. Turn left between the signs and enter the parking area. There are no restroom facilities at this trailhead.

Starting Point: Signed trailhead at far end of parking area
Difficulty Rating: 3
Distance: 6 Miles
Elevation Gain: 1,065 Feet

Comments: The trail for this hike is actually a park maintained by the city of Boulder City. It is generally kept in a high state of repair and the trail conditions are excellent. The trail climbs to a saddle between Red Mountain (see previous hike) and Black Mountain, from which you can access either peak. The view from Black Mountain is sensational. Virtually all of Las Vegas is visible to the northwest and, on a clear day, the higher peaks of the Spring Mountains are clearly visible in the background. Lake Mead lies to the northeast, and Boulder City to the south. In spring and autumn, when conditions are right, this hike can be done at dusk to watch the moon rise over Lake Mead.

Hike Description: Go around the informational sign that serves as the trailhead and take the path along the concrete spillway that is part of the flood control system for the Red and Black Mountain drainages. Head around to the left of the 15-foot deep water retention basin behind the spillway. A well-defined rock border has been installed for much of the

trail, so watch for it as you cross a few old gravel roads that are primarily used by recreational vehicles. The trail surface generally consists of sand and fine gravel. Through this section past the water retention basin, your hike direction will be toward Red Mountain.

At ½ mile into the hike, you enter an area of low hills where the trail meanders in between several of the hills in what appears to be a slight wash. The next ½ mile will be spent winding around, through, and behind the hills until you clear a small ridge and look straight up the canyon that separates Red Mountain from Black Mountain, with the saddle in the background.

The trail now runs along the left side of the main wash for the canyon, going up and down as it crosses two minor washes coming in from the left. Your general direction toward the saddle is northwest. At 1.2 miles, the trail levels out slightly for a distance as it continues up the canyon. At 1.6 miles, you get to a section of the trail with four switchbacks as the climb rate begins to increase. The trail continues to climb along the base of Red Mountain.

At two miles, you come to an 8-foot boulder on the right side of the trail. Just beyond that rock is a set of eight switchbacks that take you to the saddle. As you arrive at the saddle, you have hiked a distance of 2.25 miles and climbed 880 feet. Take the trail to the right (NNE) and go around the left side of a false peak somewhat in front of you. There are two minor switchbacks as you approach this hill. As you come around the north side of the hill, the overlook at the top of Black Mountain comes into view again.

The final climb is fairly steep as it heads toward the peak. At the top you will find a park bench and two geological signs that indicate the types of composite rock found in the surrounding mountain ranges. The hike distance to this point is 3 miles, with another 3 on the return. You will feel rewarded for your efforts by the excellent panoramic view that awaits you at the top.

To Return: Reverse your direction and head down to the starting point. If you feel like 6 miles isn't enough, when you reach the saddle take the trail that goes up to Red Mountain. That will add about another 1.2 miles to your total distance. On the way down from the saddle, use the rock borders as a guide as other trails cross the one you are on.

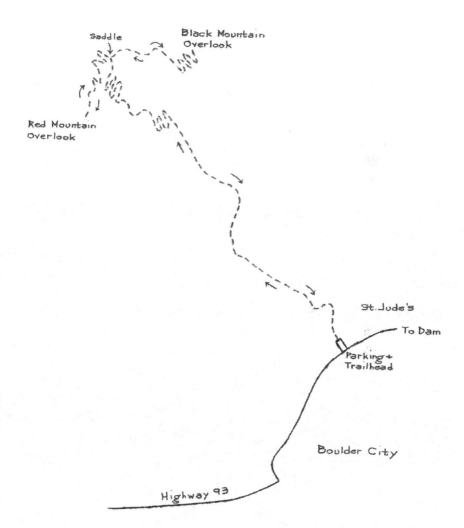

Saddle

Black Mountain
Overlook

Red Mountain
Overlook

St. Jude's

To Dam

Parking +
Trailhead

Boulder City

Highway 93

RIVER MOUNTAIN TRAIL

How to Get There: Take U. S. Highway 93 southeast from Las Vegas to Boulder City. When the highway turns left at the stoplight, continue on Highway 93 for 2.25 miles down the long grade toward Lake Mead, looking for a road sign on the left for Pacifica Way. Turn left on Pacifica Way and make an almost immediate right into the paved parking area. There is room for several dozen cars in this lot. There are no restroom facilities at the trailhead or along the hike.

Starting Point: Informational kiosk on southeast side of parking lot
Difficulty Rating: 2
Distance: 6.6 Miles
Elevation Gain: 240 Feet (on return)

Comments: This is an out-and-back hike on a trail segment that is 3.3 miles in length. It is one section of the proposed River Mountain Loop, a series of trails that encircle the River Mountains that will eventually cover a total distance of 35 miles. It is also part of the Historic Railroad Trail system, as all the signs along the route will indicate, with most of the trail on the old railroad right-of-way that was in use during the construction of Hoover Dam in the 1930's. As described here, the turn-around point for the hike is near the lower parking area at the Alan Bible Visitor Center. This trail can be combined with the Historic Railroad Tunnels hike, but the total distance of that combined hike would be nearly 11 miles. The first half of the hike is downhill, so the vertical gain listed above is on the way back. This is a desert hike with absolutely no shade, so bring lots of water and cover your head and skin.

Hike Description: From the information kiosk, take the blacktop trail that goes around the east side of the parking lot. In about 1/10th mile,

the blacktop ends and the trail surface becomes a mixture of dirt, sand, and gravel as it heads in a northerly direction. The trail becomes more defined as a 2-track dirt road as it nears a signpost with a sign for the Historic Railroad Trail and another indicating the boundary for the Lake Mead National Recreation Area. As you approach a housing development, the trail bends to the right (east) as it passes some of the houses. In 300 feet, as you approach a power line tower, look for a "Trail" sign that turns you about 30 degrees to your left. The trail bends through a wash and then resumes its northerly bearing.

At a hiking distance of ¾ mile, you encounter another "Historic Railroad Trail" sign. The trail bends to the left and begins a gradual climb over the next ¼ mile until it intersects with a gravel road coming in from behind and to the left. Take a look at this junction so that you can make the correct turn on your way back to the trailhead. Turn right on the gravel road and continue straight (north) as it becomes a 2-track jeep road. You are now on the old railroad right-of-way. As you continue along the trail, a few small hills on your right will temporarily block your view toward Highway 93, now in the distance, and some small chocolate brown peaks will be directly in front of you.

About 1.4 miles into the hike, the trail begins to make a broad, sweeping turn to the right. In this section of trail, the old railroad bed has been elevated above the surrounding desert floor by about 15 or 20 feet. As you come to the end of the sweeping turn, you will notice the trail going directly toward an old hillside cut in the rocks ahead. Pass through the cut, which is 1.8 miles into the hike. As you get to the far end, the trail bends left (southeast) for the next ½ mile. In that section, the trail crosses a major wash divided into three channels, with steel culverts allowing for water transfer. On the left near the last of these channels is a pile of discarded concrete culverts.

The trail bends to the left (east) and the Hacienda Hotel & Casino is straight in front of you. The trail crosses an old blacktop road that looks

like it could have been a highway in the long-ago past. In another 1/10th mile, a hill on your right appears to be made from volcanic rock. About 2.5 miles into the hike the trail, showing some indication of erosion, crosses a gravel road. Another "Historic Railroad Trail" sign is located at the far side of the crossing.

At slightly more than 3 miles, a set of railroad tie steps descends to a rock-bordered trail going off to the right. This is a side trail close to the Alan Bible Visitor Center that winds its way through the desert for 0.4 miles. The highlights of the trail are various types of desert vegetation and a bench on top of a small hill overlooking the Hemenway Harbor area of Lake Mead. If you choose to take the tourist trail, it will add about 1/3rd mile to your hike, as it connects with the main trail about 330 feet past the point where you first accessed it.

Just beyond this side trail the main trail you have been hiking becomes a concrete walkway and you go through an underpass below State Highway 166. As you come out the other side of the underpass, the lower lot of the Alan Bible Visitor Center is on your left and the Historic Railroad Tunnels trail begins as the concrete walkway turns and goes uphill to the Visitor Center building. At this point, you can choose to check out the exhibits in the Visitor Center, continue toward the tunnels, or turn around and return to your starting location.

To Return: Reverse your direction and head back to the starting point. The railroad bed is easy to follow. As you get within one mile of the trailhead, be sure to take a left off the gravel road onto a fainter 2-track jeep road. There is a slight rock border at this junction and it is just past a wash crossing above a culvert with a few discarded concrete culverts at the bottom of the wash on your left.

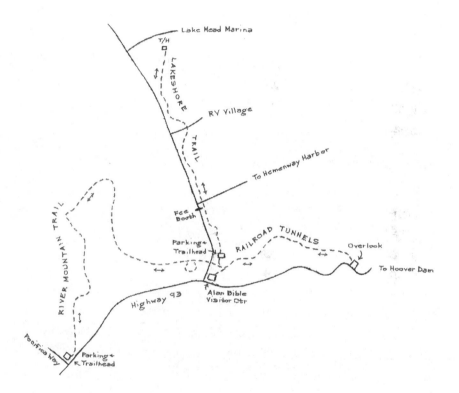

Lake Mead Marina

T/H

LAKESHORE TRAIL

RV Village

To Hemenway Harbor

Fee Booth

RIVER MOUNTAIN TRAIL

Parking +
Trailhead

RAILROAD TUNNELS

Overlook

To Hoover Dam

Alan Bible
Visitor Ctr

Highway 93

Pacifica Way

Parking +
Trailhead

LAKESHORE TRAIL

How to Get There: Take U. S. Highway 93 southeast from Las Vegas toward the dam. From Boulder City, proceed down the long grade toward Lake Mead, taking the curve to the right. Before you get to the Hacienda Hotel & Casino, Highway 166 goes to the left toward the lake. Take the turn on 166 and turn right into the lower lot of the Alan Bible Visitor Center, where the actual trailhead for the Historic Railroad Tunnels hike is located. There is a portable toilet at the lot, with modern restrooms and drinking water at the Visitor Center just up the hill.

Starting Point: Alan Bible Visitor Center lower lot
Difficulty Rating: 2
Distance: 5.8 Miles
Elevation Gain: 340 Feet (on return)

Comments: This trail was originally built by Eagle Scouts from the Boulder Dam Area Council. It is seldom used today, so you may not see any other hikers on the trail. It follows the Lakeshore Scenic Drive (Highway 166), staying within 50 feet of the road surface for much of its length. It is an out-and-back hike, stretching between the Alan Bible Visitor Center and the old Lake Mead Marina near the Las Vegas water plant. If you don't mind the occasional noise from traffic on the road and the feeling that you are definitely not in the wilderness, the hike offers panoramic views on the way out of the lake on your right and, in the last mile, some nice views of the River Mountains on your left. The outbound leg of this hike descends toward the lake, so your elevation gain is on the return trip. Because most of the surrounding terrain is scrub desert and the temperature is generally higher than Las Vegas, I recommend that you only do this hike between November and early April.

Hike Description: The unmarked trail begins at the north side of the lower lot, next to a runoff opening for drainage in the parking area. The dirt trail starts off heading north with a rock border on both sides. In a short distance, there is a slight bend to the left (NNW), which is the general direction for the entire outbound portion of the hike. About 1/5th mile into the hike, there is a small indicator sign for "Trail" that points straight ahead. In another 1/10th mile, look for a sign titled "Lake Mead Informational Sign." The trail bends to the right for a very short distance going through a wash and then bends left back toward the road.

About 2/3rd mile from the start, you pass the fee booth for automobile access into the Recreation Area. At 0.8 miles, the trail crosses the paved road going to Hemenway Harbor, the main marina for pleasure craft on this part of the lake. Past the crosswalk, the dirt trail continues with another rock border. In about ¼ mile, you cross a wash about 20 feet in width. The next part of the hike provides the best panoramic views of the lake. The trail begins to approach the Lake Mead RV Village, which looks like an oasis in the desert with all of the mature trees surrounding the RV sites. At 1.8 miles, you cross the paved road that services the Village and the Boulder Campground.

On the other side of the road is a trail sign that gives a distance of 1.1 miles to the Lake Mead Marina. Shortly after the road crossing, the trail bends to the right away from Highway 166 and goes in the direction of Boulder Beach. The trail then crosses the paved road servicing the Beach Store. A trail sign at the crossing indicates the direction to the old marina. Take a look to your left as you hike along, noting how rugged the River Mountains appear to be. Continue on the dirt trail for another ½ mile, until it ends in the vicinity of the marina. The original trailhead for this hike was probably located at this end of the trail, as there is old but still functional signage directing you back to the Visitor Center.

To Return: Reverse your direction and head back to the starting point. The trail follows the highway and you can't get lost.

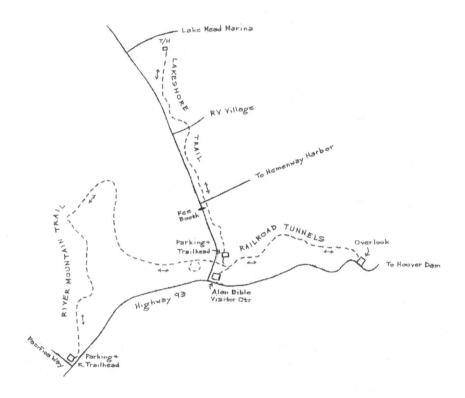

Lake Mead Marina

T/H

LAKESHORE TRAIL

RV Village

To Hemenway Harbor

RIVER MOUNTAIN TRAIL

Fee Booth

Parking+
Trailhead

RAILROAD TUNNELS

Overlook

To Hoover Dam

Highway 93

Alan Bible
Visitor Ctr

Pacifica Way

Parking+
Trailhead

HISTORIC RAILROAD TUNNELS

How to Get There: Take U. S. Highway 93 southeast from Las Vegas toward the dam. From Boulder City, proceed down the long grade toward Lake Mead, taking the curve to the right. Before you get to the Hacienda Hotel & Casino, Highway 166 goes to the left toward the lake. Take the turn on 166 and turn right into the Alan Bible Visitor Center. There are excellent restroom facilities at the Visitor Center accessed by the upper lot, and you can begin the hike from that location. The lower lot is the "official" start of the trail, and has a portable toilet located there.

Starting Point: Alan Bible Visitor Center lower lot
Difficulty Rating: 1
Distance: 4.2 Miles
Elevation Gain: 65 Feet

Comments: This flat trail follows the railroad bed that was used to transport construction materials and equipment to the site of Hoover Dam during its construction beginning in 1931. The tunnel section of the trail presently runs east from the Alan Bible Visitor Center for 2 miles to a point near the Lake Mead Overlook. In the second mile of the hike, you will encounter 5 tunnels, each 25 feet in diameter, that were dug through the rock ledges to the south of the current Lake Mead. Eventually, the trail system will be extended another ¾ mile to the dam itself.

Hike Description: The trail starts from the sign at the lower parking lot for the Alan Bible Visitor Center. The trail can also be accessed from the upper parking lot in front of the Visitor Center by crossing the service road for the Center and heading for the gate entrance to the old railroad bed. Follow the trail to the gated area about 1/5th mile from the start.

189

After going through the gate, you will be heading in a northeast direction. As you walk along this section, the lake is to your front and left. Some of the landmarks you might notice include Hemenway Harbor, Boulder Beach and the Lake Mead RV Village, and the water treatment facility a little farther to the left.

As you round a bend on the railroad bed, you will begin heading east toward the dam. At a distance of one mile into the hike, look down into a ravine on your right. Discarded below are several concrete plugs that were removed from the dam area during the installation of the turbines at the generating plant. The first tunnel is about ¼ mile ahead. Off to your left you will get a great view of the marina and several small rocky islands popping out of the waters of Lake Mead.

The first two tunnels are relatively close together, only separated by about 340 feet. The first tunnel is 250 feet long and the second is 290 feet long, both being constructed directly through the rock. At the end of each of these tunnels you will see timber and planking supports that prevented loose rock from falling on those sections of track. The second tunnel was burned in an arson fire in 1990. As you pass through, notice the extensive use of shotcrete on the walls, which was used to solidify the rock that had become loosened during the fire.

The third tunnel is approximately 1,100 feet past the second. Again you should notice the timber and planking support system at the far end of the tunnel. This tunnel is marginally the longest of the five at 360 feet.

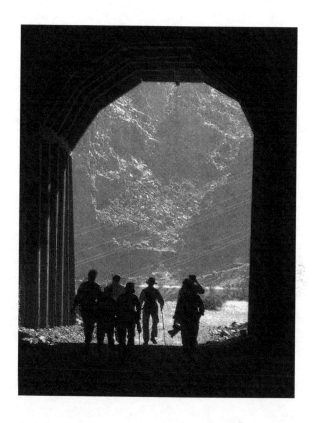

As you exit this tunnel, look down to your left into the ravine. You will see part of a rail car axle and some railroad ties that were dumped when the track was torn up. The fourth tunnel is another 500 feet ahead, and is the shortest of the five at 180 feet. Presumably, this tunnel did not experience any significant problem with falling rocks, probably because of the short distance, for there is no timber support system within the tunnel.

The final tunnel is 950 feet ahead. As you approach it, look up to the top of the area above the tunnel. There is a rock wall border that has been constructed as the outer limit of the Lake Mead Overlook accessible at this point from Highway 93 near the dam checkpoint. The tunnel goes below the overlook area. It is about 330 feet in length. This tunnel is different from the first four in that there is a bend within the tunnel, so it appears much darker in the opening as you approach it. This tunnel

also experienced a fire that occurred during 1978 and was sealed for a long period. It was restored and reopened in July 2001.

As you exit the fifth tunnel, a high cyclone fence, padlocked and fortified with barbed wire on the top, blocks any further hiking. You have gone 2.1 miles and reached the end of the line (for now).

To Return: Reverse your direction and head back to the starting point. You can't get lost. If you are hiking this trail during March or April, you may see some abundant wildflowers along the route, if you didn't get a chance to notice them on the outbound leg of your hike.

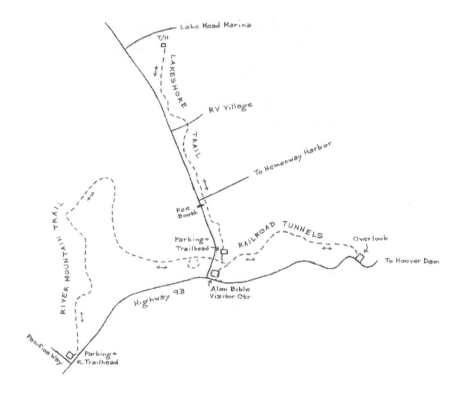

LIBERTY BELL ARCH

How to Get There: Take U. S. Highway 93 southeast from Las Vegas to Hoover Dam. Cross the dam and proceed 3.7 miles into Arizona on Highway 93. About ½ mile beyond a passing lane for the southbound traffic, the highway passes over the top of a ridge with a dirt cut on both sides of the road. On the left side of the highway is an obscure gravel pull-off with room for about a dozen cars. This is the parking location for the Liberty Bell Arch hike. Beyond this spot, the highway proceeds downhill for a long stretch and in about one mile crosses a bridge over a wash with the Arizona Hot Springs trailhead just beyond. If you go too far the first time, turn around where it is safe and proceed back to the top of the ridge.

Starting Point: Gravel pull-off indicated above
Difficulty Rating: 2
Distance: 5 Miles
Elevation Gain: 400 Feet

Comments: Although this hike is relatively unknown and does not have a well-defined parking area or a signed trailhead location, it is one of the best hikes in the Lake Mead area. It is described in this book as an out-and-back hike, although there are several cross trails that can be explored when you are ready for longer hikes. Along the way you get to see some history (remnants of an old gold mine that operated in the 1940's), some great geology (a natural arch about 30 feet high that resembles the Liberty Bell when viewed straight on), and some fantastic scenery (the farthest point of the hike is a bluff about 700 feet above the Colorado River). There are countless prickly pear cactuses along the trail, and around the first part of April each year the deep pink blossoms they produce provide a colorful backdrop to the hike. This is a lower desert hike that should not be attempted during the summer months.

Hike Description: Begin this hike by crossing Highway 93 and going to the right (back toward Hoover Dam) to the end of the road cut (about 50 feet). When you get to the metal guardrail, go left inside the end of the guardrail into an apparent road drainage. In the drainage is an unmarked faint trail. In less than 100 feet, an old jeep track, still not very well-defined, goes off to the left out of the drainage. Take this track to the left and go around the ridge that is bisected by the highway. About ¼ mile from the start is a cairn that marks a right turn onto a single lane trail. Take a right on this trail. From here to the farthest point on the hike, the trail will be relatively easy to follow, with dozens of cairns along the path to mark turns and continuations.

Having taken the right past the cairn, the trail heads briefly in a westerly direction toward some cliffs in the distance that are on the Nevada side of the river. The trail has several bends and turns, but continues generally in a southwest direction as it heads toward the arch and the bluff beyond. Slightly more than ½ mile into the hike, you approach a spot where you can see an area of black rock formations in the distance. In another 1/8th mile, the trail bends to the left at the top of a 50-foot gorge that drops further away from you in a short distance.

After the bend, the trail makes a steep descent down a ridge. Since this trail is not maintained on a regular basis, there is often loose dirt and small rocks on the sloping portions of the trail, and extra care should be taken on any of the downhill or uphill sections to avoid slipping. The steep descent you are now on runs for about 500 feet, and empties into a drainage at the bottom with a few large caliche boulders laying in the drainage. Go past the boulders and make a sharp right (about 120 degrees) onto the trail that climbs in a southwest direction. You may notice that this ascending portion of the trail has a rock wall on the downhill side to protect the trail from erosion. This rock wall, along with a few other similar sections of rock wall in the next 1/5th mile, is not recent, but indicates someone's desire in the past to make sure the trail was kept in a good state of repair.

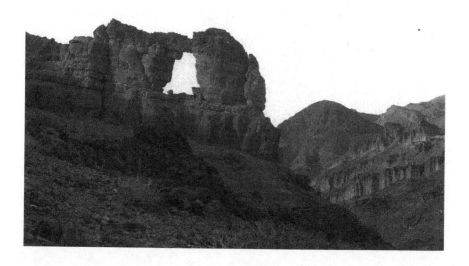

The trail continues to climb until it reaches the top of a ridge and makes a sharp bending turn to the right. As you come around this section, which is a little more than one mile into the hike, look over to the right and you can see some cables tied around a large rock formation and what is left of a large sluice. This sluice was used to separate the ore from the larger volume of dirt that came from the mine on the other side of the ridge from the sluice. The trail goes between the sluice and a rocky drainage that is littered with cast-off parts and hose sections that were used for pulling water up from the Colorado River to use in the sluice. The trail crosses the tip of the ridge and descends over some rocky sections toward a wide wash area. At the bottom of the steeper portion of this downhill section, a trail goes off to the right toward the old mine. It is worth it to make the short detour to get an idea of the work necessary to move the mined earth, even though the mine entrance has now been filled in to avoid any accidents.

If you have taken the detour to view the mine site, return to the trail junction and continue outbound on the main trail. In about 1/8th mile, the drainage of the wash area narrows and the trail you are on drops into

the rocky drainage, which contains at least a dozen cairns. Continue in this wash for a little more than 800 feet, where you will see a cairn on the right marking the trail continuation. Take the right and start climbing up to a ridge. The climb up the ridge is about 1/8th mile in length. At the top of the ridge, go left at the trail junction marked with a cairn. You have now gotten sufficiently north of the arch (on your left) so that you can clearly see the extent of the opening in the rock.

The trail now heads in a southwest direction as it begins a fairly long climb around to the south side of the arch. The similarity of the opening in the arch to the shape of the Liberty Bell becomes more and more apparent as you continue on this climb portion. Just past 2 miles into the hike, as you are about to cross a ridge that will block your view of the arch, turn around for what is the best angle to view the opening in the arch. After you have taken a picture or two, continue on the trail in a southwest direction.

The last ½ mile of the trail is highlighted by passing through an area of dark-brown rock formations that include a number of medium- to large-sized boulders. The trail crosses a couple of step ridges on the way to the highest point. At one spot, you think you are only 50 feet or so from the top, only to discover that there is another higher level in about 100 yards. As you make the climb to the highest part of the bluff, the trail crosses a rocky area and the Colorado River becomes visible below and to your left. Continue up to the highest point on the bluff for the most expansive view of the river, which is about 700 feet below your present location. This is a great place to hang out for a while and enjoy a snack. Especially during the weekend, you will probably spot some kayaks, rafts, or larger motorized watercraft exploring the channel of the river.

To Return: Retrace your steps off the bluff, following the trail back to the highway. At about 5/6th mile on the return, a cairn marks a trail junction where you will turn right to retrace your steps. While the trail that goes straight will get you back to the highway as well, do not try this route until you have a good familiarity with the area. When the trail

drops into a wash, turn left at the cairn marking the spot and proceed up the wash. About 1 ¼ miles into the return, a cairn marks a right turn out of the wash area toward the old mine. After climbing over and around a few more ridges, the trail, with a rock wall retaining the soil, drops steeply into a wash. Make the 120-degree left turn into the wash and proceed about 300 feet up the wash. Look for the cairn that marks the trail climbing out of the wash on the right side. From this point on, it is very easy to follow the trail until it meets with the old jeep track about ¼ mile from the highway, which you have already gotten a good view of. Take a left on the jeep track and return to your vehicle.

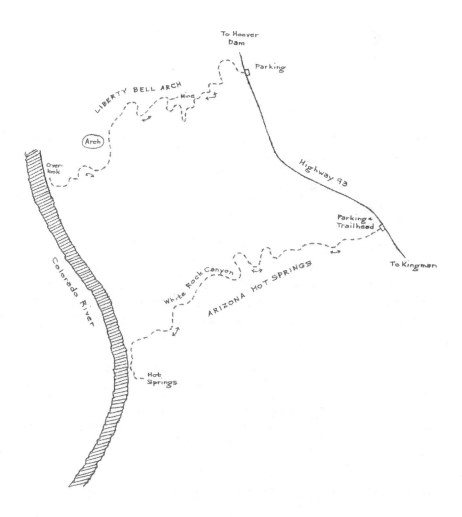

197

ARIZONA HOT SPRINGS

How to Get There: Take U. S. Highway 93 southeast from Las Vegas to Hoover Dam. Cross the dam and proceed 4.5 miles into Arizona on Highway 93. At the bottom of a one-mile downhill section, the road crosses a bridge over a wash, with the turnout for the Arizona Hot Springs just beyond. Be careful as you exit the highway, since there is no right turn lane to get out of the way of traffic. The parking area will hold about 20 cars comfortably.

Starting Point: Southwest side of parking area
Difficulty Rating: 3
Distance: 6 Miles
Elevation Gain: 800 Feet (on return)

Comments: Arizona Hot Springs is described in this book as an out-and-back hike. It has the lowest elevation above sea level of any of the hikes listed in the book. Consequently, it experiences extremely high temperatures in the summertime. You should probably avoid this hike between mid-May and late September. In addition, about two miles of the hike route each way is in White Rock Canyon, with an average width of 15 or 20 feet, and is subject to some intense flash flooding conditions. Do not attempt this hike if the weather forecast includes any chance for high rainfall amounts. If you are planning on spending some time in one of the small pools at the springs, make sure you have a swimming suit or trunks along. Bring more water than you usually would for a 6-mile hike.

Hike Description: The hike begins at the southwest side of the parking area by a sign titled "Lake Mead National Recreation Area" that gives the distances to Lake Mojave and the Arizona Hot Springs. The trail

past the sign starts off in a southwest direction, the general outbound direction for the entire hike. It immediately begins to descend toward the opening for White Rock Canyon, which appears as some brown volcanic rocks about ½ mile in the distance. The trail surface is dirt with only a few imbedded rocks. There are several brown and green signs with directional arrows pointing out the hiking route.

The early part of the trail appears to be an old jeep track, which ends somewhat as the trail drops into a minor wash about 1/3rd mile into the hike. Past that wash, the trail becomes a wide single track for about 450 feet until it drops into the White Rock Wash, the major drainage for the area. For the next 2.25 miles, you will be hiking over a composite of sand and pea gravel, with some occasional larger rocks and boulders. Most of these rocks and boulders are white or light gray in color, contrasting sharply with the brown pigmentation of the volcanic rock that makes up the canyon walls. This is evidence of the extreme force with which large volumes of water can cascade down the narrow, lengthy canyon.

About 1/10th mile after dropping into the wash, short tan-colored walls begin to form along the sides of the wash. Within 1/3rd mile, the color of the walls switches to dark brown as the walls gain increasing height on both sides and you enter the canyon itself. For the next mile, you experience a sense of confinement as the canyon stays very narrow with walls on either side in excess of 100 feet in height.

About two miles into the hike, the canyon suddenly widens for a distance of about 1/5th mile. As the canyon walls pull back in this stretch, they attain a height of about 400 feet above the wash floor. Just as suddenly, the canyon walls converge again to about 15 feet in width, and stay that way until you exit the canyon about 2.5 miles into the hike. As you exit the canyon, the Colorado River, which at this point flows through Lake Mojave, is visible ahead.

Proceed within 100 feet of the water and look for a sign that directs hikers to the left, or downriver. For the next 0.4 miles, the trail winds

along the bank of the river. In places, it makes short, steep climbs over rocks as it continues toward the hot springs area. Even with directional signs, you may wind up on a secondary trail that is not officially open, even though it appears to be the best route. It is slightly easier to follow the official trail on the way back, but you may find that route slightly treacherous. In any event, do not stray very far from the river's edge as you proceed.

If you are on the right trail, in about ¼ mile from your first sighting of the river you will descend on the trail to a gravel-filled wash. Generally, you will be able to see some water in the wash to your left. Turn left into the narrow wash to access the hot springs. You soon will see water flowing down the wash in increasing volumes as you continue upstream, with the water temperature also rising the farther you go. In about 1/8th mile you come to a 20-foot steel ladder that has been bolted to the side of a waterfall. The hot springs are located a short distance beyond the top of the ladder. Be careful as you climb, since warm water is usually dropping over the falls and hitting portions of the ladder. Also, be advised that the hot springs may contain an amoeba called Naegleria Fowleria, which could enter through the nose and cause infection or death, so don't submerge your head in the hot springs pools.

When you have had your fill of the hot springs, which reach temperatures of 120 degrees Fahrenheit, follow the wash downward past the point where you accessed it and you will come out at an alcove on the river that is a favorite spot for canoeists to beach their watercraft. There is a rock outcropping just past the beach area where you can feel the water from the river and two outhouses that appear to be maintained on an occasional basis. On weekends, this is a very popular camping area for people who have accessed this spot via the river.

To Return: Reverse your direction to the trailhead. Until you get back to White Rock Canyon in ½ mile, the trail is sporadic and occasionally difficult to follow for short distances. Take it slow and try to maintain

visual contact with the river at all times. Once in the canyon, you will realize that the wash is steeper than you thought on the way down, and that it takes a lot more effort to deal with the loose material that constitutes the surface of the wash when you have to climb through it. If you experience any overheating, slow your pace down and drink plenty of water.

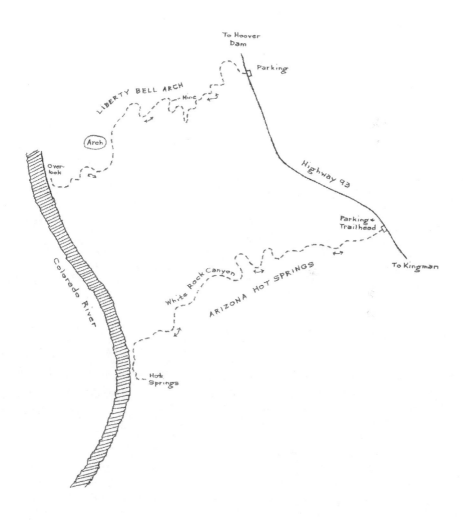

ABOUT THE AUTHOR

CHRIS DEMPSEY was raised and lived most of his adult life in the Twin Cities metropolitan area of Minnesota. Apart from his working career, he stayed physically active by playing golf during the summer, skiing during the winter, and running during the entire year. In late 2000, he and his spouse moved to Las Vegas for warmer weather and mountain vistas.

In early 2002, he joined the Lone Mountain Hiking Club and began experiencing the scenic beauty of the area around Las Vegas. Hiking also satisfied the need for physical activity, and he soon found himself on the trails several times each week.

In 2004, Chris began leading organized hikes for the Red Rock Canyon Interpretive Association. Currently, he leads about five hikes each month for Red Rock, as well as occasional hikes for Lone Mountain Hiking Club and the Sun City Summerlin Fitness Department. Even though Chris is retired, he sometimes feels that hiking has become a full-time occupation.

Made in the USA
Middletown, DE
18 October 2017